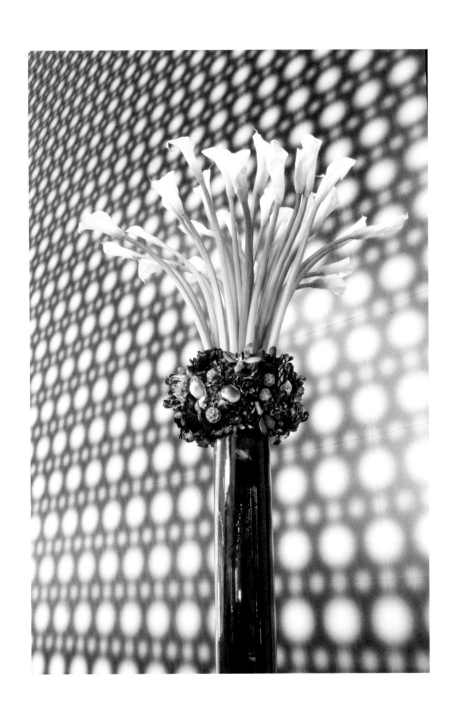

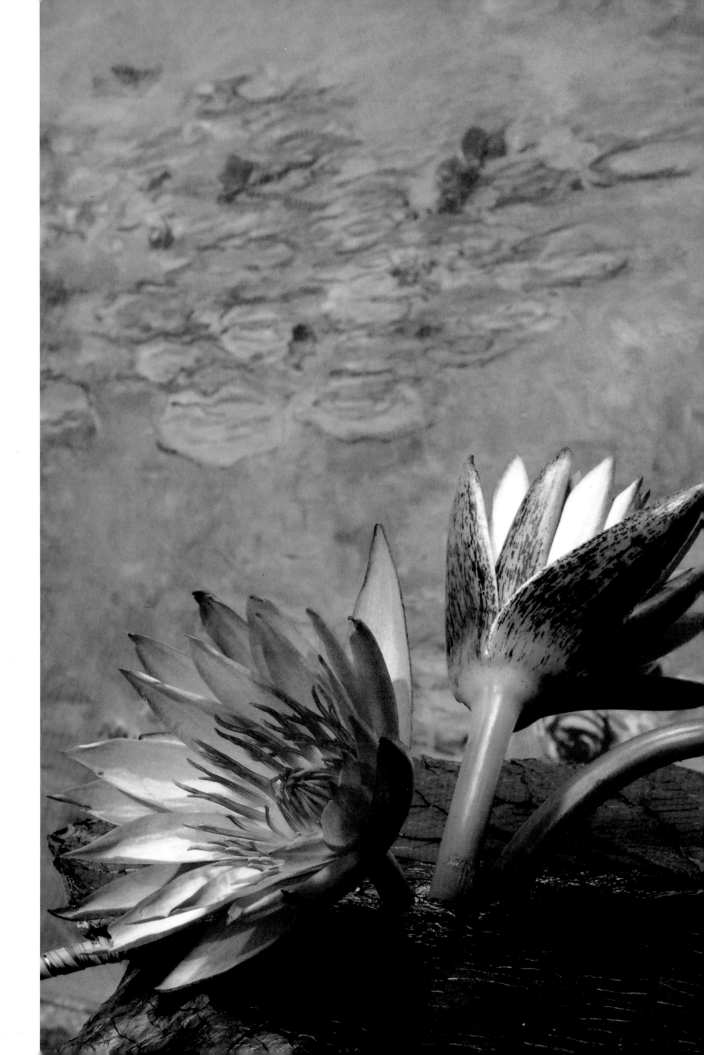

*More than anything
I must have flowers
always, always.*

Claude Monet

Bouquets to Art™

at the

FINE ARTS MUSEUMS
of SAN FRANCISCO

LEGION OF HONOR

DE YOUNG

PAMELA J

BOUQUETS TO ART
at the FINE ARTS MUSEUMS
of SAN FRANCISCO

All photographs © 2006 by Pamela J
Text © 2006 by Pamela J
Design: Pamela J
Editor: Jean Brook

FIRST EDITION

All fine art except as otherwise credited
is in the collections of the
FINE ARTS MUSEUMS OF SAN FRANCISCO,
Legion of Honor and de Young

Color Reproduction at Tien Wah Press, Singapore
Printed and bound at Tien Wah Press, Singapore

ISBN: 0-9777713-0-X

Page 1: Gerhard Richter, *STRONTIUM*
Floral design by Jun Piñon, Piñon Design
Page 2: Claude Monet, *Water Lilies*
Floral design by Kelly Carr, Trillium Designs

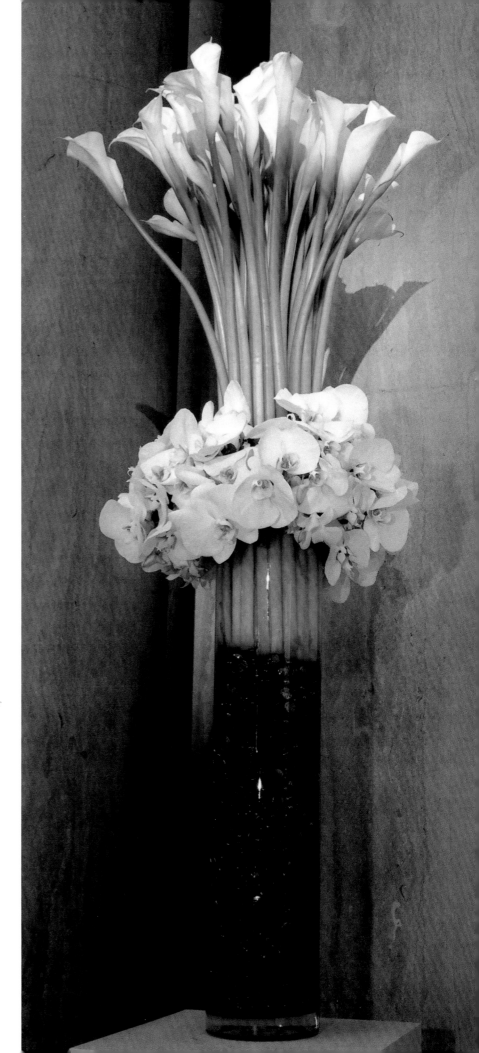

*Flowers worthy of
paradise.*

John Milton

Bouquets to Art 2004

Floral Design
Jun Piñon,
Piñon Design
San Francisco, CA

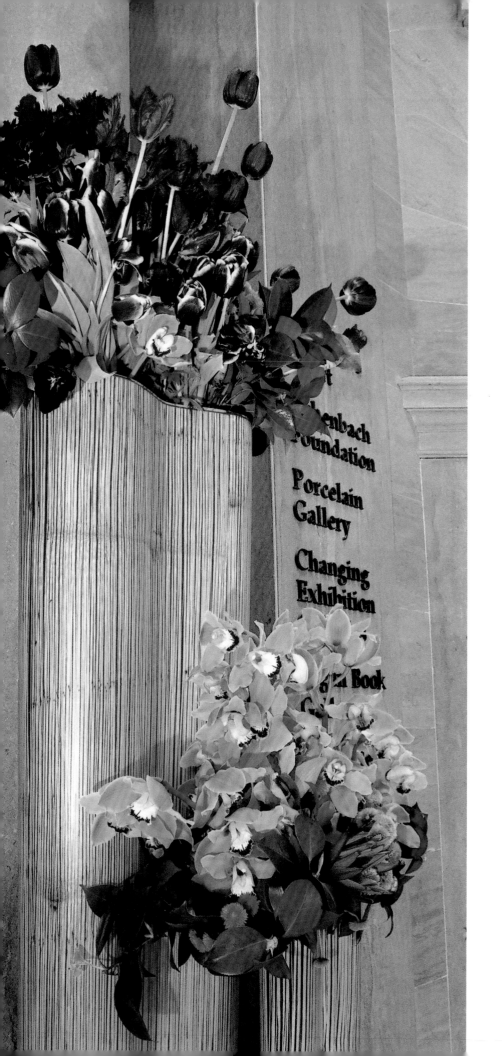

C O N T

E N T S

Bouquets to Art 2004
Rotunda

ORNA MAYMON OF ORNAMENTO, San Francisco, CA
replicates the shapes of the Legion's special 2004 Art Deco
exhibit with two pairs of tall pressed bamboo containers.
Filled with a profusion of purple tulips, variegated white
and pink parrot tulips, contrasting chartreuse cymbidium
orchids, and fuchsia lotus, the floral columns are a beautiful
complement to the Art Deco theme.

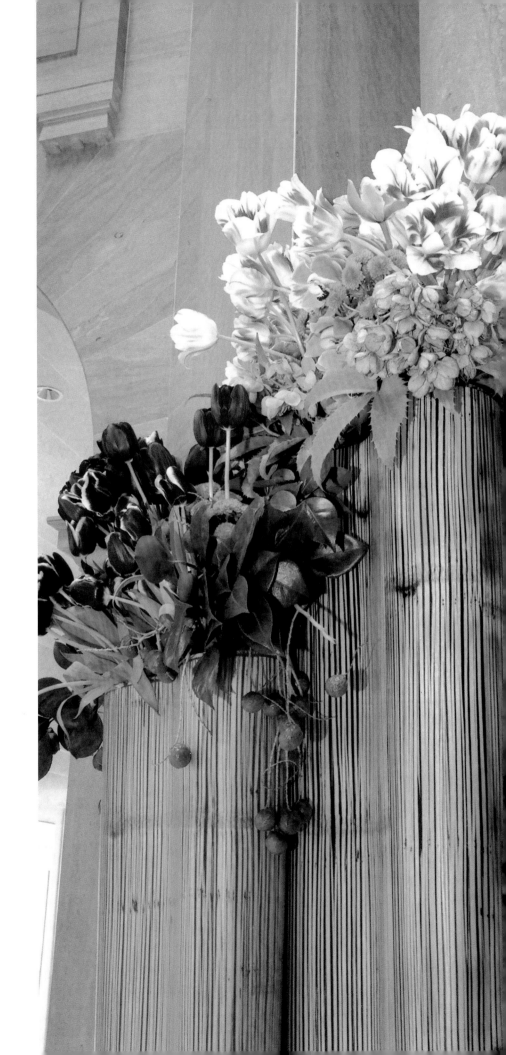

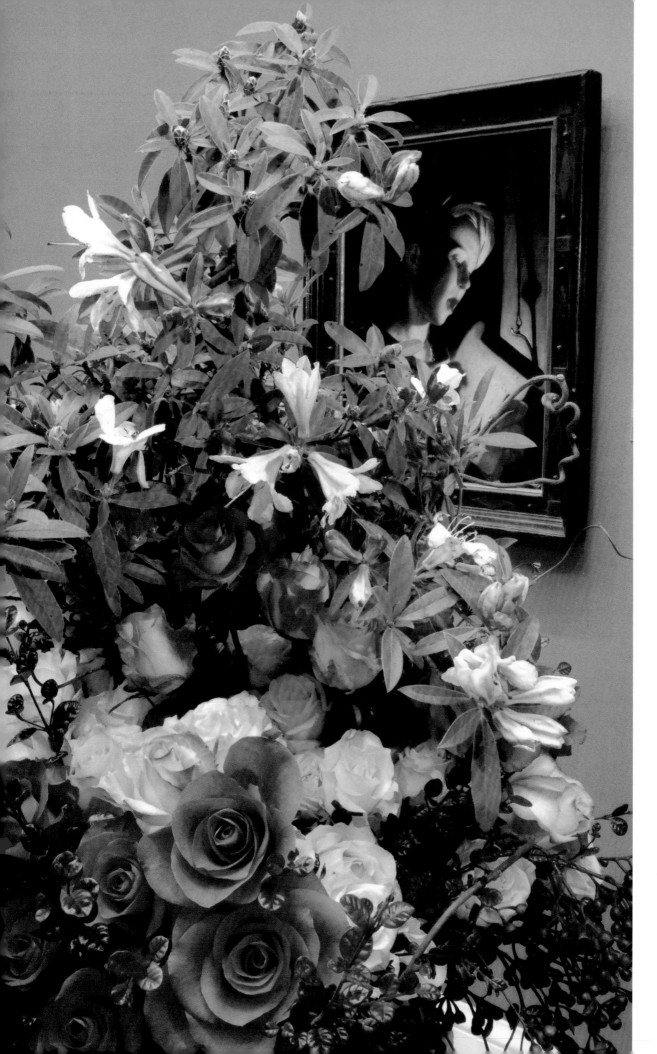

Bouquets to Art 2004

GALLERY 6
THE GEORGE AND
MARIE HECKSHER
GALLERY

The Candlelight Master
French, active ca. 1620-1640
Young Boy Singing
Gift of
Archer M. Huntington
in memory of
Collis H. Huntington

STEPHEN O'CONNELL
OF FLORAMOR STU-
DIOS, San Francisco, CA
captures the magical light
in the painting with a rich
tapestry of leonidas and
Hollywood roses, tree
azalea, lophomyrtus leaves,
and curly willow.

Bouquets to Art

The Legacy and History
at the
Fine Arts Museums of San Francisco

Bouquets to Art is San Francisco's harbinger of spring. Since 1984, this much-anticipated event has become a time-honored annual tradition. For one week in March, the Bay Area's finest floral designers have transformed either the M.H. de Young Memorial Museum or the California Palace of the Legion of Honor into a glorious garden of culture celebrating the pairing of floral art with fine art. While the pairs will be together for a very brief time, the new creations that emerge become that year's *Bouquets to Art* legacy. Year after year, record-breaking numbers of visitors enter the museum in anticipation of what new feats of imagination the designers will reach that year. The visual feast that awaits them is savored and appreciated all the more, knowing the fragile and fleeting nature of its existence.

The marriage of art and floral art is a tradition initiated by the Boston Museum of Fine Arts in 1976, which they named *Art in Bloom*. Many other museums across the country now carry on this springtime tradition either annually or biannually under the name *Art in Bloom*, as at the New Orleans Museum of Art, the Saint Louis Art Museum, and the Mint Museum of Craft + Design in Charlotte, NC; or under a variety of other names, such as *Art Alive* at the San Diego Museum of Art; *Florescence: The Arts in Bloom* at The Museum of Fine Arts in Houston; *Fine Art & Flowers* at the Wadsworth Atheneum Museum of Art in Hartford, CT; *Art Blooms at the Walters* at The Walters Art Museum in Baltimore; and *Art en Fleurs* at the Milwaukee Art Museum, to name just a few.

Bouquets to Art in San Francisco was initiated twenty-one years ago by Ian McKibbin White, then director of the Fine Arts Museums. Inspired by *Art in Bloom* at the Boston Museum of Fine Arts, he came to the San Francisco Auxiliary of the Fine Arts Museums and proposed the idea of a fundraiser that would present exceptional floral art paying tribute to the collections of the Fine Arts Museums. A small team of Auxiliary members took on the challenge and moved forward with the planning, preparation, and organization of the event. However, without the enthusiastic support and encouragement of the Bay Area's finest floral designers, the event would not have happened. Year after year it has been their creative, financial, and time commitment that has been indispensable to the success and growth of the event.

Orchestrated and sponsored by the Auxiliary, *Bouquets to Art* made its debut at the M.H. de Young Memorial Museum in Golden Gate Park in 1984 as a three-day event featuring approximately twenty-five floral designers. Today, there are nearly one hundred exhibitors and a team of more than thirty volunteers from the Auxiliary organizing, planning, and promoting what has become the Fine Arts Museums' major fundraiser. In addition to the floral exhibits, the week-long event also includes a gala opening night, preview party, and silent auction; lectures; master design classes; and luncheons. What emerges out of this joint effort between the Auxiliary and the floral designers is a rich legacy that is recreated anew each year as each designer visualizes and complements the works of art in their own unique style and over one hundred Auxiliary members devote themselves to making each year more successful than the year before.

Bouquets to Art 2002

CATE KELLISON OF ROSE AND RADISH, San Francisco, CA makes a simple, yet very strong statement with a floral sculpture of the old man resting on his cane. Repeating the red of his trousers with a solid mass of bright red tulips, the floral sculpture repeats the bent-over body of the man, while the pole represents his cane.

GALLERY 7
THE ROBERT DOLLAR
GALLERY

Georges de La Tour
French (1593-1652)
Old Man, ca. 1618-1619
Oil on canvas
Roscoe and Margaret Oakes
Collection

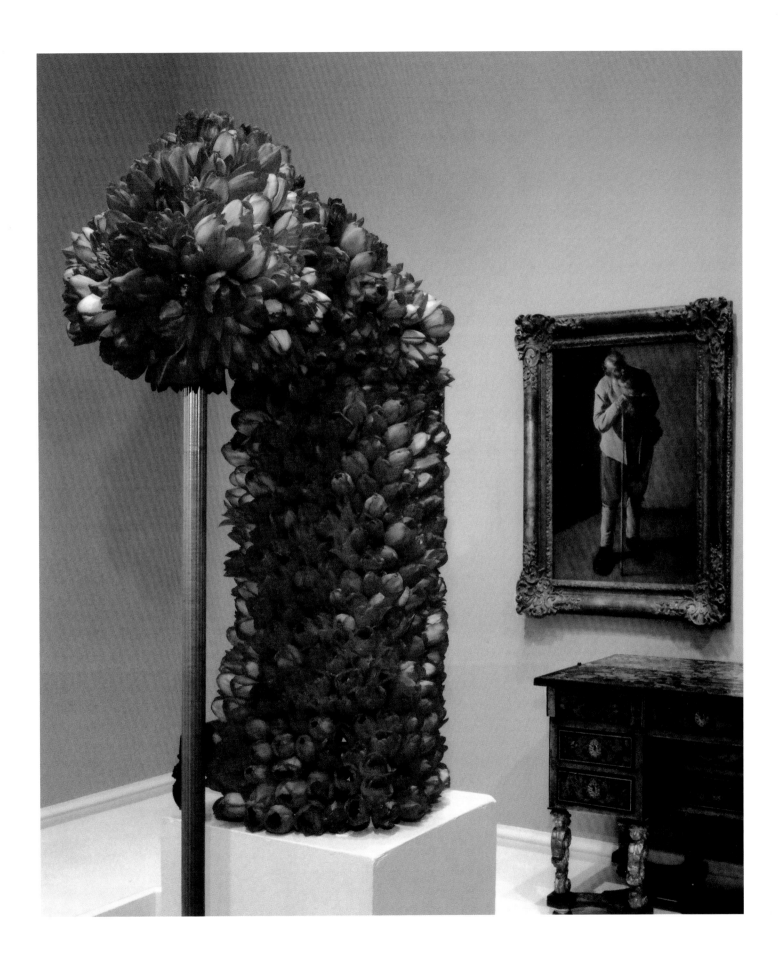

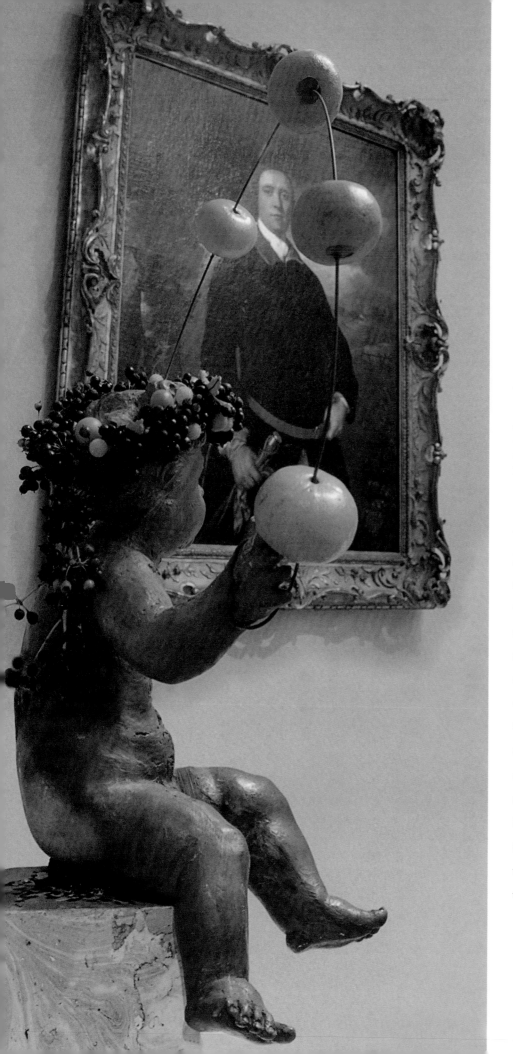

Gallery 13
The Marianne
and Richard H. Peterson
Gallery

Thomas Gainsborough
British (1727-1788)
Samuel Kilderbee of Ipswich
ca. 1755
Oil on canvas
M.H. de Young Endowment Fund

Bouquets to Art 1997

Ron Morgan, Oakland, CA
always highly creative and often
whimsical in his work, breaks with
tradition and playfully places a
delightful German putto juggling
oranges for Thomas Gainsbor-
ough's formal portrait of the Earl of
Orange. Dressed only in a crown
of fruit and berries, and innocently
smiling up at the reserved, yet
amused barrister, the little per-
fomer is obviously enjoying both
the moment and his audience, and
we are entertained with what might
well be a scene from Shakespeare.

The Fine Arts Museums of San Francisco was formed in 1970 by the union of the M.H. de Young Memorial Museum and the California Palace of the Legion of Honor. Under a joint action of the trustees of the two museums, the collections of each were joined under a single administrative head. The Legion now houses the best of the collections of antiquities and European art from both museums, as well as the Achenbach Foundation for Graphic Arts. The de Young museum focuses on American art of all periods, costumes and ethnographic textiles, and the arts of Africa, Oceania, and the Americas. It is from these rich collections of art treasures that Bay Area floral designers have been fortunate to draw their inspiration. For the early years, and while the Legion was under renovation, *Bouquets to Art* took place at the de Young museum in Golden Gate Park. In 1996, following the grand reopening of a newly renovated Legion of Honor in October 1995, *Bouquets to Art* moved to this museum where it remained through 2005.

Now after ten years at the Legion, *Bouquets to Art* returns in 2006 to the exciting and impressive new de Young museum that opened to wide acclaim in October 2005. With nearly one hundred talented and enthusiastic floral designers weaving their magic in galleries that already take one's breath away, the show is destined to be an over-the-top floral christening of this glorious new museum in historic Golden Gate Park and an unforgettable beginning to a new legacy of San Francisco's harbinger of spring, *Bouquets to Art*.

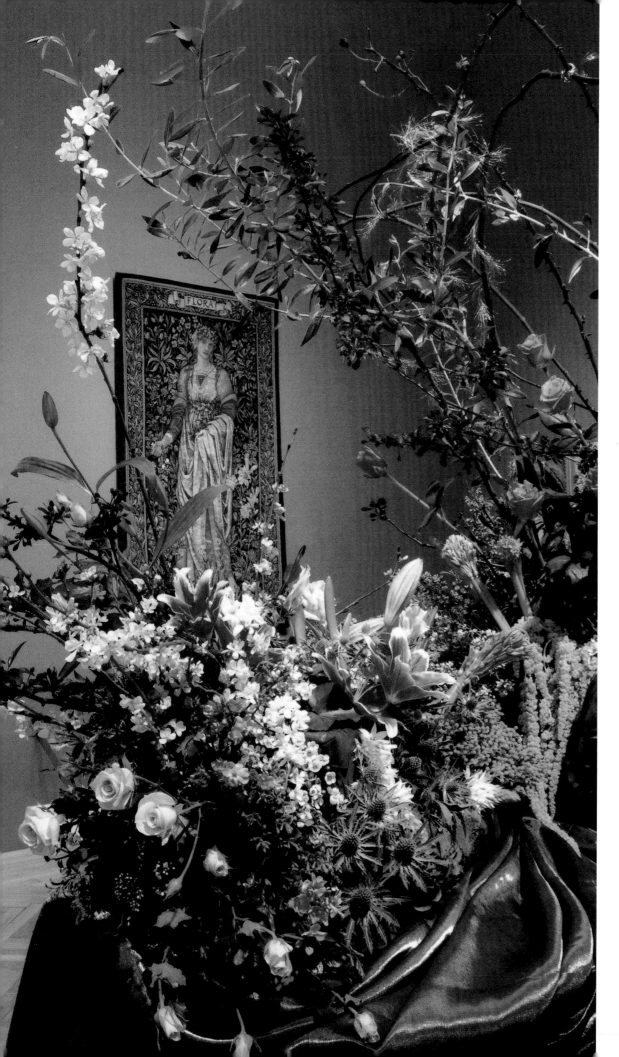

Bouquets to Art 2005

Edward Burne-Jones
English (1833-1898)
Flora, 1886-1920
Wool, silk, cotton
tapestry weave
Museum purchase
Dorothy Spreckels
Munn Bequest Fund

JANAN GREEN,
HARRIET MERRITT,
AND ALLANA MERRITT
OF ARTISTIC DESIGNS
BY JANAN, Half Moon Bay,
CA weave a beautiful
tapestry of spring flowers
reflecting the colors and
textures of the lovely *Flora.*
Plum blossoms, star of
Bethlehem, pink hydrangea,
champagne roses, green
amaranthus, galyx leaves,
stargazer lilies, and blue star
thistle expertly wrapped in
shimmery silk fabric create
a luxuriant and joyful tribute
to the flora of spring.

Bouquets to Art

Legion of Honor
1997 - 2005

Flowers and fine art awaken our senses and nourish our soul. Individually they are inspiration and delight. Paired together, they are magic. It is a window into this magic that I have attempted to create through the images in this book.

Each year as I entered the Legion the morning of set-up day, I would relish the beauty of the spectacle that was unfolding before me. Flowers were everywhere; some exhibits had been installed in completion; others were emerging out of an abundance of flora and creative energy. Then I would begin my journey to photograph as many as possible within the brief window of time before the opening that evening. My objective was not to merely juxtapose the two, but to unite the fine art and floral art in a way that would create a unique image of its own. So much was intuitive. Many times I did not realize what I had captured until I saw the printed image later. Other times the magic jumped out at me through the lens as I focused and angled my camera. In either case, I was not just an observer, but a participant with my camera in creating something new, a third work that honored the two art forms, but could also stand on its own artistic merit.

Writing the commentaries accompanying each exhibit was a fascinating experience. As I spoke with each floral designer individually, their stories of creative inspiration gave new life and meaning to both their floral art and the fine art. It is my hope that these commentaries will provide a greater understanding of the creative process behind the floral works and in doing so, also provide a new and deeper insight into the fine art.

For nine years, it has been my joy and privilege to be a part of this event made possible by the generosity of spirit of the floral designers, the Auxiliary volunteers, and the staff of the Fine Arts Museums, who together make it all happen.

May the magic long continue.

1997

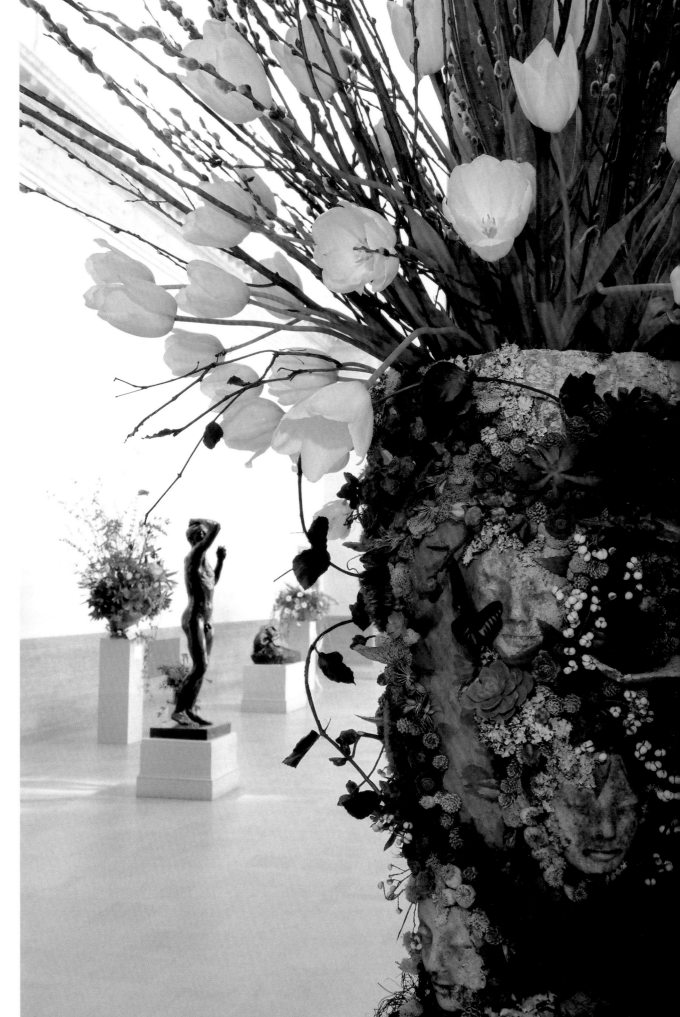

Art is the flower of culture.
The beauty of this flower,
universal in its appeal,
acts to open up people's lives
and bring them closer together.

Daisaku Ikeda

Raise the curtain on the
"Renaissance of Humanism"
Sendai, Japan, 1988

ROTUNDA *(below)*

Michel Anguier, French (1612-1686)
Hercules and Atlas, late 17th century, bronze
Museum purchase, William H. Noble Bequest Fund

GALLERY 10 *(page 17)*
ADOLPH B. AND ALMA DE BRETTEVILLE SPRECKELS GALLERY

Auguste Rodin, French (1840-1917), *The Age of Bronze (L'Age d'Airain),* ca. 1875-1877, bronze

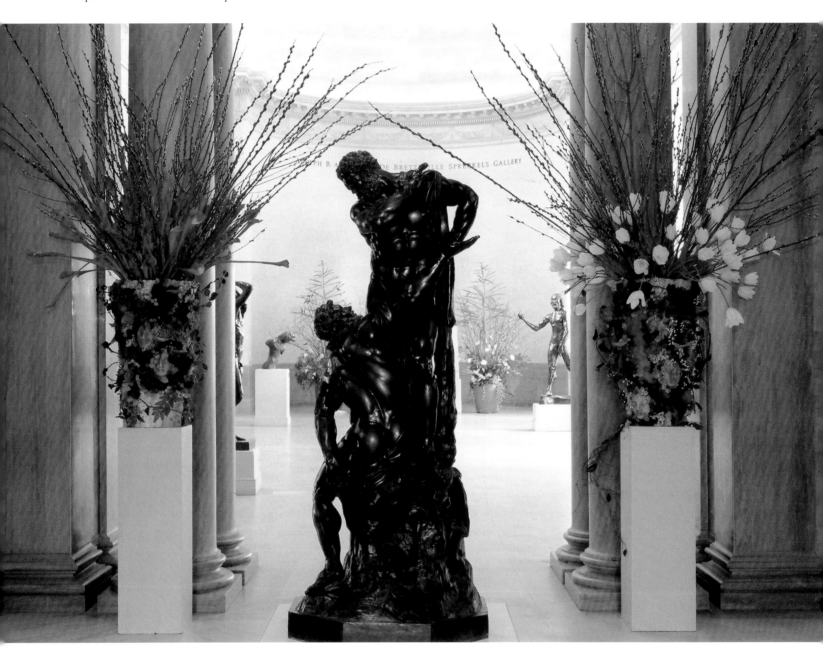

PATRICK KNIGHT OF P. KNIGHT FLORAL AND EVENT DESIGN, San Francisco, CA graces the rotunda with a magnificent pair of sculptural vases covered with an array of earthy plant material surrounding a number of enchanting faces that give the ensemble an almost ethereal feeling. The faces are constructed using mannequin heads given an algae wash to create a weathered-garden look. A variety of dried and fresh elements are artistically combined to provide an earthy environment for the faces: pine cones, grapevine, lichen, sheet moss, paved eucalyptus foliage and escheveria combined with reindeer moss, poppy pods, lotus pods, sphagnum moss, and preserved Algerian ivy. Delicate butterflies and small bugs complete the feeling of a magical garden bursting into bloom. To make a bold and strong statement, each vase is topped with a mass of a single kind of flower, green goddess calla lilies and white French tulips accented with towering branches of pussy willow. The inspiration for this creative adventure came from the faces of the sculptures within the Rodin gallery, which reappear on the vases as if they are peering back at you from the gallery.

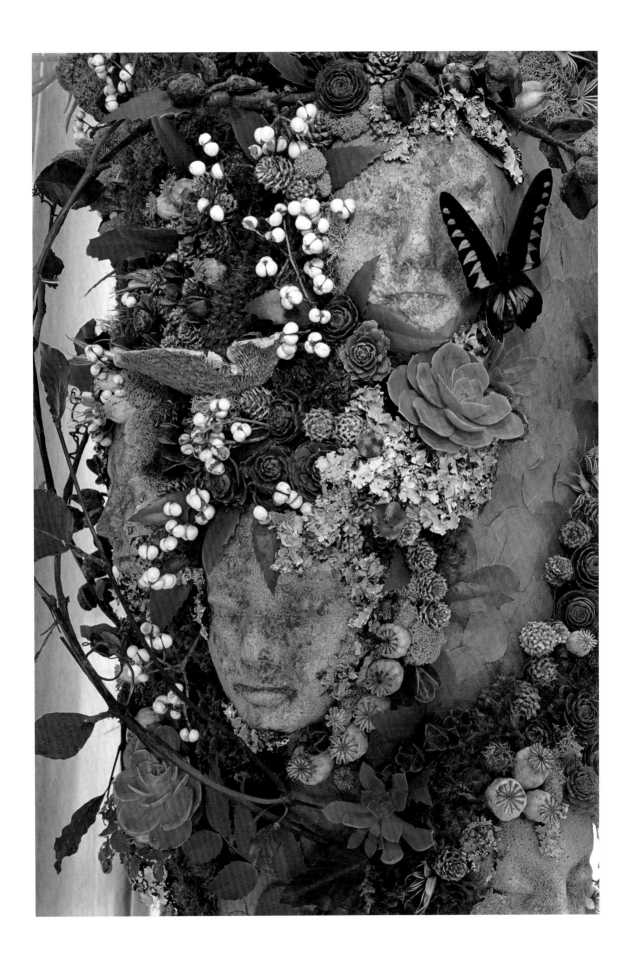

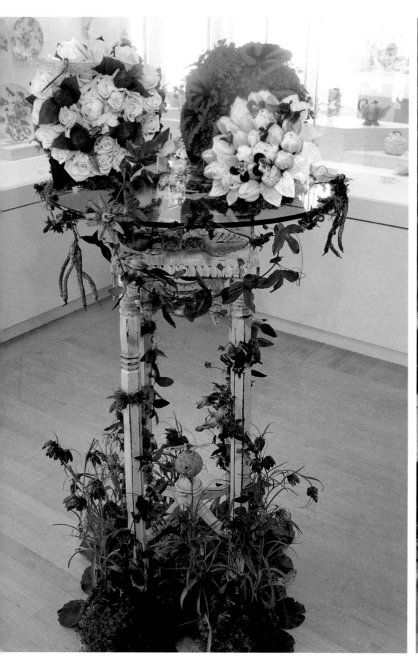
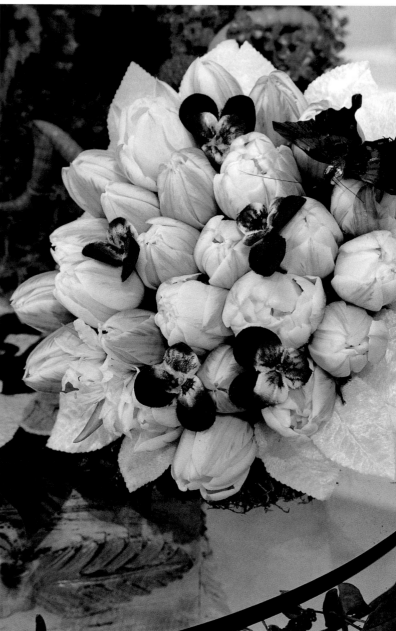

MARCIA MAFFEI OF FLORAGARDENS, San Anselmo, CA was naturally drawn to the Porcelain Gallery's beautiful collection of English porcelain plates by her favorite color combination of green and white. Inspired by their variety of bugs, green and white fruits, and whimsical plants, she incorporated all these elements into her floral design. Three floral plates rest on the glass top of an antique garden table entwined with

GALLERY 23
CONSTANCE AND HENRY BOWLES PORCELAIN GALLERY

English Porcelain Plates, Chelsea, 1745-1760
Teapot and Cover, ca. 1756, Langton Hall Factory, English,
Soft-paste porcelain

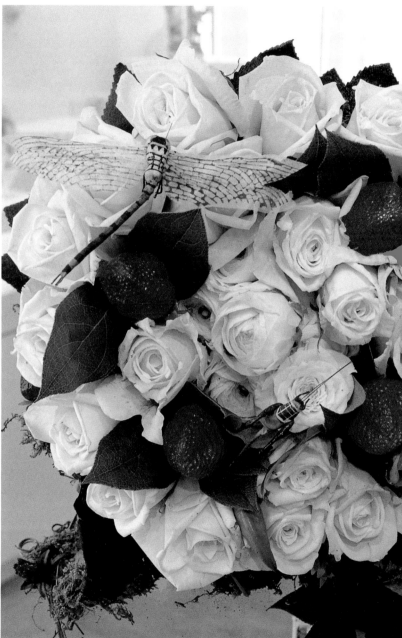

passion vine and runner beans, and nestled at the bottom amidst a garden of artichokes, white and purple fritillaria, meleagris, baby tears, and galex leaves. The large white "plate" is made with white roses, faux strawberries, and green velvet leaves; the smaller white "plate" is parrot tulips, velvet pansies, and white velvet leaves; and the green "plate" is baby tears, begonia leaves, and galex leaves. Dragonflies, a grasshopper, and a butterfly complete the picturesque garden scene.

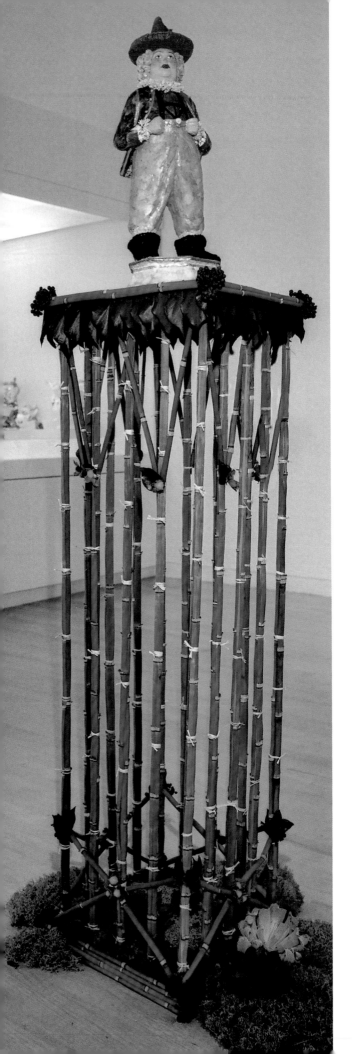

CONSTANCE AND HENRY BOWLES
PORCELAIN GALLERY
18th - 19th Century Porcelain

Court Jester Johan Fröhlich
Johann Joachim Kandler
German, Meissen Factory
Roscoe and Margaret Oakes Collection

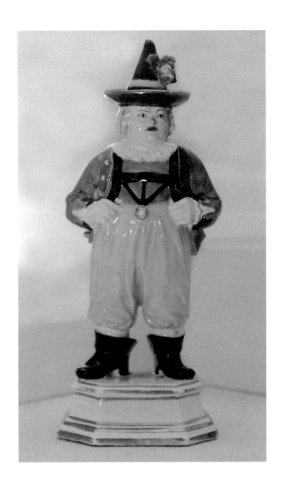

DOMINIQUE PFAHL OF FLORÉAL, San Francisco, CA recreates a perfect floral replica of a small porcelain figurine of a court jester. Made from papier mâché with a hand-painted face, her jester is completely dressed in a variety of flower petals, each glued on by hand. The orange-red hat is Chinese lanterns, his hair cotscomb, the blue shirt belladonna, the suspenders sushi seaweed, the neck and cuff ruffles genestria, the yellow pants rose and jonquil petals, and the boots black sesame seeds with acacia inside. He stands on a pedestal of rose petals supported by a stand of donkey tails, ivy leaves, and colorful berries.

Dominique's work was a tribute to her dear friend and mentor Betty Bogart, recently deceased at the time, who had introduced her to *Bouquets to Art* ten years earlier. In memory of her laughter, sense of humor, and lively personality, Dominique chose the happy figure of the jester.

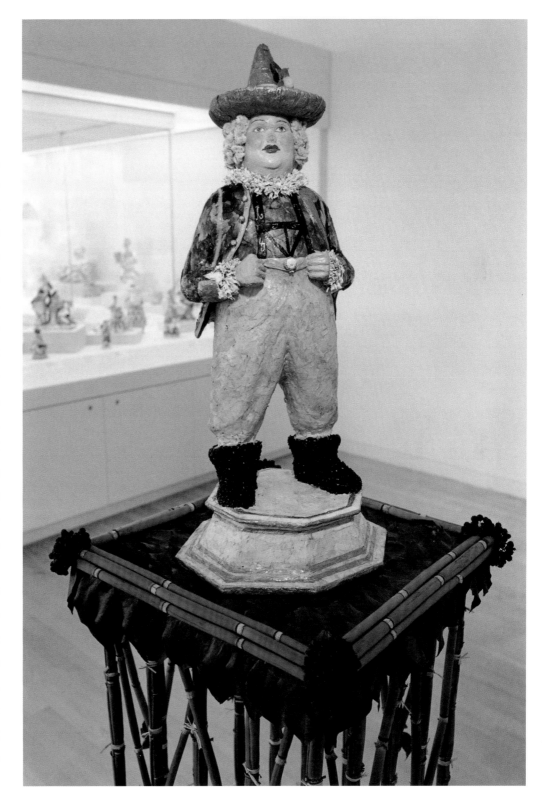

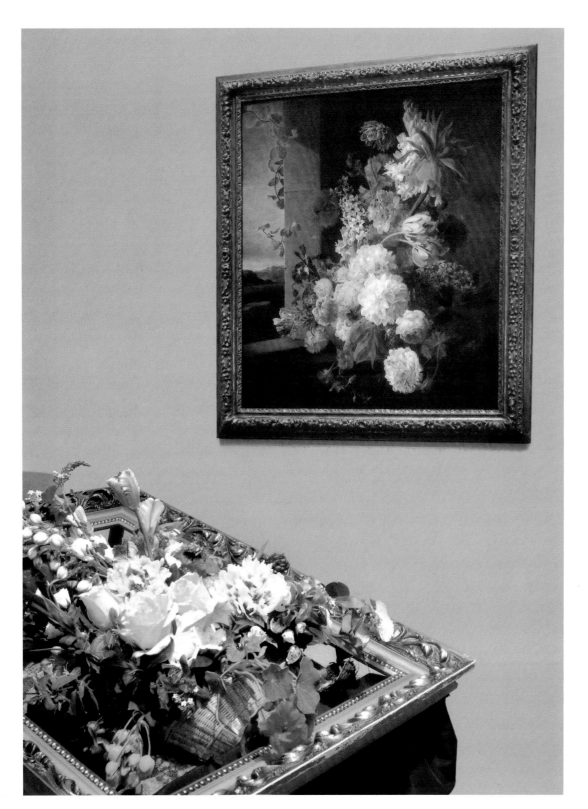

GALLERY 15
THE WILLIAM FRIES II
GALLERY

Jan-Frans van Dael
Flemish (1764-1840)
Flowers before a Window, 1789
Mildred Anna Williams
Collection

KAREN BABA AND BARBARA ATKINSON OF PLAN DÉCOR, Burlingame, CA breathe new life into this 18th century still life painting with the beauty and fragrance of a closely matched living replica. Encased in a gilded frame and bursting forth in a profusion of springtime exuberance are peonies, yellow roses, nasturtiums, fritillaria, parrot tulips, purple hyacinths and iris, and delphinium. Reflecting the painting's flowers in both color and form, the arrangement is angled and set low for close viewing and full appreciation of the three-dimensional living floral tapestry.

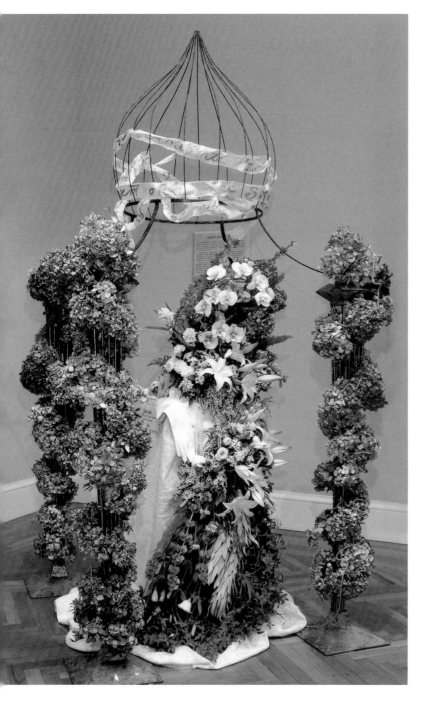
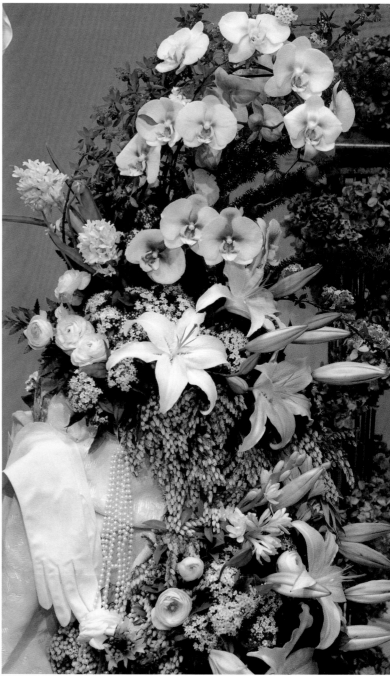

JANAN GREEN OF ARTISTIC DESIGNS BY JANAN, Half Moon Bay, CA and assistant PAM CHARBONNEAU viewed *The Russian Bride's Attire* as needing an arrangement "over the top" to interpret and reflect the opulence and grandeur of the wedding preparation scene. The first step was the design of the onion dome, supported by four wire stand columns, all connected for stability, and then executed to exact specifications by a local welder. Dried hydrangeas taken from her garden were hand-tinted with layers of color, threaded on wire, and then wrapped around the columns. Drawing on the elegant and feminine details in the painting, Janan places pearls, a prized jewel of the 19th century, white gloves and a silk pillow amidst a luxuriant display of blush pink phalaenopsis orchids, Casablanca lilies, hyacinths, ranunculus, tuberoses, pierras white bells, asparagus fern, bells of Ireland, and smylax. The final touch is a stream of French ribbon woven in the dome with the words of a Russian love poem written in the Cyrillic alphabet.

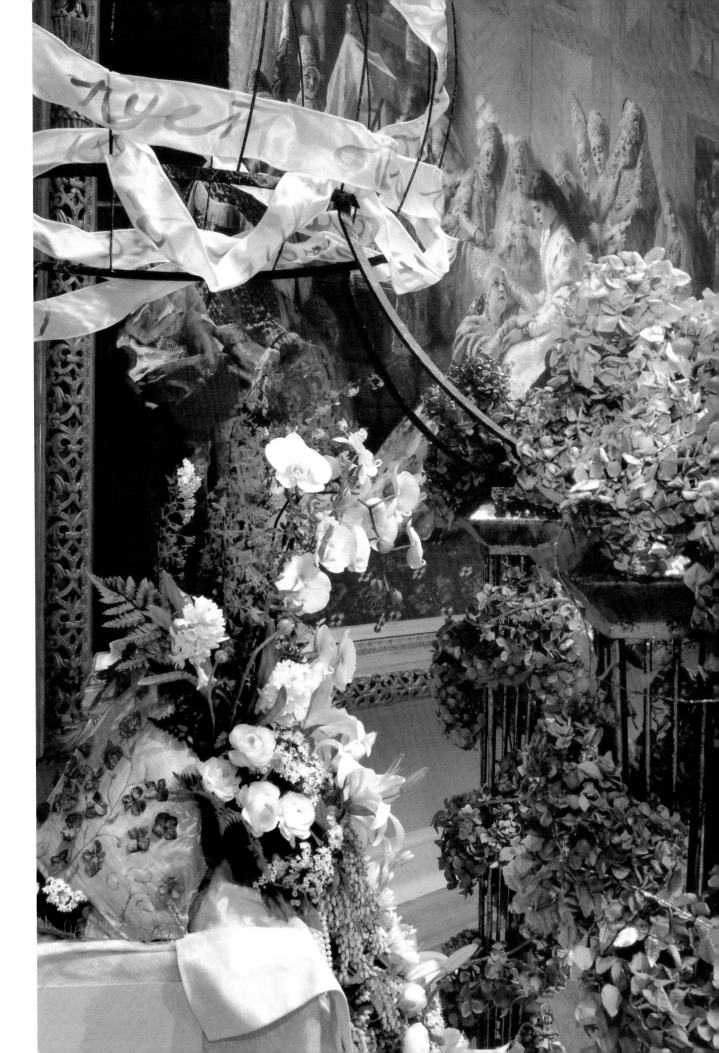

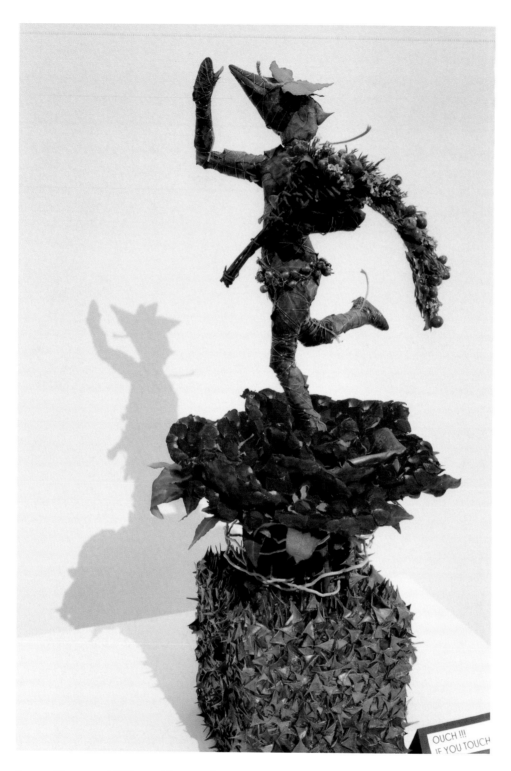

OUCH !!!
IF YOU TOUCH

Ikuyo Nakase, AIFD, of Hanaju Florist Co. Ltd., Tokyo, Japan creates an enchanting plant material replica of a bronze figurine of a Roman running man. A small wooden artist's model with movable joints forms the base of the figure, which is then wrapped and glued with plant material. His spirited stride is perfectly captured landing on a full-blown rose, skillfully created with dried rose petals and leaves, resting on a pedestal of rose thorns. Ikuyo drew her inspiration from the ancient tale of the diminutive character Tom Thumb and his adventures with the Princess Thumbelina, who often played together

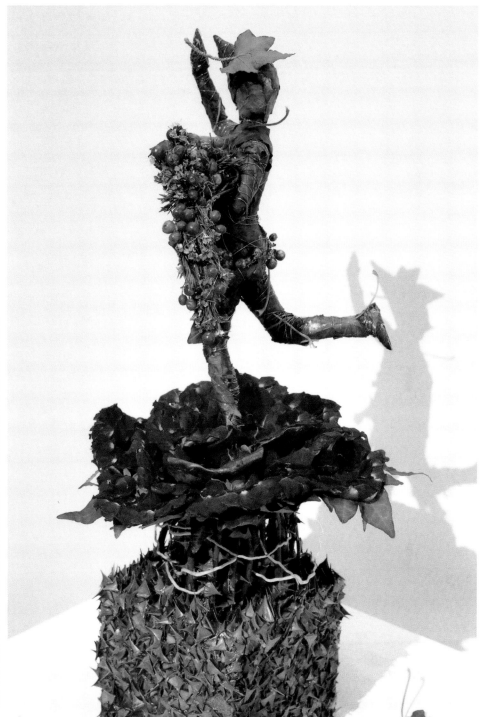

ANCIENT HALL

Figurine of Running Man
Roman, 1st - 2nd centuries A.D.
Bronze
Gift of Edward Nagel

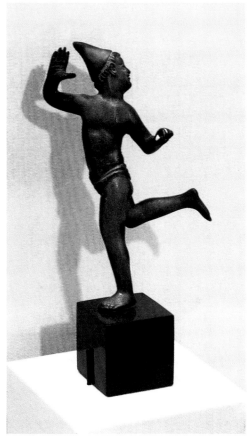

on the flowers. Their favorite flower was the rose, symbol of beauty and the heart, but also possessing dangerous thorns. The little messenger is carrying a bouquet of flowers and berries, paying his respects to all that is beautiful in life despite the danger that may come with it, as represented by the thorns. The sign "Ouch!!! If You Touch" is a warning. But life itself is a paradox, for even though people know they can be hurt by what attracts them, they will proceed toward the attraction regardless of the outcome.

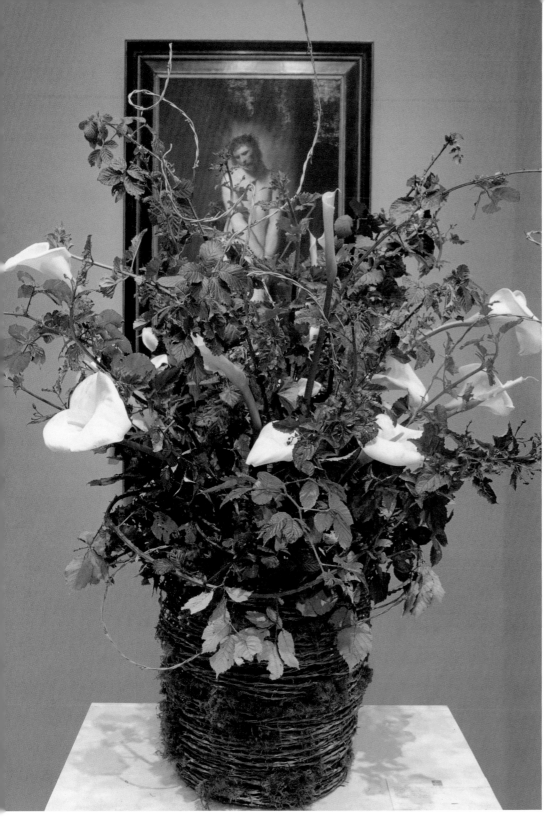

Gallery 14
Michael A. and Hanna Naify
Gallery

Pieter Franz de Grebber,
Dutch (ca. 1600-1652)
Christ at the Column, 1632
Oil on panel
Museum purchase
Mildred Anna Williams Collection
Bequest Funds of Henry S. Williams
in memory of H.K.S. Williams

LORRAINE ROSS of Brookdale, CA creates a profoundly provocative arrangement that succeeds in portraying the painting's message of Christ's spiritual transcendence over the painful agony of his crucifixion and death. A bouquet of coastal blackberry brambles emerging out of a basket of barbed wire offers a rugged contrast to the pristine and silky texture of the calla lilies. The basket, specially commissioned by artist BILL SORICH of La Honda, CA, was completed with the long top wires left free to be entwined throughout the brambles and flowers as the last step in bringing together the vulnerable purity of the flowers with the harshness of the barbed wire.

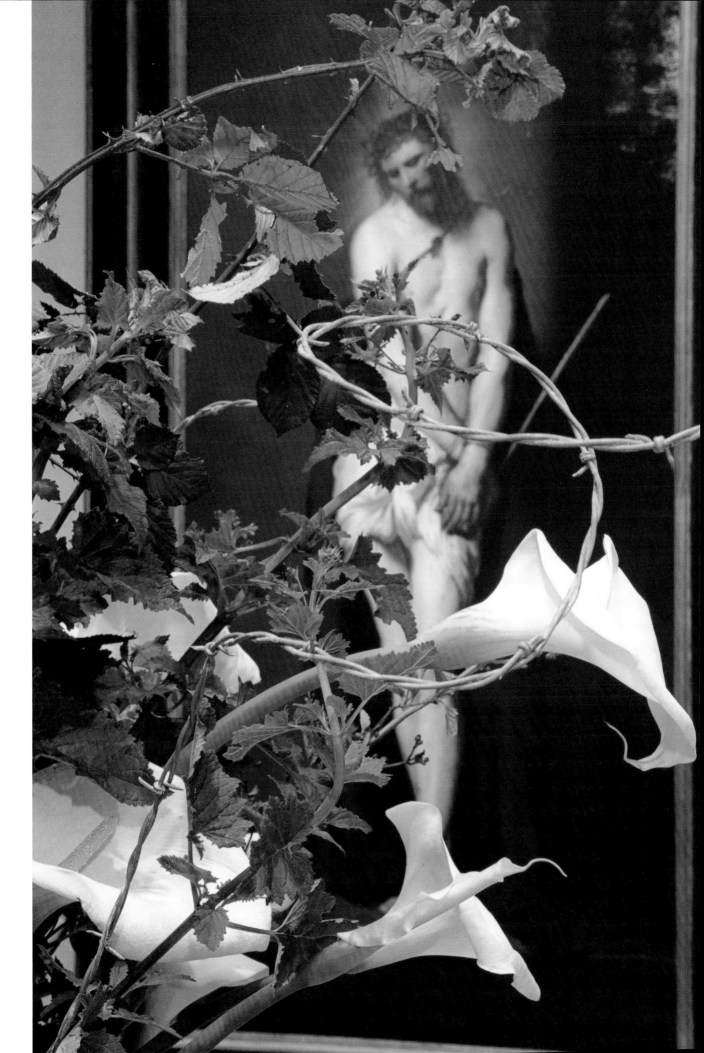

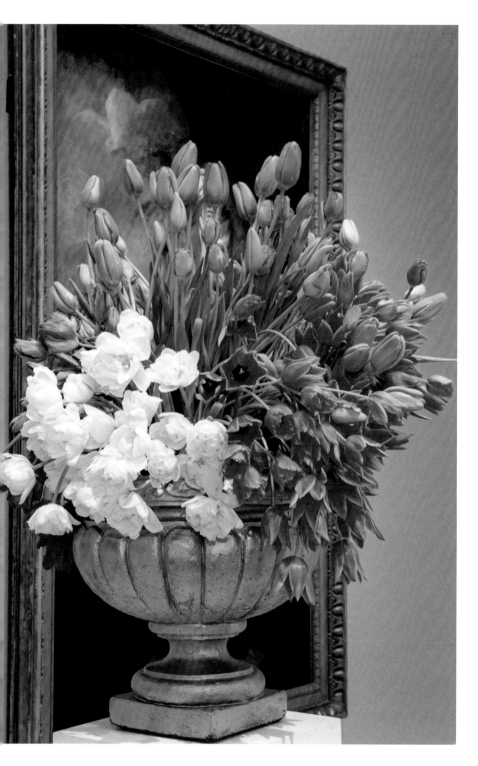

GALLERY 13
THE MARIANNE AND
RICHARD H. PETERSON
GALLERY

Left and page 29

Sir Henry Raeburn,
Scottish (1756-1823)
Sir William Napier, Bart.,
after 1810
Oil on canvas
Museum purchase
Gift of the M.H. de Young
Endowment Fund

Right

Edward Lear,
British (1812-1888)
Masada (or Sebbah) in the Dead Sea
1858
Oil on canvas
Grover A. Magnin Bequest Fund

CATE KELLISON OF ROSE AND RADISH, San Francisco, CA provided the inspiration for the 1998 *Bouquets to Art* poster image (page 35) with a design both powerful and elegant in its simplicity. A pair of huge terracotta urns overflowing with an abundance of brilliant red-orange tulips, accentuated with a burst of white tulips, graced each side of the doorway within the gallery. Cate succeeded in complementing two very different paintings with an identical pair of arrangements by focusing on the common elements of color and shape. The long, graceful, flexible stems of the tulips followed the form and reflected the color of both the man's riding coat (page 35) and the landscape's cliff above. Representing the white clouds to the upper left of the gentleman and the sky beyond Masada, the burst of white tulips provided the final touch to unite the two paintings.

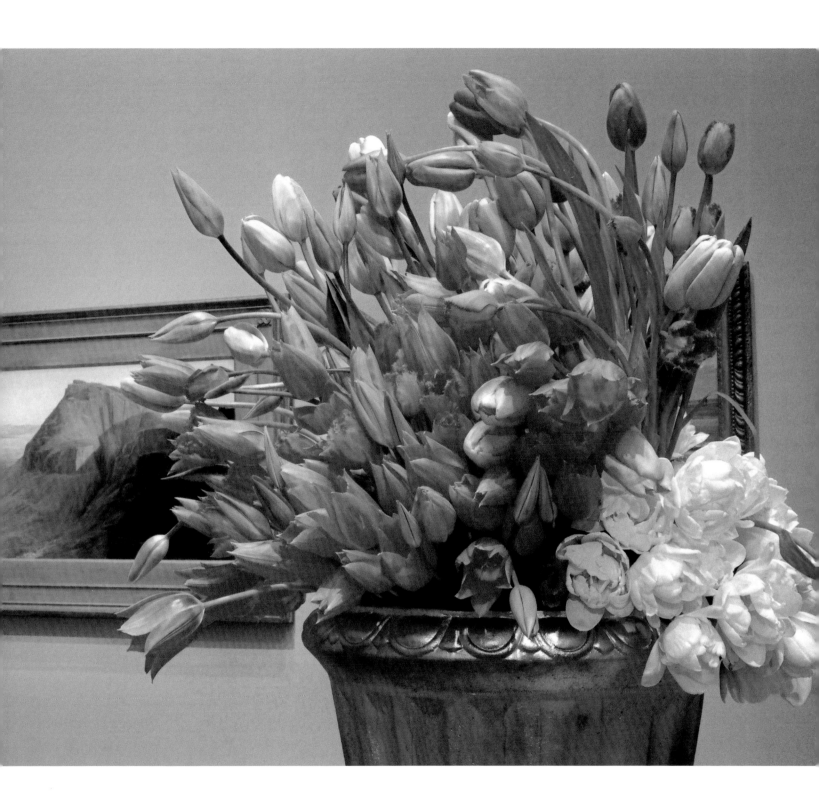

1998

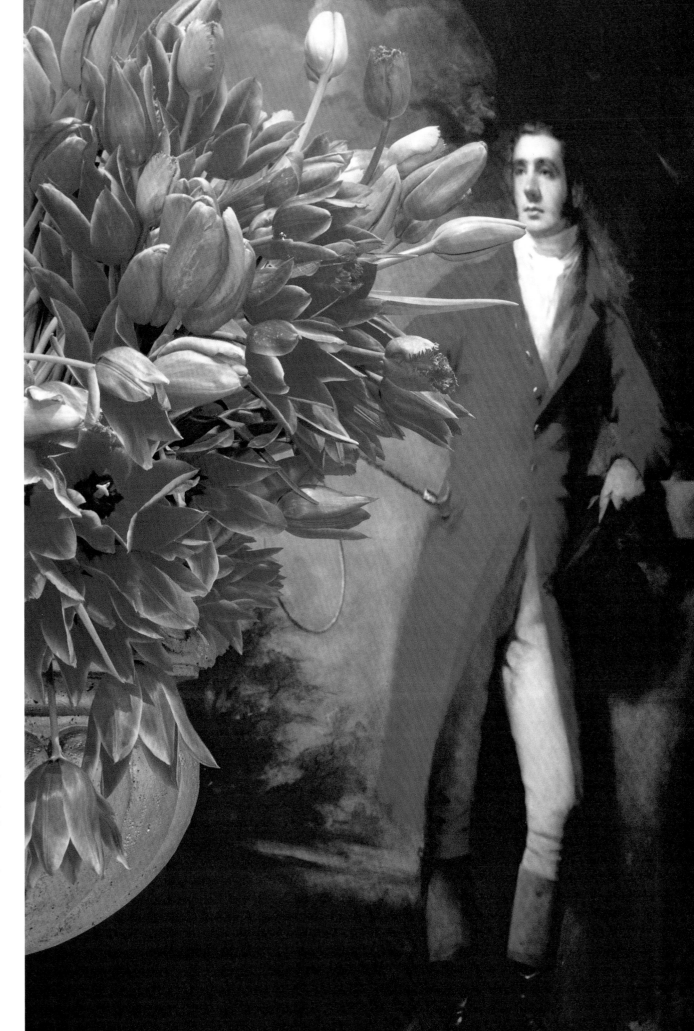

Whatever a man's age,
he can reduce
it several years
by putting a
bright colored flower
in his buttonhole.

Mark Twain

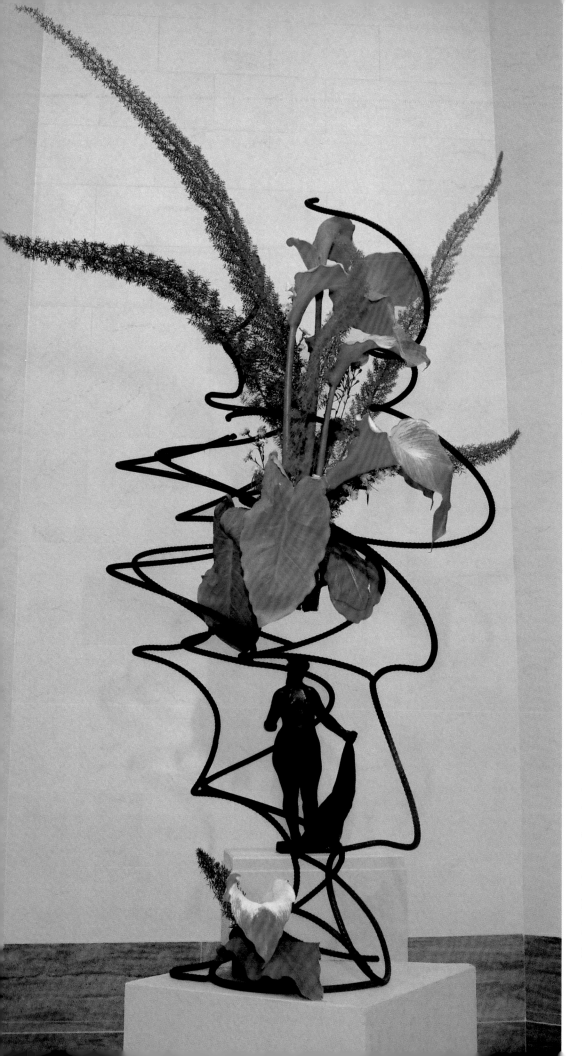

GALLERY 12
WALTER AND PHYLLIS
 SHORENSTEIN COURT

Right:
Auguste Rodin
French (1840-1917)
Bust of Edward H. Harriman
ca. 1909, marble
Gift of W. A. and E. Roland
Harriman

Left:
Pierre-Auguste Renoir,
French (1840-1917)
Small Standing Venus
19th - 20th century, bronze
Bequest of
Mrs. Ruth Haas Lilienthal

GAIL CORREIA OF SAN FRANCISCO BAY
AREA IKEBANA INTERNATIONAL, San
Francisco, CA creates a stunning comple-
mentary piece capturing the graceful move-
ment and shape of Renoir's Venus. Done in
the classical beauty and simplicity of design
of the Sogetsu school of Ikebana, she uses
only two plant materials: green goddess
calla lilies and leaves, and foxtail asparagus
fern. Finding beauty in resourcefulness, Gail
used a twisted piece of rebar left over from
home construction for her container. She
then heated, molded, and welded the curves
of the rebar, perfecting the shape into one of
her own design. The foliage is supported by
lead coil contained within a can tied to the re-
bar, then concealed with a leaf. The lower lily,
leaf, and fern rest in a small container at the
base providing a perfect balance of design.

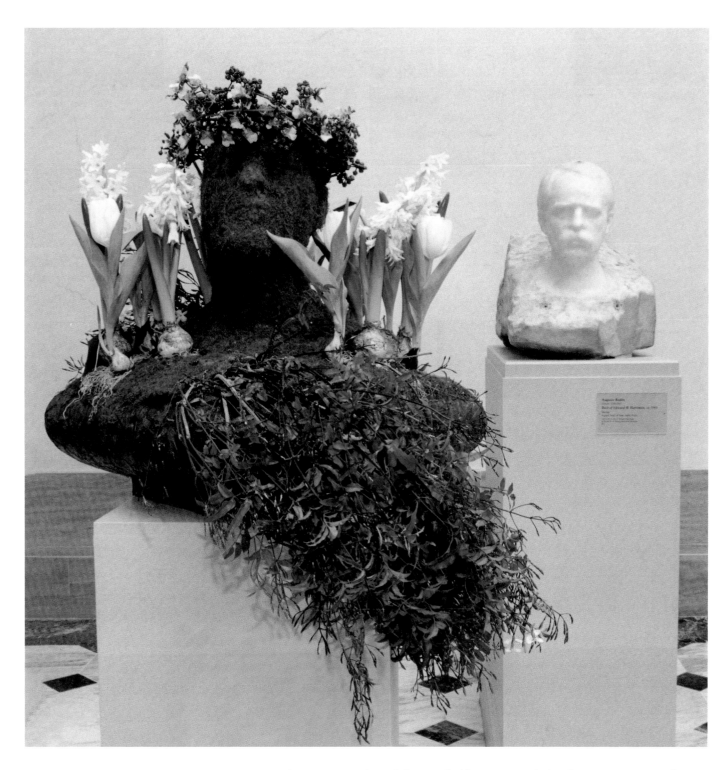

MICHAEL MERRITT OF THE THOUGHTFUL FLOWER, Modesto, CA approaches each design as a building process in which each step is as important and strong as the completed work. His floral complement to the Rodin bust is a styrofoam-based head covered and molded with a cement compound that is then covered with sheet moss from his own garden. While different in texture and composition, both marble and plant material emanate from the earth, a correlation that Michael chose to emphasize in this work. Bare-bulbed tulips and hyacinths emerge out of the mossy rim of the old metal container covered in dry ivy leaves, and a profusion of Italian jasmine cascades downward as if growing from the earth. A crown of burgundy chocolate oncidium orchids graces the head, repeating the color of the closed jasmine buds and adding a rich contrasting color to the green and white creation.

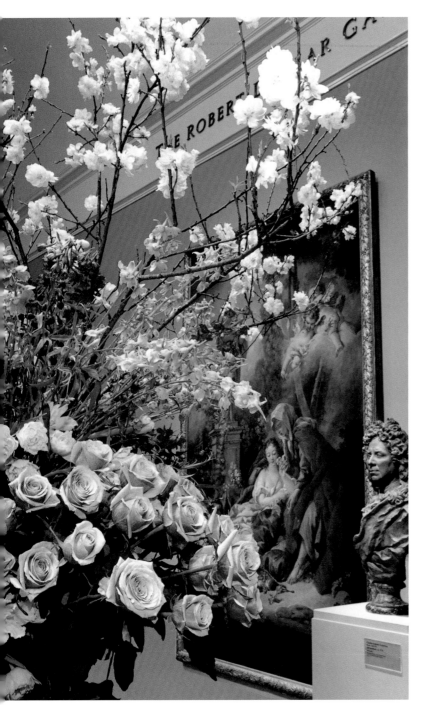

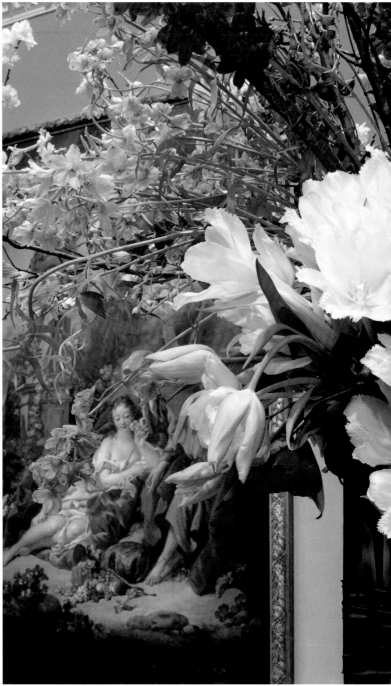

ORNA MAYMON OF ORNAMENTO, San Francisco, CA expresses the lushness and fertility of spring with a colorful and exuberant display of spring blossoms and flowers that echo the painting's mythical theme of Vertumnus, Roman god of fertility, and Pomona, chaste goddess of fruit trees and gardens. Orna related the voluptuous and sensuous beauty of the woman in the painting with her own feelings of spring, fertility, and rebirth as she nurtured new life awaiting the birth of her daughter. The decorative composition and rich tapestry of colors in the painting—deep blues and reds, yellow ochre, lemon yellow, peach, and rosy pinks—were the inspiration for the selection of seasonal flowers: brilliant pink roses, yellow tulips and roses, deep blue belladonna, and airy white cherry blossoms. Placed in a grouping of four large glass vases, each bouquet of flowers is an equally important player in the creation of this vibrant springtime symphony of color.

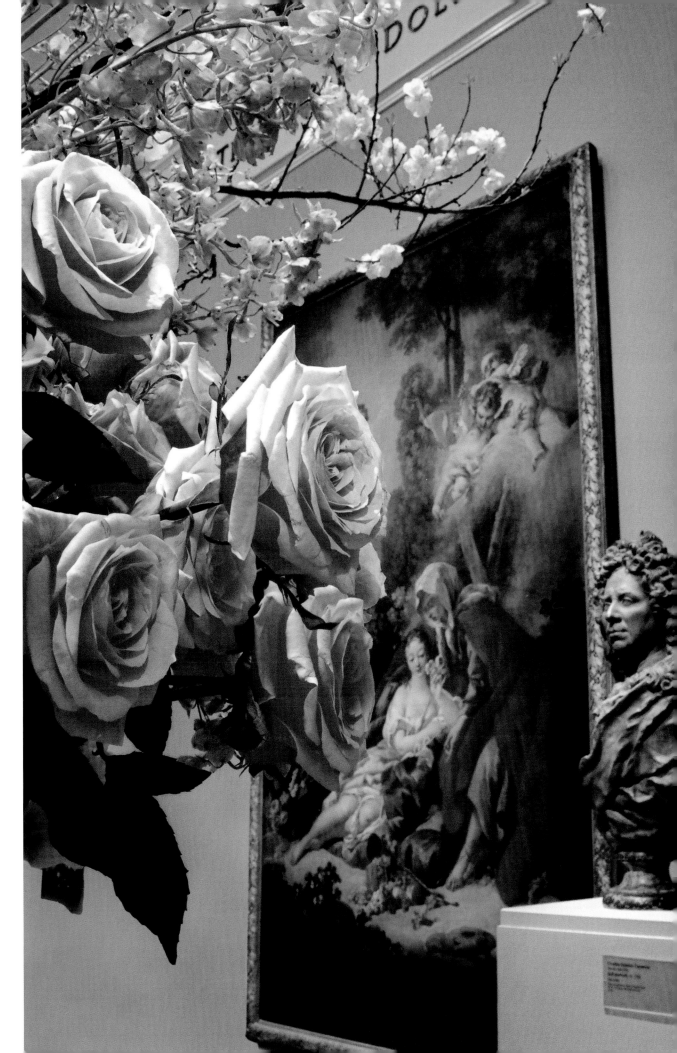

GALLERY 7
THE ROBERT DOLLAR
GALLERY

Painting:
François Boucher
French (1703-1770)
Vertumnus and Pomma, 1757
Oil on canvas
Museum purchase
Mildred Anna Williams
Collection

Sculpture:
Charles-Antoine Coysevox
French (1640-1720)
Self-portrait, ca. 1702
Terracotta
Museum purchase
Grover A. Magnin
Bequest Fund

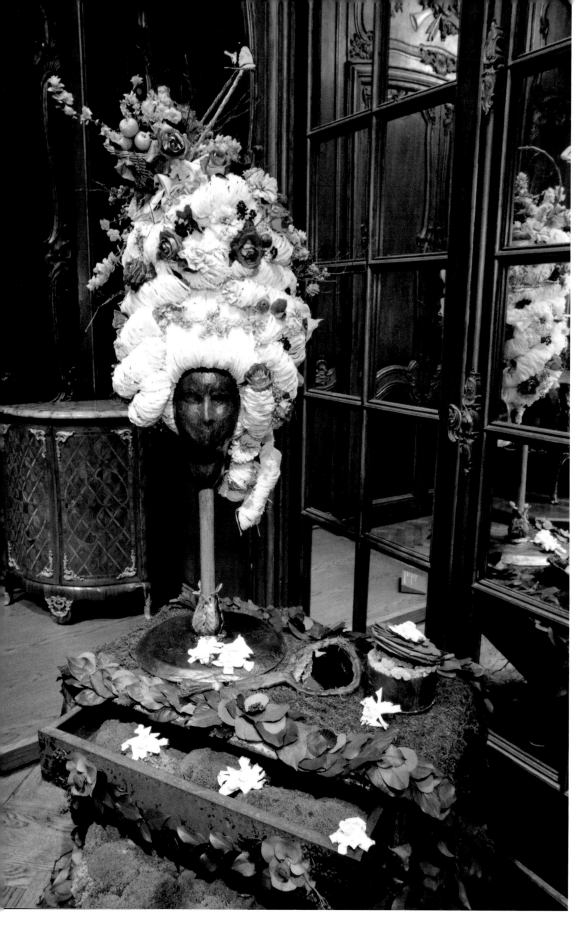

DOMINIQUE PFAHL OF FLORÉAL, San Francisco, CA provides us with her unique and festive view of the toilette of Marie Antoinette. An elaborate perruque, or wig, made of large layers of bleached raffia crowns a papier mâché pedestal bust, hand-finished to appear like polished wood that echoes the rich luster of the room's wood paneling from Rouen, France. All the flowers woven into the wig, including the bouquet basket on top, are natural flowers that have been freeze-dried. The chest of drawers, decorated with dried moss and leaves, hold a leaf-trimmed mirror and dusting powder jar filled with freeze-dried roses. Dominique adds the natural perfumer of fresh gardenias to complete the 18th century French royal toilette.

GALLERY 9A
LOUIS XV PERIOD ROOM

Janan Green and Harriet Merritt of Artistic Designs by Janan, Half Moon Bay, CA, in keeping with the time period of the Louis XVI Room, give us an exquisite floral example of the enormous white powdered wigs decorated with flowers worn by ladies of the 18th century French court. Reflecting the elegant white and gold of the room's paneling, they create a vibrant and lush head-dress of white chrysanthemums and roses topped with an array of color-ful flowers: pink calla lilies, peonies, ranunculus, bouvardia, nerene lilies, and chrysanthemums; purple scil-lia and Mexican sage. Spider plant and string-of-pearls add a touch of greenery and contrast. The wistful terracotta head, cut off at the neck, reminds us that it would often be "off with her head" for women who fell out of favor within the court.

Gallery 11
Louis XVI Period Room

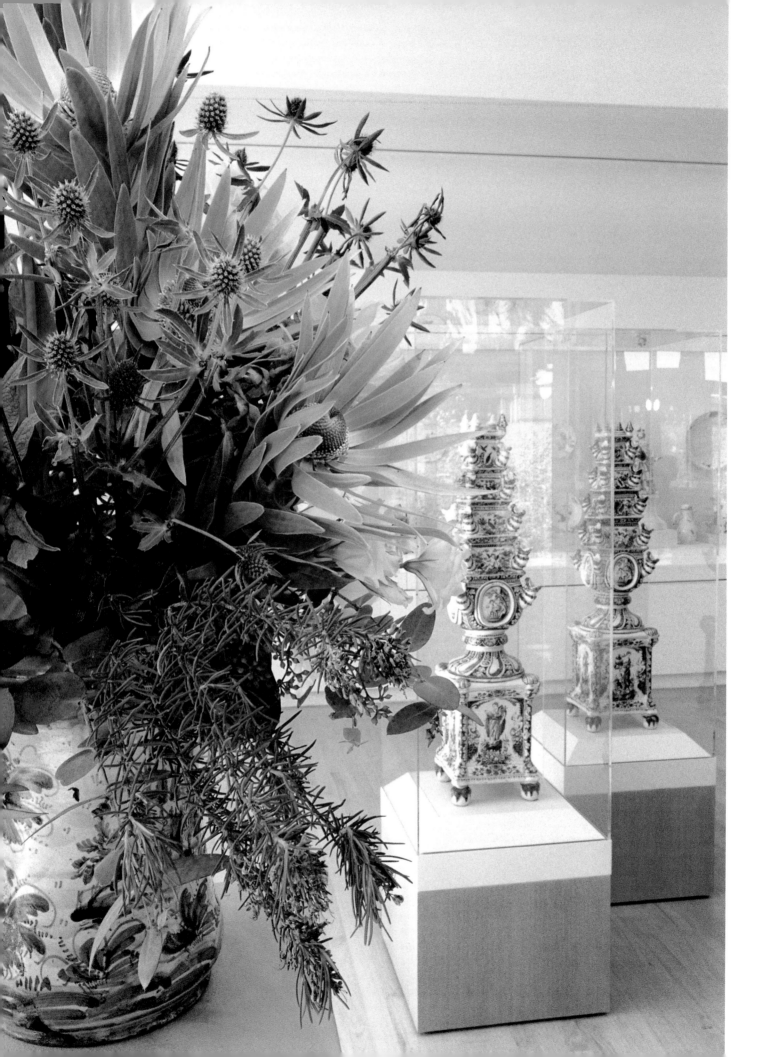

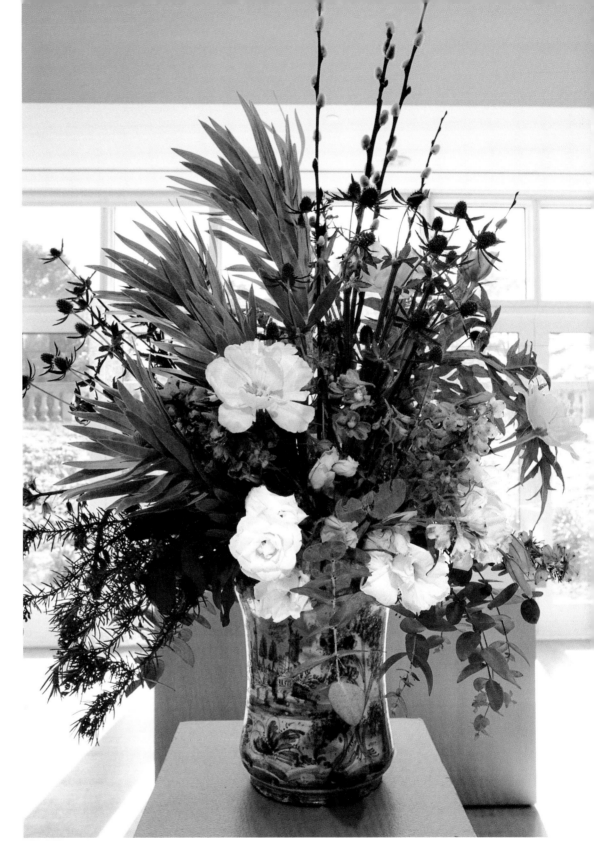

GALLERY 23
CONSTANCE AND
HENRY BOWLES
PORCELAIN GALLERY

Pair of Tulip Vases, ca. 1690
Adriaenus Kocks,
(fl. 1687-1701)
Delft, "Greek A" Factory
Tin-glazed earthenware
Bequest of Frances Adler Elkins

LURLINE COONAN OF THE WOODSIDE-ATHERTON GARDEN CLUB, Woodside, CA creatively uses color, container, and plant material to complement the shape, texture, and color of a prized pair of tulip vases. Deep blue delphinium and white roses capture the colors of the vases, while bold shimmery silvertree leaves emulate the smooth, polished texture of the porcelain and, along with sprigs of blue thistle, repeat the sharp outline of the tulip tiers. Pussy willow provides visual height, and silver dollar eucalyptus and rosemary cascading around the blue and white chinese porcelain container complete the design.

Left: Jasper Johns, American, b. 1930, *Figure F from the Color Numeral Series,* 1969
Color lithograph, Anderson Graphic Arts Collection

Right: (detail) James Rosenquist, American, b. 1933, *Off the Continental Divide,* 1973-1974
Color lithograph, Anderson Graphics Arts Collection

PATRICK KNIGHT OF P. KNIGHT FLORAL ART AND EVENT DESIGN, San Francisco, CA drew his main inspiration from the stairs in James Rosenquist's *Off the Continental Divide* and then worked with a color palette of purples, yellows, oranges, and greens taken from the art works on that side of the gallery to create this bold and impressive "stairway to heaven." Reflecting the natural wood frames of the contemporary lithographs, the structure and ladder are made from large curly willow branches that have been stripped down to give the natural look of bleached wood. Phalaenopsis, oncidium, dendrobium, and vanda orchids; amaranthus; liriope grass; and immature dates cascade out of a cluster of succulents, kumquats, fritillaria, poppy pods, fresh wheat, and coxcomb at the top of the ladder. At the base, creamy calla lilies, so perfect they appear like porcelain, combine with philodendron foliage, artichoke, and coxcomb to create a lush garden of exotic beauty, dazzling each step of the way.

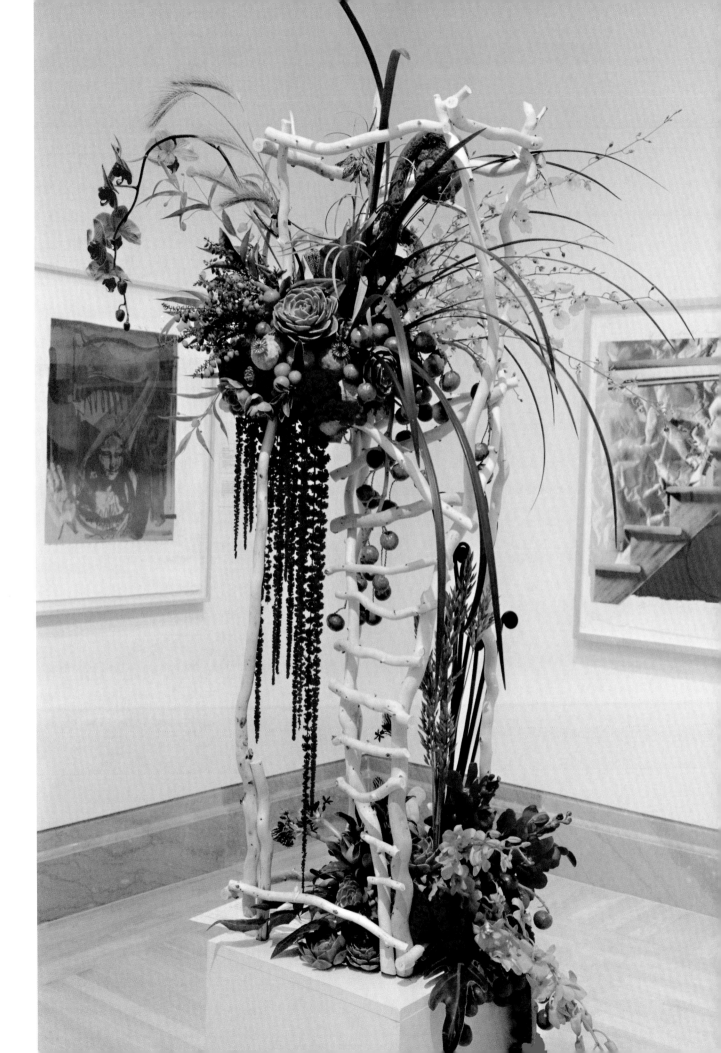

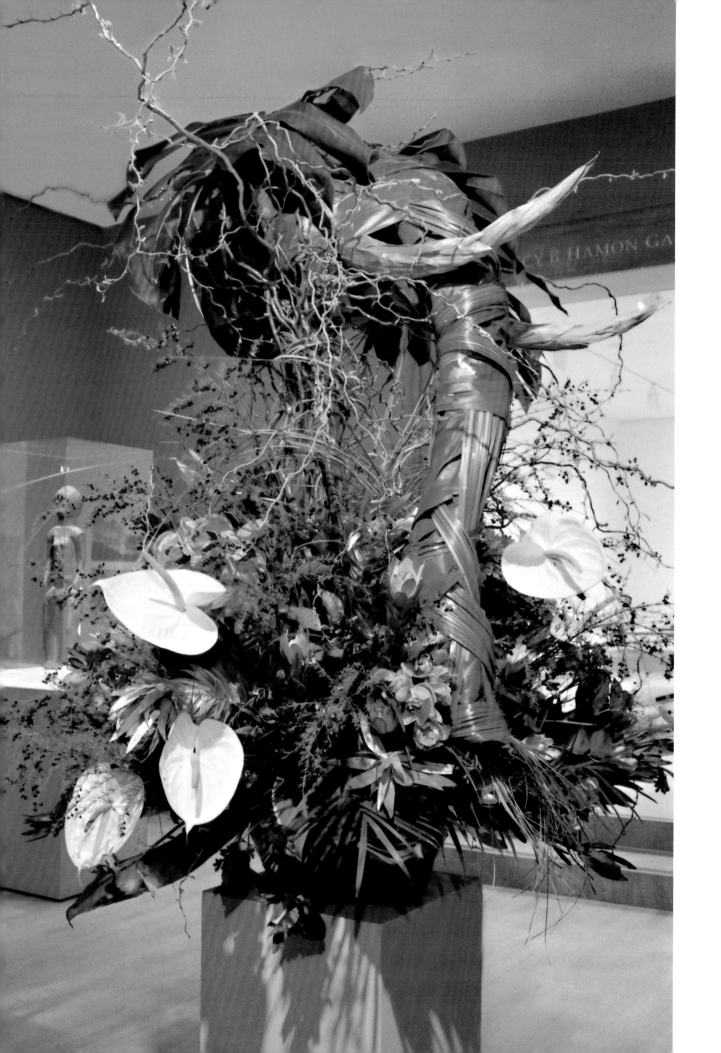

ROSEKRANS COURT
Special Exhibition

NANCY B. HAMON
GALLERY and
THE WATTIS GALLERY

*The Art of
Central Africa*

Background
sculptures and
photographs the
ROYAL MUSEUM
FOR CENTRAL AFRICA
Tervuren, Belgium

CHIZURU INOUE, AIFD, AND YUMI TAKENAKA, AIFD, OF INOUI DESIGN (FORMERLY KYO'S FLOWERS), Burlingame, CA, assisted by the staff of Kyo's Flowers, complement the special exhibition *The Art of Central Africa* with magnificent floral renditions of an elephant and a lion, the two animals most thought of with safari. The huge elephant's head with tusks of silver leaf protea, ears of giant monstera leaves, and a trunk of flax, tea leaves, and bear grass woven together is raised up high in the gallery, creating a realistic sense of the animal's size. As if emerging out of the bush, the elephant is surrounded by a profusion of African plant material: masses of curly willow, palms, kangaroo paws, cymbidium orchids, and white anthuriums. The lion is equally impressive with a well-constructed face of silver leaf protea and a luxuriant mane of painted raffia. Like his companion, he emerges from a variety of colorful African flora: various palm leaves, protea, red willow, ginger, and anthuriums.

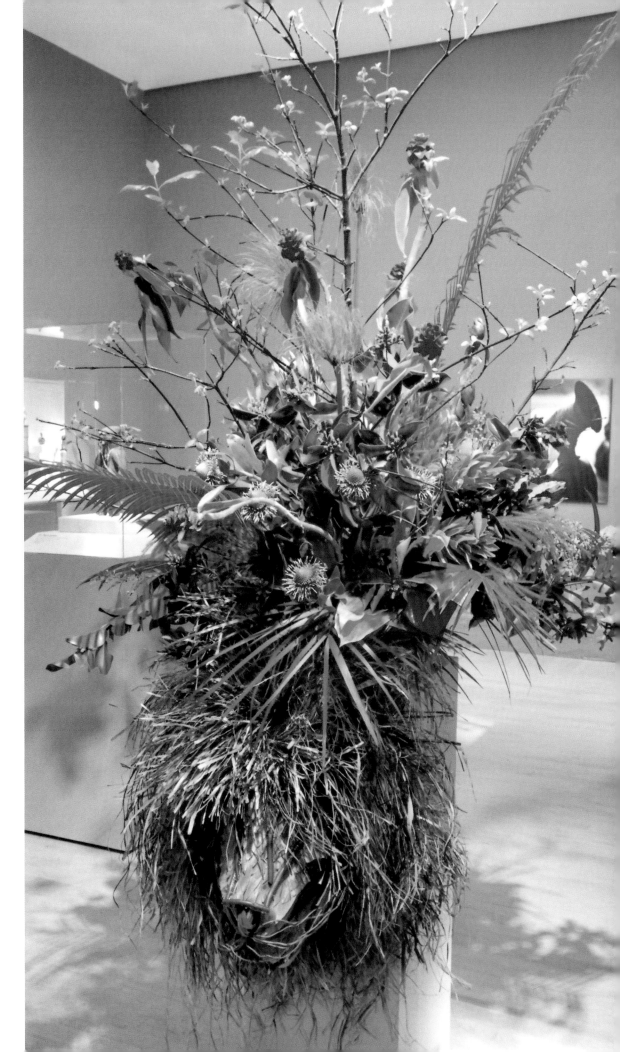

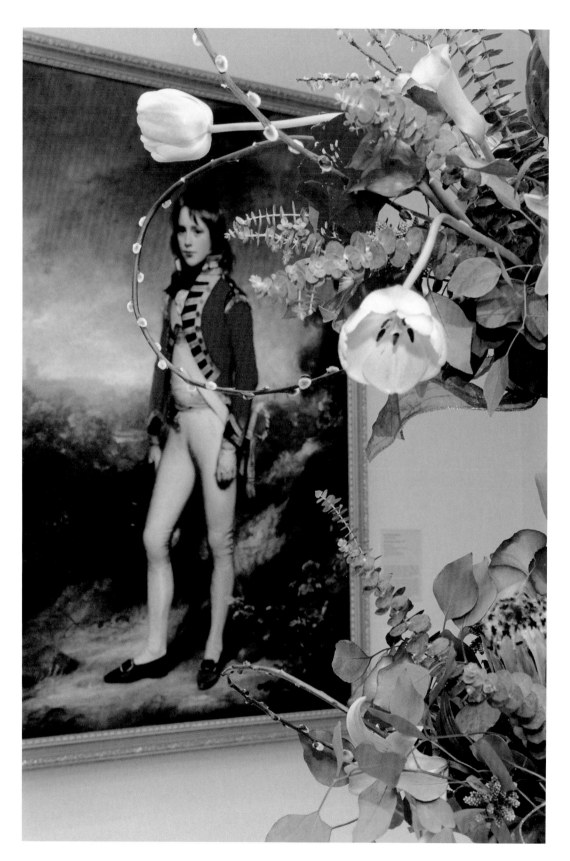

GALLERY 13
THE MARIANNE AND
RICHARD H. PETERSON
GALLERY

Left:

Sir William Beechey
English (1753-1839)
Master James Hatch, 1796
Oil on canvas
Mildred Anna Williams
Collection

Right and page 53:

Sir Joshua Reynolds
English (1723-1792)
*Anne, Viscountess of Townsend,
afterward Marchioness Townsend*
1779-1780
Oil on canvas
Roscoe and Margaret Oakes
Collection

48

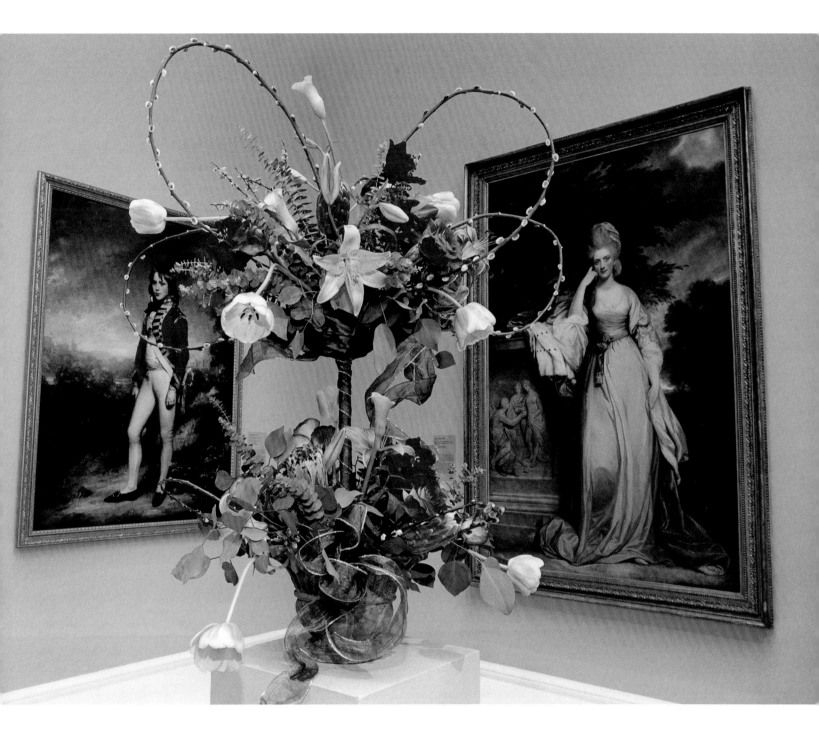

Carolyn Musto of CMM Designs, San Mateo, CA for the Hillsborough Garden Club, Hillsborough, CA found her inspiration for this design in the graceful rhythmic movement and richness of color in Reynolds' portrait of Anne, Viscountess of Townsend. For the basis of her design, Carolyn chose a topiary style as an abstracted form of the viscountess' tassled waistband and feminine curves. The teal blue of the sash is repeated with eucalyptus leaves and French wire ribbon wrapped around the center column and then woven among the flowers, the rusty red of her drapery with leonidas roses and lilies, and the warm pink tones of her dress and complexion with French tulips, stargazer lilies, and calla lilies. The final designer touch emulating the rhythm in the painting is curled pussy willow. The graceful curves of the branches complement the Beechey painting as well, unintentionally uniting the two.

1999

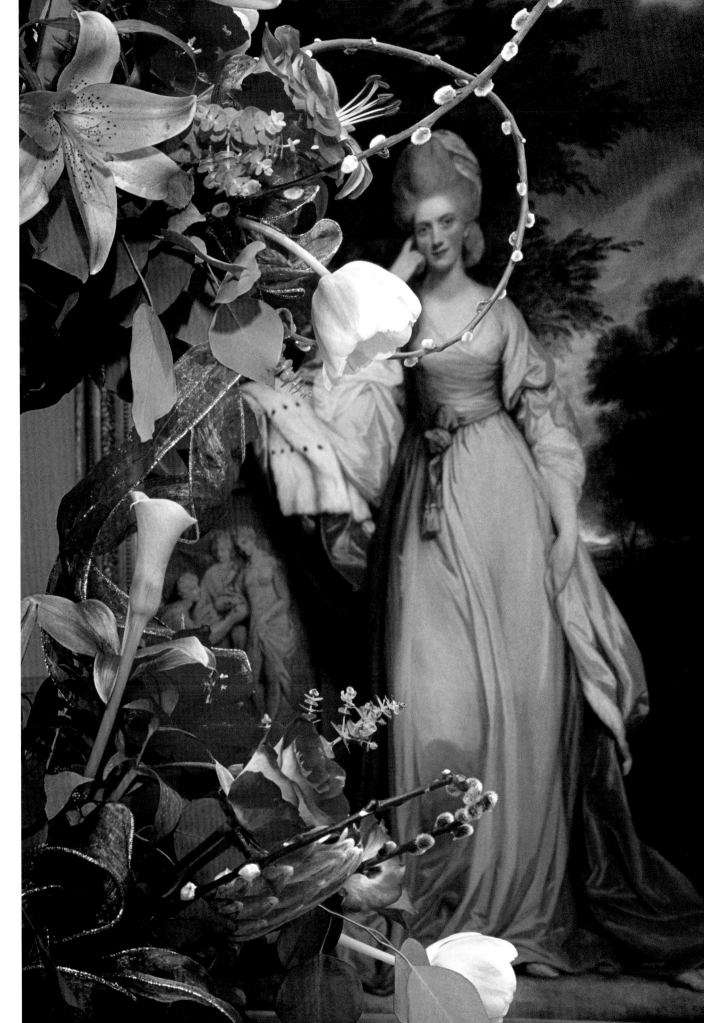

A feast of flowers
here behold
A thing of joy to see
But ah!
To me 'tis sweeter far
To feast my eyes on thee.

Victorian Valentine

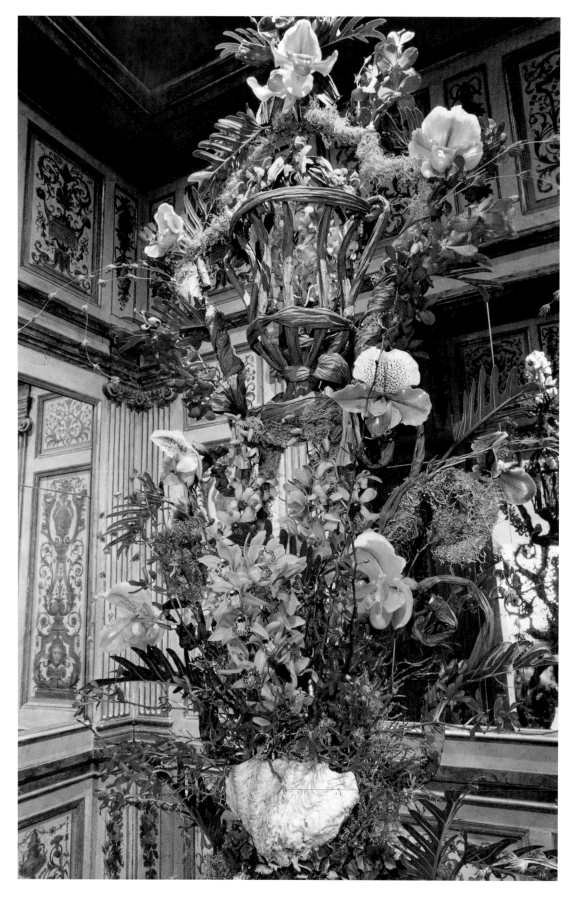

Antechamber, France, ca. 1680
Painted wood

THIERRY CHANTREL OF LA FOLLIA FLORAL AND GARDEN DESIGN, San Francisco, CA was inspired for this design by the Baroque motifs painted on the walls. These wild but still architectural motifs called for a "see-through" sculptural piece composed of the classic decorative elements found in 17th century French rooms: scrolls, ribbons, bows, shells, faces, foliate motifs, flowers, and vases. Thierry used orchids for their texture and architectural look and because they carry all the color tones found in the room: coral, pink, yellow, green, maroon, and purple. The eight-foot tall structure is covered with gray lichens and blue paper ribbon reflecting the dominant blue and gray in the room. The various orchids, shells, and leaves were carefully selected and placed for color and design so that each element would be presented most effectively to contribute to the overall arrangement.

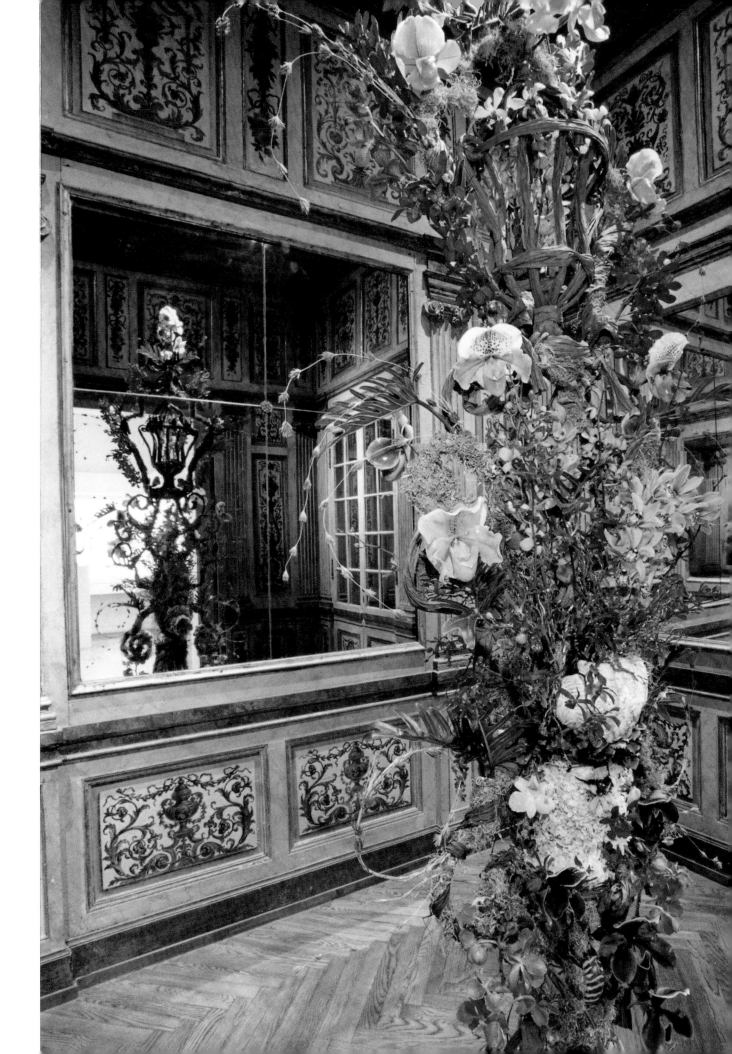

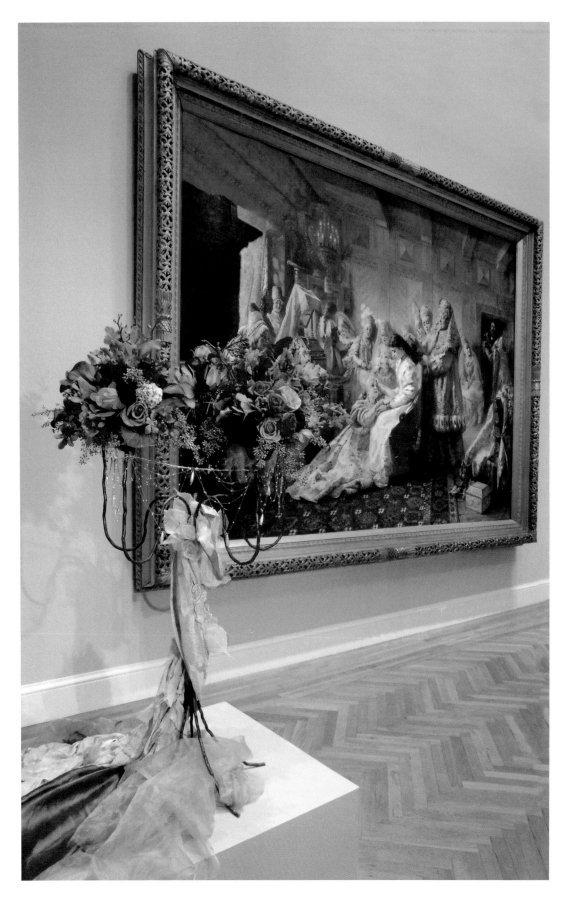

GALLERY 17
THE JUNE GOETHE
CRAYCROFT
GALLERY

Koustatin Makovsky
Russian (1839-1915)
The Russian Bride's Attire, 1889
Gift of M. H. de Young

PAT GIBBONS OF PAT GIBBONS FLORAL DESIGN STUDIO, El Cerrito, CA evokes the opulence and Old World feeling of the Russian bridal scene through her selection of flowers and plant material. Inspired by the textures and richness of color in the painting, she selected a color palette in perfect harmony with the art work: black magic and spicy roses, red mokura orchids, miniature calla lilies, viburnum, and eucalyptus berries. A wrought iron candelabra echoes the chandelier above the gathering and the silk organza fabric is carefully draped to follow the flow of the dresses of the bride and her attendant.

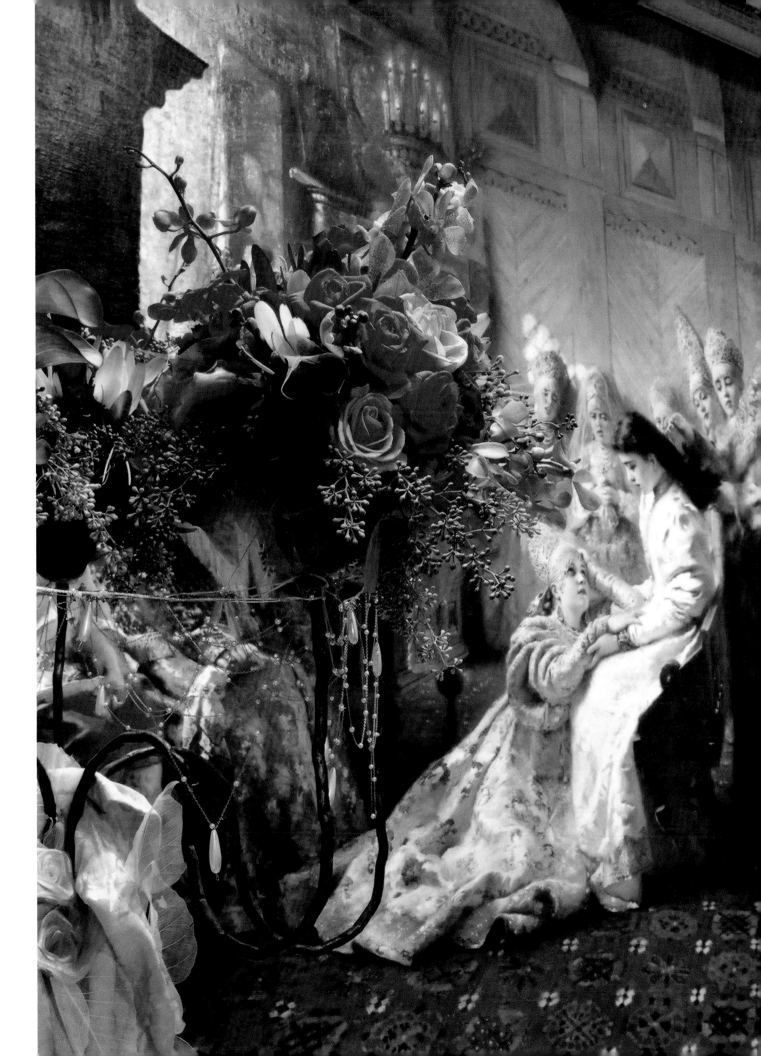

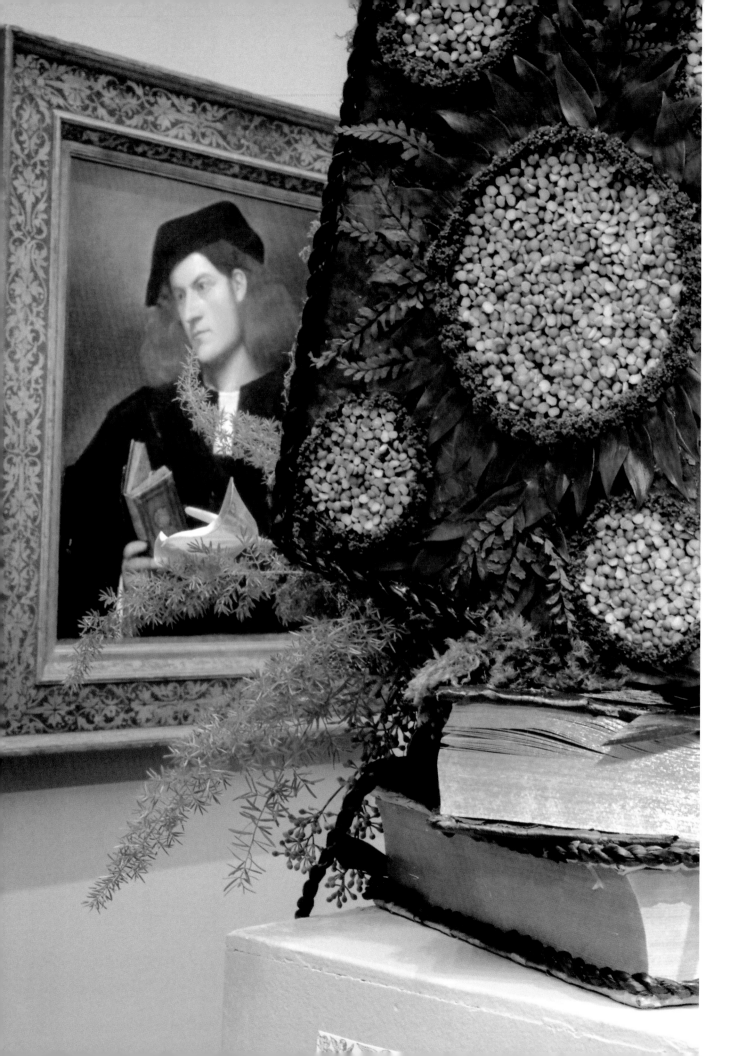

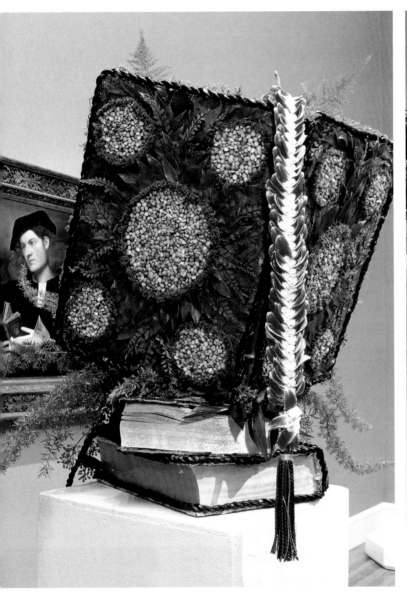

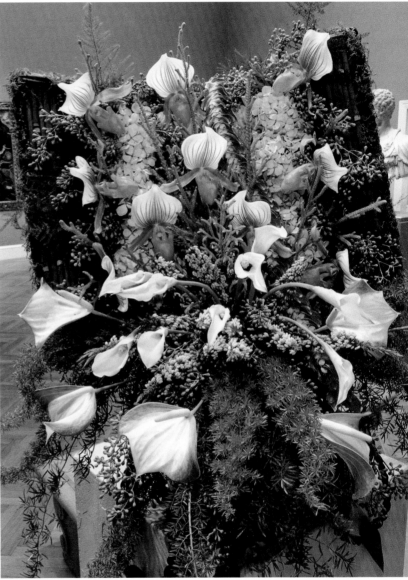

Michael E. Valentine of Valentine and Riedinger Flowers, San Francisco, CA (in 1997) creates a moving tribute to dear a friend through this beautiful and intricately designed floral replica of the open green book held by the young man in the painting. When someone's life is referred to as an "open book," we think of a person without pretense, honest and straightforward, unafraid to let others see who they really are and what they believe in. Michael honors such a life in this open floral book with a profusion of white calla lilies, hydrangeas, anthuriums, and lady slipper orchids contrasting with green asparagus fern and seed eucalyptus, all accentuated with a vibrant lei bookmark of fuchsia orchids. The book's cover design is a labor of love. The medallions are made of dried peas individually glued to a fiberboard backing and then surrounded with individual leaves of deep green glossy foliage and ferns. A noble tribute to a dear friend, whose life and love of books and learning will long be remembered.

Auguste Rodin, French (1840-1917)
The Kiss (Le Baiser), ca. 1884
Bronze
Gift of Alma de Bretteville Spreckels

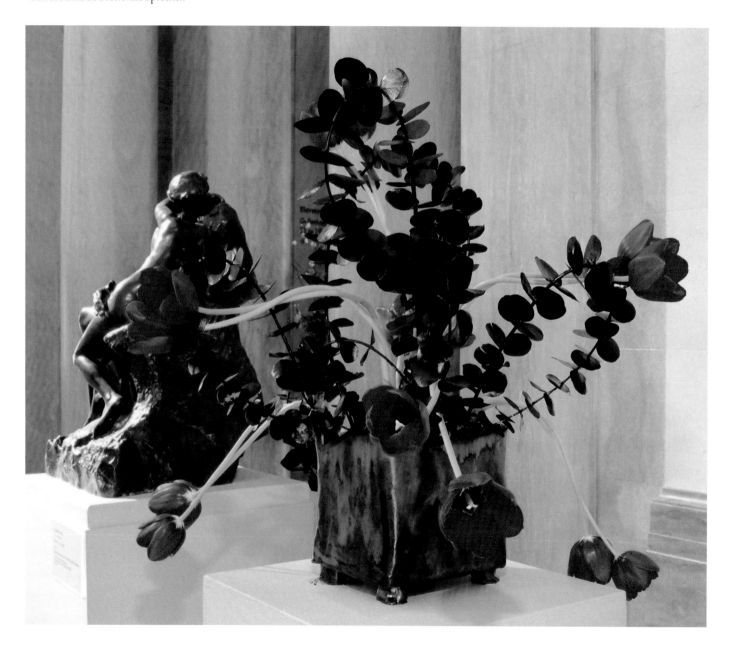

CAROLYN MUSTO OF CMM DESIGNS, San Mateo, CA for the HILLSBOROUGH GARDEN CLUB, Hillsborough, CA complements Rodin's well-known *The Kiss* with a simple and highly imaginative floral representation of the sculpture's emotional and physical expressions. Pairs of intertwined red French tulips gracefully caress, emulating the lovers' passionate embrace. Dark bronze-colored eucalyptus in a matching polished ceramic vase reflect the bronze of the sculpture and create a dramatic contrast to the tulips. Color, form, movement, and texture are all combined in a floral work to successfully unite with and complement the fine art.

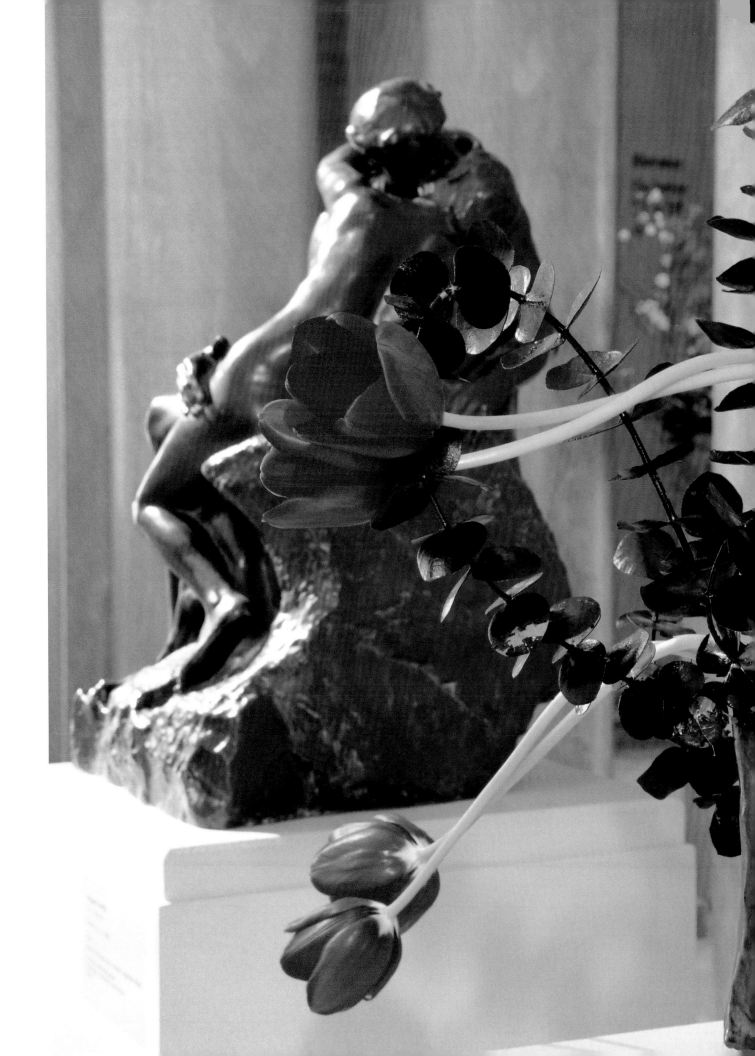

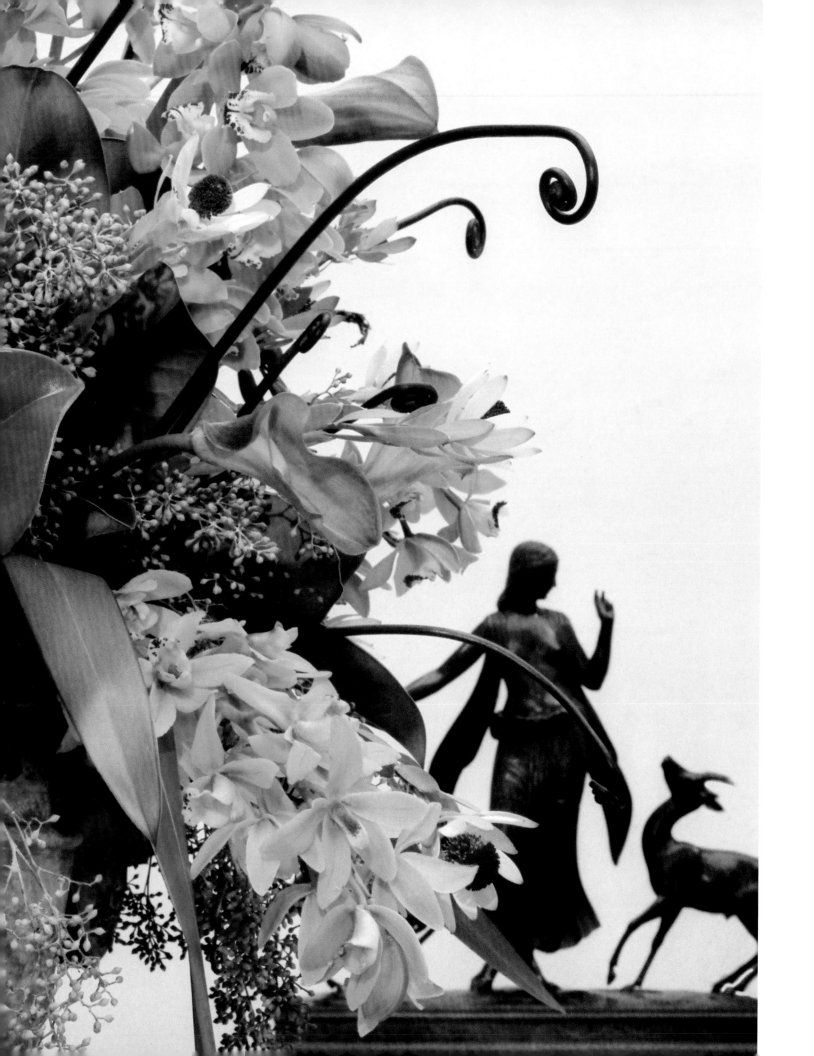

Left: Paul Manship, American (1885-1966)
Dancer and Gazelles, 1921
Bronze
Bequest of Helene Irwin Fagan

Below: Elie Nadelman, American (1885-1946)
Buck Deer, ca. 1915
Bronze and onyx
Bequest of Helene Irwin Fagan

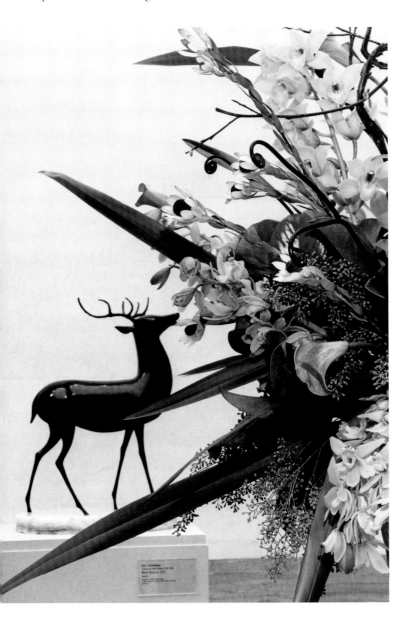
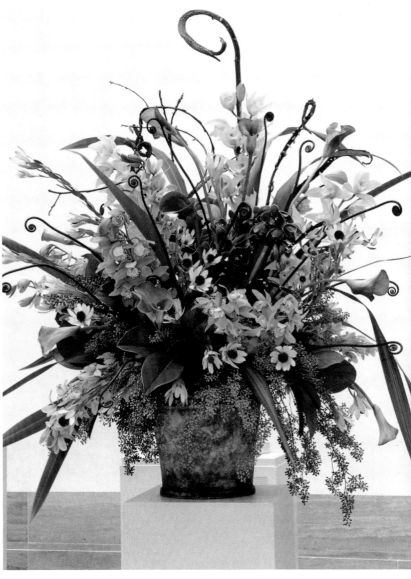

JUDITH HAWLEY OF HEARTS AND FLOWERS, Tiburon, CA brings to life two exquisite bronze sculptures through the use of color, line, and form in her arrangement. Inspired by the deep rich color of the bronze, Judith chose colors to both complement and contrast with the art works. Blue-black flax leaves, seed eucalyptus, and the bronze underside of magnolia leaves echo the dark hues of the bronze sculptures, while a profusion of several colors of cymbidium orchids, leucadendron, and rust-orange calla lilies create a dramatic contrast. Seeing the sculptures as "very lined," she chose sword-like green flax leaves to create strong lines that reflect the sharp edges and form of the buck, and curled fern fronds (monkey tail) and willow to complement the soft curves and follow the lines and form of the woman and fawn. A moss-covered terracotta container is the perfect complement to the earthy opulence of the arrangement.

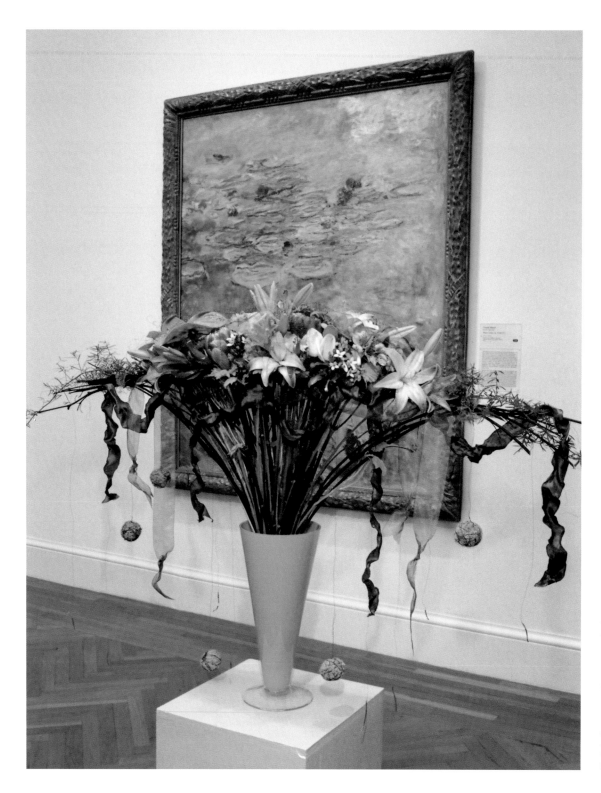

GALLERY 19
THE EDWARD E. HILLS
GALLERY

Claude Monet,
French (1840-1926)
Water Lilies, ca. 1914-1917
Oil on canvas
Mildred Anna Williams
Collection

AMY KEE, AIFD, CAFA, OF AMYKEE FLORAL DESIGN, San Francisco, CA draws on the painting's depth and beauty of color for her main inspiration. Pink, lavender, and peach became her primary color palette with the use of pink lilies, bovardia, peonies, and hydrangea; peach oceania roses and French tulips; and purple and pink asters. To incorporate the water and bridge with the flowers, Amy wove sheer lavender-blue organza ribbon into the arrangement to emulate the rippling effect of water, and created a forarmature to represent the bridge. Green anthuriums represent the lily pads and hanging green amaranthus complete the arrangement.

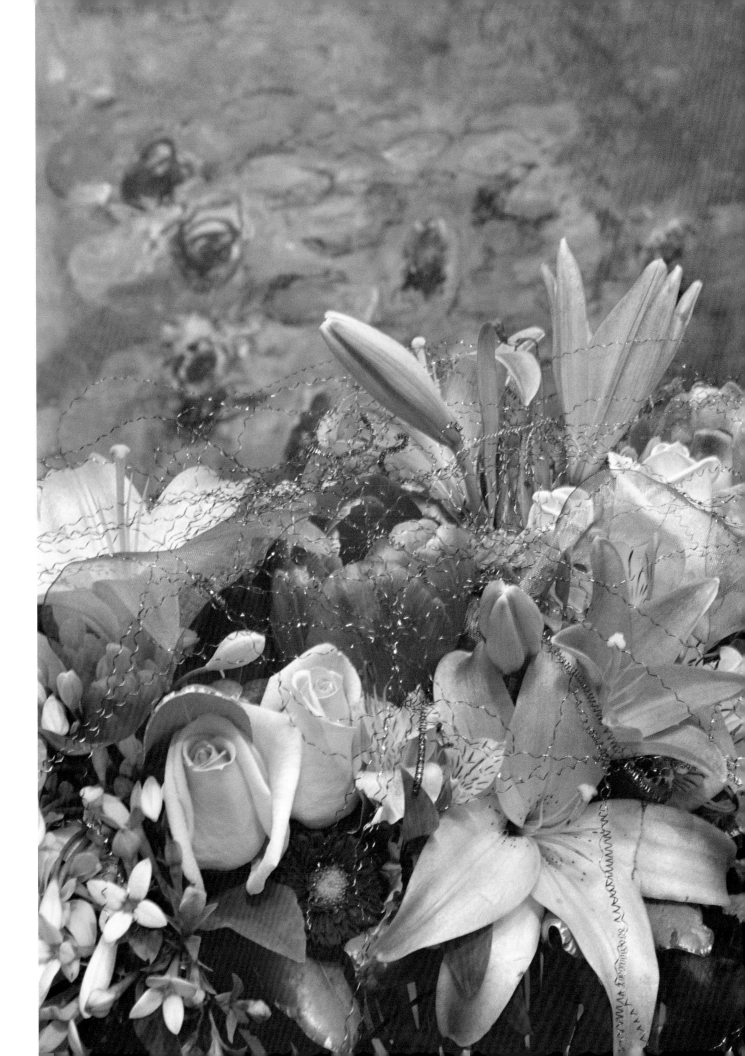

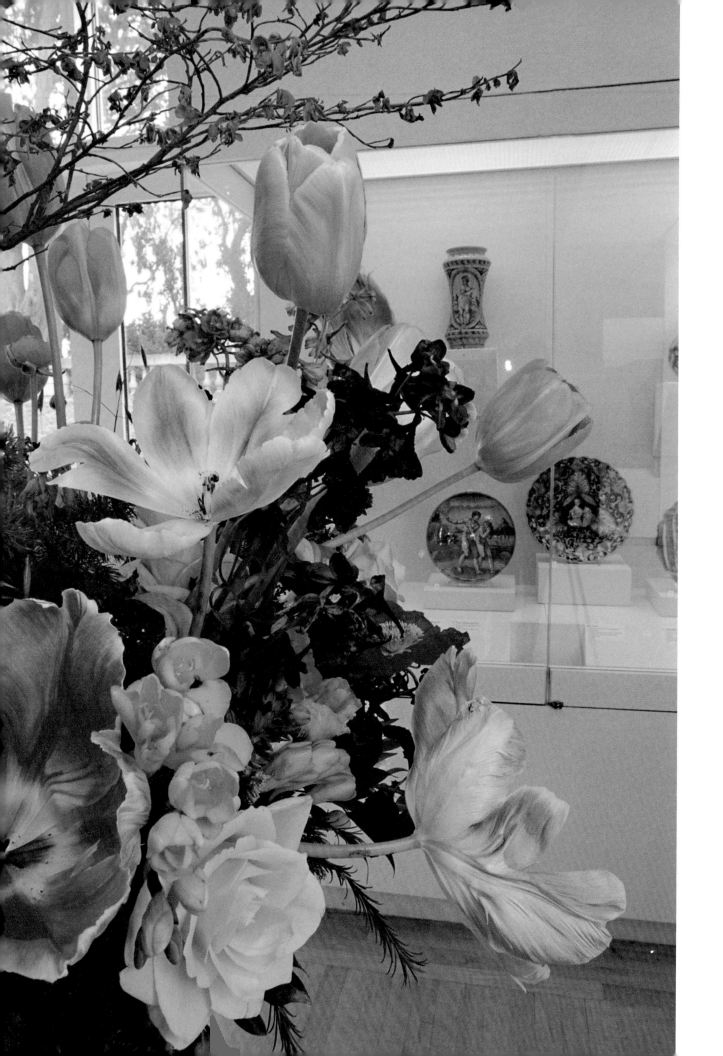

Plate: Adam and Eve, ca. 1550, Italian, Urbino
Tin-glazed earthenware (maiolica)
Bequest of Mary Louise (Mrs. Ashton) Potter

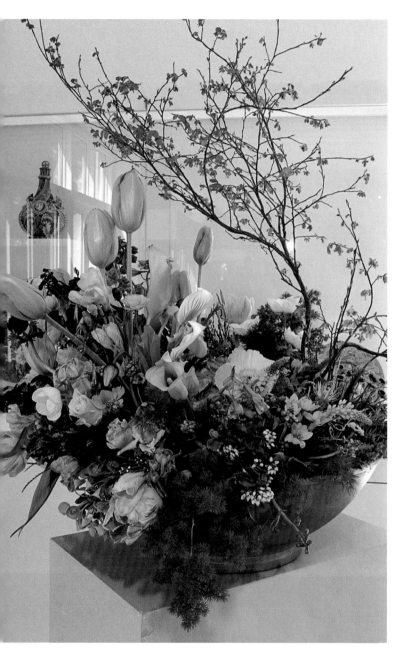
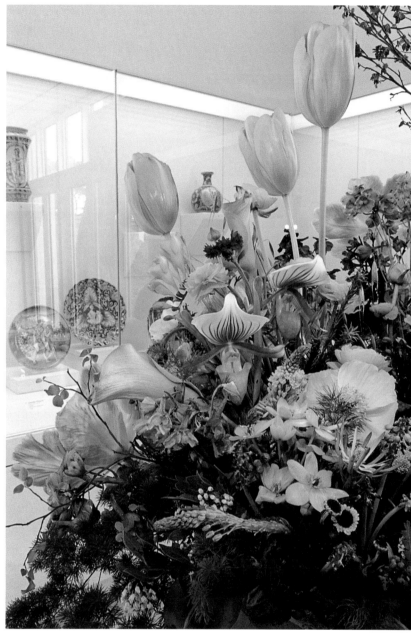

JOLIE FAY FOR FLORAMOR STUDIOS, San Francisco, CA finds the opportunity to interpret art works with flowers the most enjoyable part of participating in *Bouquets to Art.* Finding inspiration in the blues and yellows of the Italian maiolica porcelain plates, and the Adam and Eve theme in one and the beard of an old man in another, she targeted the plates' stories and colors for her floral interpretation. White tulips and pierras bells represent the texture and color of the old man's beard, while mood moss and manzanita branches are the backdrop for the Garden of Eden's exuberant explosion of yellow, orange, blue, and white blossoms. While the blue came easily with belladonna and grape hyacinths, matching the many shades of yellow was a challenge beautifully met with apricot parrot and French tulips; yellow narcissus, tulips, and freesia; and pale yellow roses. Jolie is presently of CITY CELEBRATIONS, San Francisco, CA.

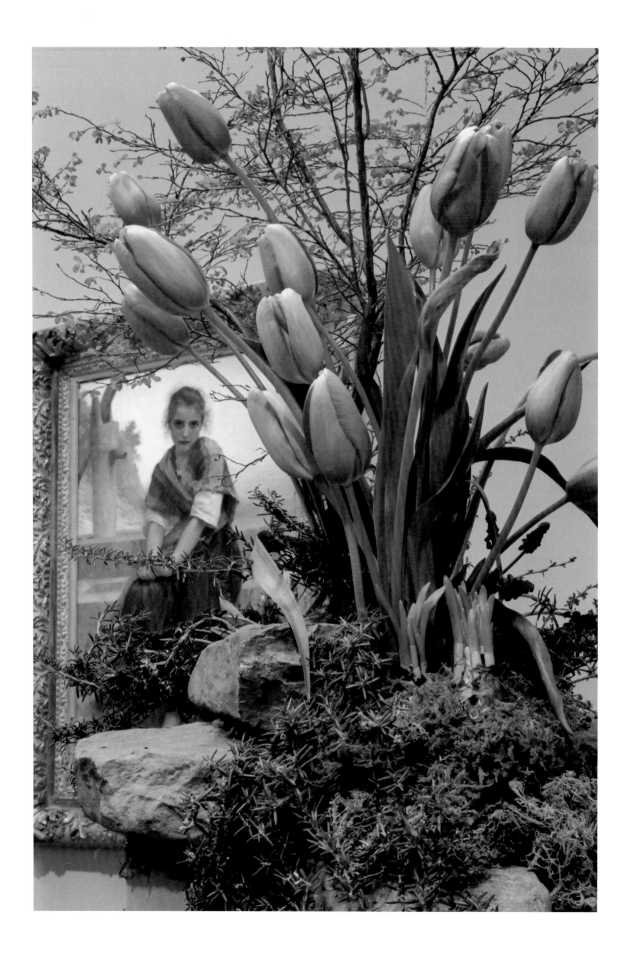

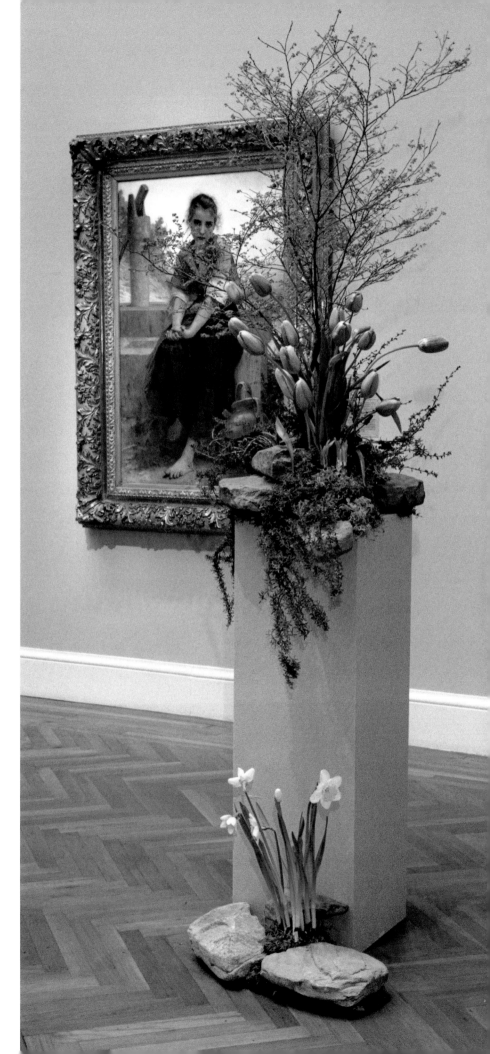

GALLERY 17
THE JUNE GOETHE CRAYCROFT
GALLERY

William Adolphe Bouguereau
French (1825-1905)
The Broken Pitcher, 1891
Oil on canvas
Gift of M.H. de Young

NEIL HUNT FOR MICHAEL DAIGIAN DESIGN, San Francisco, CA provided the inspiration for the 2000 *Bouquets to Art* poster (following page) with his earthy and sensitive interpretation of Bouguereau's well-known *The Broken Pitcher*. The harsh realities of peasant life in the 19th century are expressed through the use of stone and earthy plant material: mosses, rosemary, and spring branches. The sentimentality of the painting softens the harshness of these realities and Neil captures this sentiment with the use of soft pink French tulips and spring narcissus. The sexual symbolism of the broken pitcher is made more explicit by the plaintive expression on the young girl's face, which is beautifully framed by the tulips. Neil is presently of HUNT LITTLEFIELD, San Francisco, CA.

2000

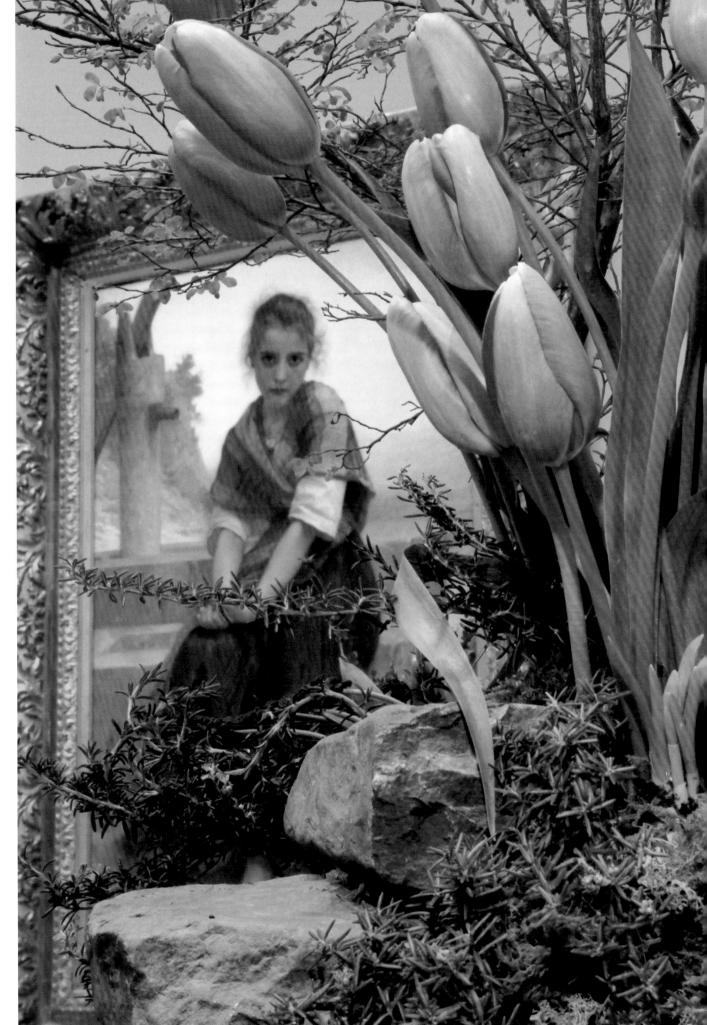

*And the rose gardens
and the jasmine
and geraniums
in Gibraltar as a girl
where I was a flower
of the mountain.*

James Joyce

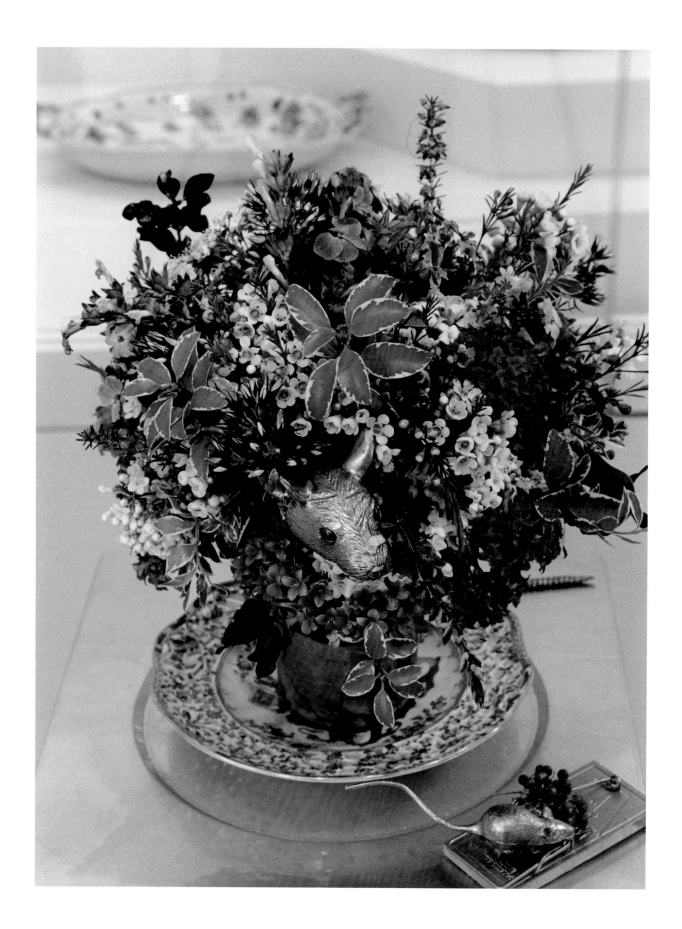

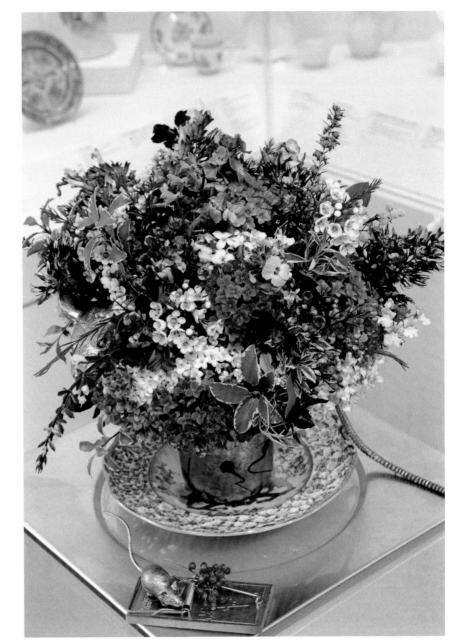

GALLERY 23
CONSTANCE AND
HENRY BOWLES
PORCELAIN GALLERY

Covered dish and fixed tray in form of mouse
ca. 1780
Jingdzhen (Ching-te Chen), Chinese
Porcelain with overglaze
painting and gilding
Gift of
Alma de Bretteville Spreckels

PAULA SKOV, MOLLY HOFMANN, DEBBIE ABLIN, AND JULIE KEIL OF THE MARIN GARDEN CLUB, Marin County, CA were charmed by the porcelain mouse butter dish and in turn charm the viewer with their delicate spring arrangement with flowers straight from their gardens: viburnum, tea leaves, and daphne. The colors and shapes of the tiny blossoms echo the delicate pattern and color of the porcelain butter dish and many of the nearby porcelain plates and dishes. Nestled among the flowers is a large gold mouse peering out as if eyeing the fate of his little friend drawn to the berries on the golden trap!

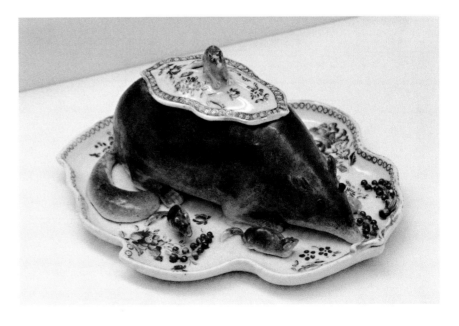

Auguste Rodin, French (1840-1917), *The Three Shades*, ca. 1898
Courtesy of the San Francisco Arts Commission, gift of the Rafael Weill Memorial Committee

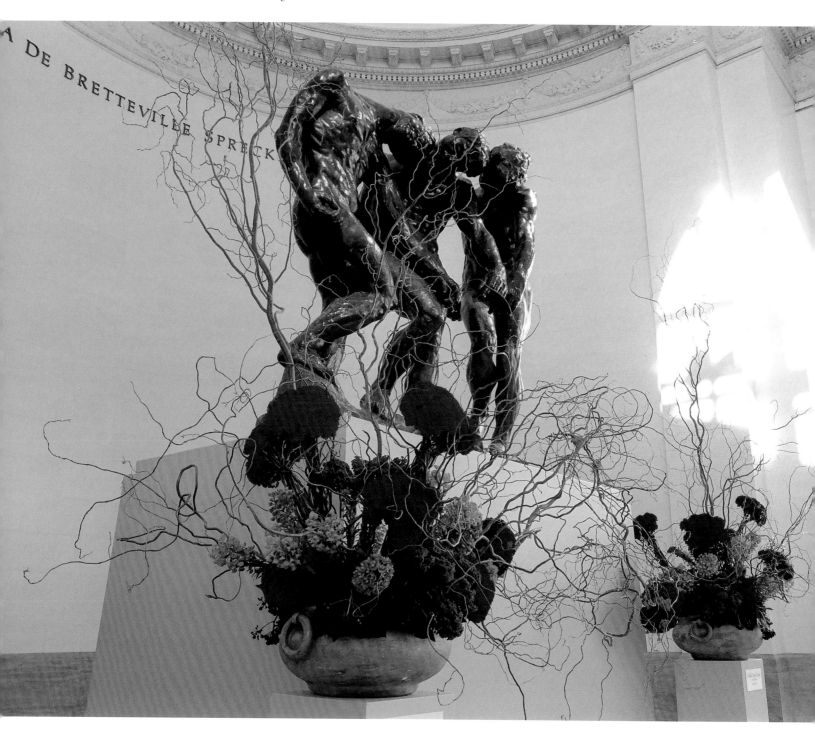

MICHAEL DAIGIAN OF MICHAEL DAIGIAN DESIGN, San Francisco, CA uses simple, yet highly effective design techniques to complement a prime focal point of the Legion, Rodin's formidable sculpture *The Three Shades*. The huge scale of the art work demanded the arrangements be placed in containers of strong visual weight. Low terracotta-finished concrete bowls hold soaring branches of curly willow and bundles of twenty-five bright red carnations wrapped together with curly willow. Dark green euphorbia and lighter green monbresia provide density, texture, and accentuating color. By using bundles of flowers, Michael achieves the desired effect of portraying the round, powerful, and muscular physiques of the men's bodies, while the curly willow reflect the form and movement of the bodies' stance.

Auguste Rodin
French (1840-1917)
John the Baptist, Preaching, 1878
Gift of Alma de Bretteville Spreckels

RON MORGAN, Oakland, CA. captures the mood and strength and presence within the Rodin sculpure gallery with this eloquent green and white foliage arrangement. Set atop a Victorian Grand Tour bronze sculpture of Atlas holding up the world, purple marantha leaves, galyx, and bromiliads soar upward with society garlic in the center, blending into a cascade of variegated ivy and succulents. The scuptural form and ebony luster of the Atlas figure harmonizes so well with the Rodin sculpture that it appears to be an integral part of the gallery.

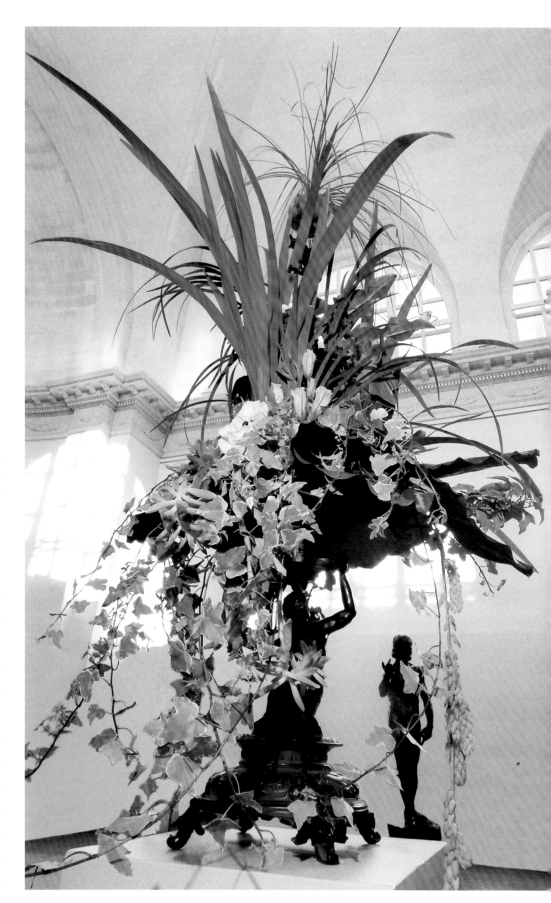

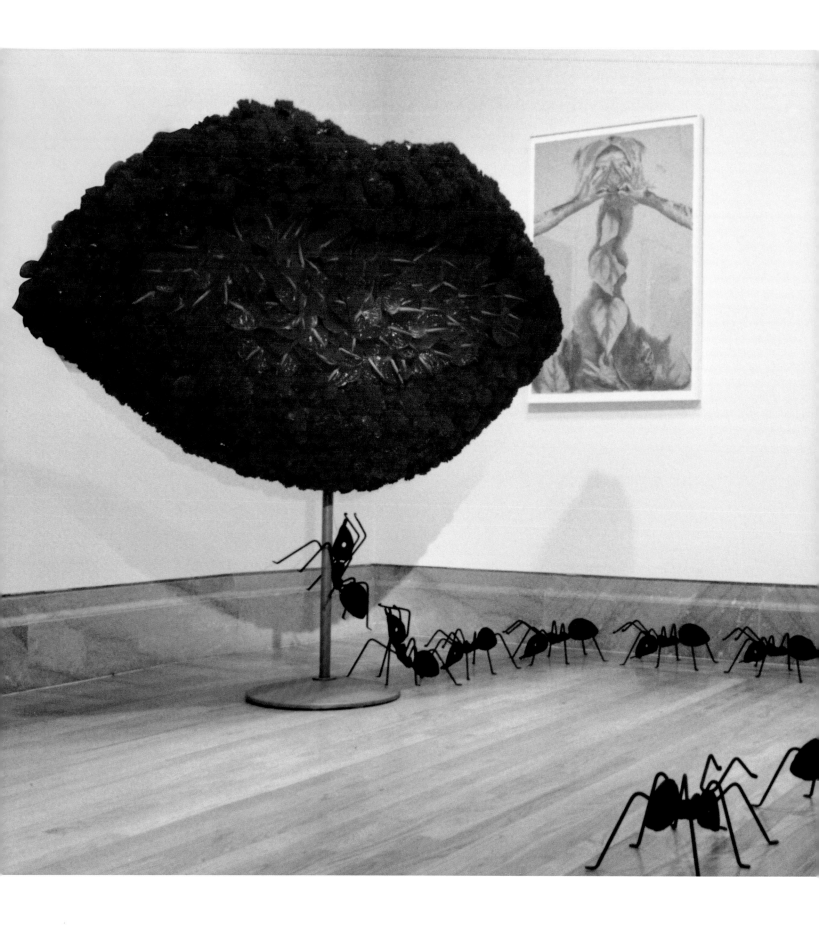

ANDERSON GALLERY
OF CONTEMPORARY GRAPHIC ART

Marisol (Marisol Escobar), American , b. 1930
Catalpa Maiden About to Touch, 1973
Color lithograph, Anderson Graphic Arts Collection

WILSON MURRAY OF MOLECULES, San Francisco, CA had people hurrying to see the much talked-about pest invasion going on in the Anderson Gallery! Highly creative, and often with a twist of humor, Wilson's exhibits at *Bouquets* always delight a broad spectrum of viewers from children to adults. This year's art work selection was particularly challenging, but in the end inspired this very inventive and delightfully amusing interpretation. Many a child has used their fingers to stretch their mouth and lips into a wild distortion as depicted in the print, and/ or made prints of painted leaves on paper as done in the lithograph with catalpa leaves. With the same free-spirited and childlike creativeness, Wilson used brilliant red carnations and anthuriums to create an enormous pair of lips and then, in keeping with the catalpa tree theme, rested them on a simple pedestal-type trunk. The giant black ants are marching towards the tree and up the trunk in search of the sweet nectar of the luscious red lips of the Catalpa Maiden.

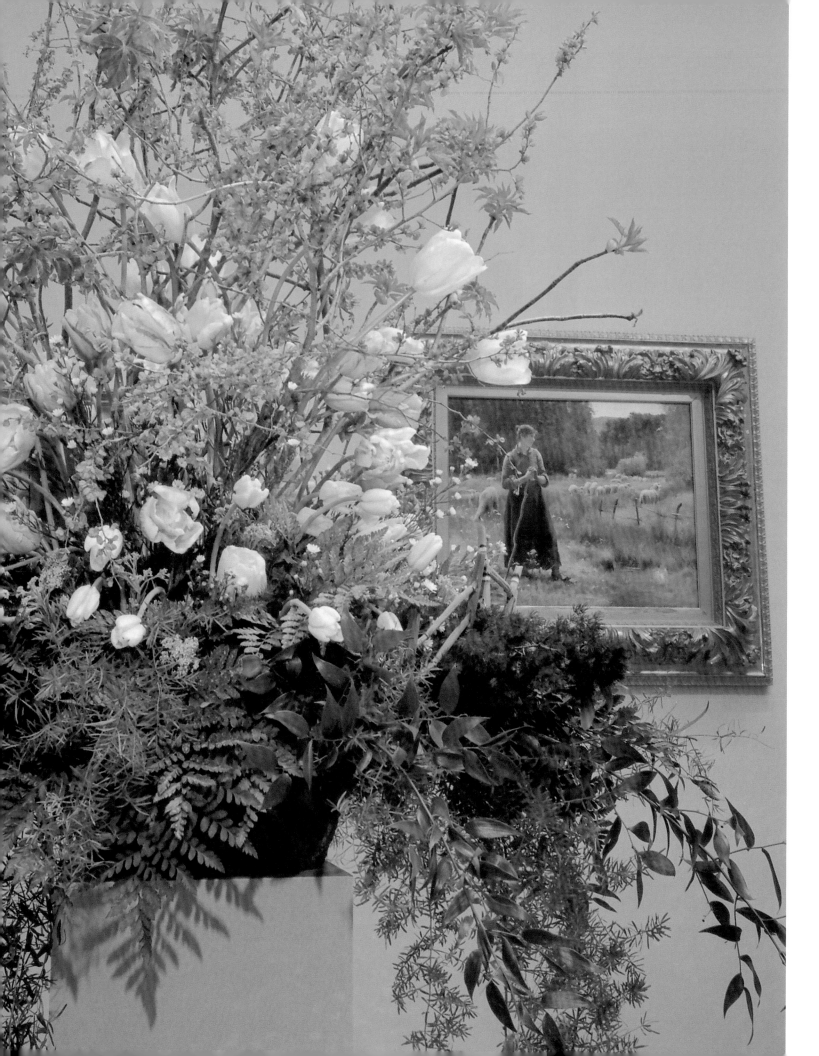

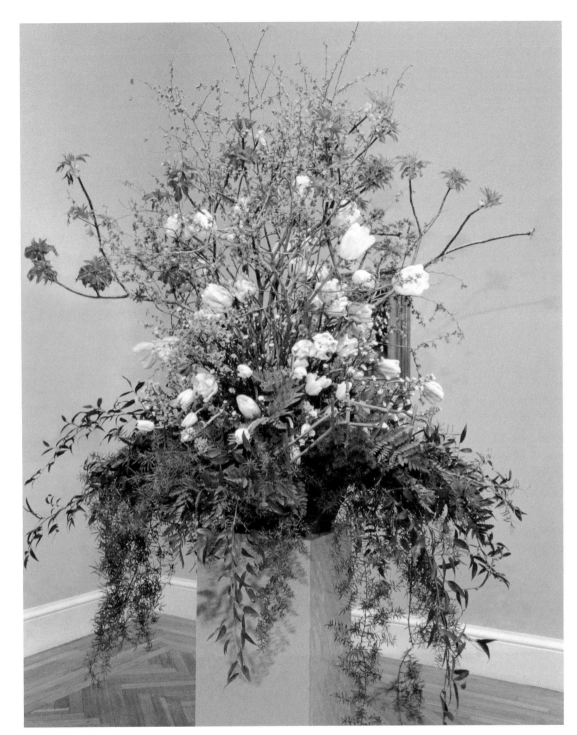

GALLERY 17
THE JUNE GOETHE
CRAYCROFT
GALLERY

Julien Dupré
French (1851-1910)
Peasant Girl with Sheep
Oil on canvas
Gift of M. H. de Young
Estate

DONNA HIGGINS OF DESIGN & INTERIORS, Los Altos, CA brings her love of all things natural into full expression in the beautiful and ever-popular green and white theme of this arrangement. Inspired by the painting's subject of a young shepherdess and her flock, Donna evokes the pastoral feeling using only green plant material in a variety of shades: flowering buckeye branches, asparagus and maidenhair ferns, and dark green tree foliage. White French tulips and roses, and green and white parrot tulips complete the feeling of calm and serenity as expressed in the painting. Carefully placed to blend with the foliage and flowers is a fence made of dried horsetails, the finishing touch for her very successful natural interpretation of the *Peasant Girl with Sheep*.

One of a pair of night tables (tables de nuit), ca. 1770
Martin Carlin, French (1735-1785)
Gift of Mrs. Bruce Kelham for the Grace Spreckels Hamilton Collection

Rolltop desk (bureau à cylindre), ca. 1770
Maker unknown, probably Spain
Mahogany and rosewood inlaid with satinwood, ebony, and maple

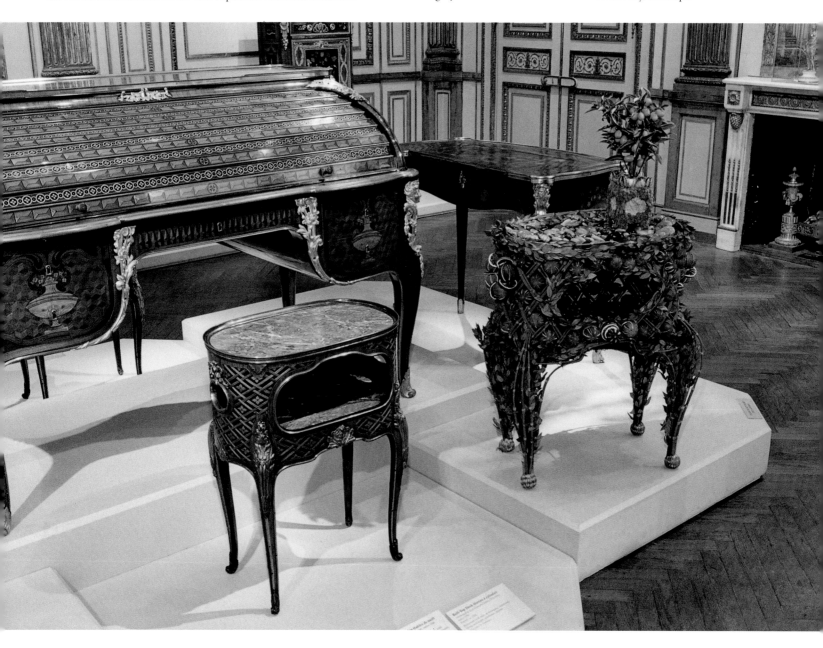

THIERRY CHANTREL OF LA FOLLIA FLORAL AND GARDEN DESIGN, San Francisco, CA recreates a stunning plant material replica of an 18th century French night table. In keeping with the light feeling of the original table's three-dimensional inlay work, the floral table was made with an open-trelliswork motif of horsetails. The single jasmine blossom motif in each square of the original is represented with dried open oranges to create a feeling of wood tones. The brass molding is made with ruscus dyed in orange and red wood tones. Replicating the hooves of the legs are horsetail balls; and the marble plates, river rock pebbles. The square cachepot, a replica of a pink porcelain miniature Versailles box in the display case opposite, is made of pink button statice, cobra lily, and nigella pods, and planted with a kumquat, as the original Versailles boxes (*caisses à orangers*) were made to be planted with exotic specimens such as citrus trees.

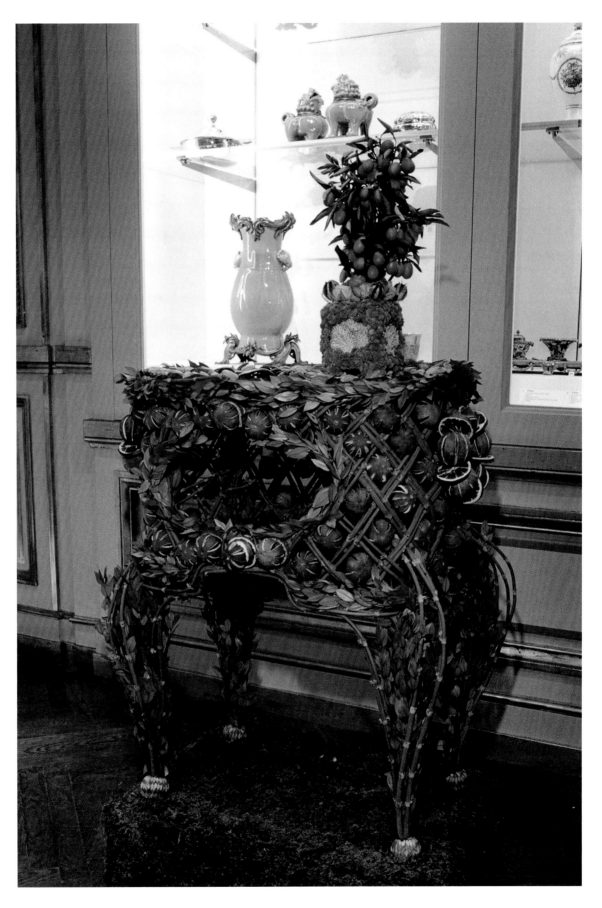

Pair of lion dogs (ky-lins)
ca. 1700
Chinese celadon porcelain
with French gilt mounts
ca. 1750
Bequest of Michel Weill

Vase
Chinese celadon porcelain
with French gilt bronze
mounts, ca. 1750
Gift of
Archer M. Huntington

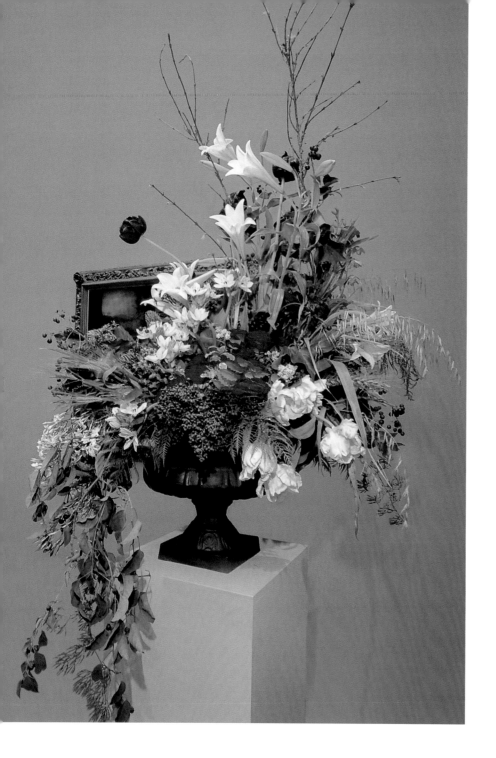

MICHAEL RITZ OF CHURCH STREET FLOWERS, San Francisco, CA looked deep inside the layers of texture and color in the painting and complemented the work with an arrangement that elicits both a feeling of strength and serenity. Painting with flowers and plant material that reflect contrasting light and color, Michael is able to give each element the same level of importance both in the arrangement and in its relation to the painting. Pure "white Europe" longiflorum, often referred to as the Easter lily, here evoke the spirit of mother and Christ child, while the bright white stars of Bethlehem bring to mind the story of Jesus' birth. Various wheat grasses and the oats gently framing Mary's face are reminiscent of the manger and pastoral setting of the holy birth. Beautiful pale pink parrot tulips and a cluster of fragrant jasmine complete the light-colored palette and complement the soft skin tones of the mother and child. In dramatic contrast are the rich dark colors of deep purple peony tulips, purple privet berries, blue scilla, fern, ornithogalum, and cascading tree ivy with berries. Tall branches of forsythia, just starting to open, represent the sun coming up each day. Black magic roses and hypericum berries intertwined and cradled in the center, as the mother cradles her child in the painting, complete the elegant dramatic sweeping motion and S-curve of the arrangement, perfectly reflecting the classical line of beauty.

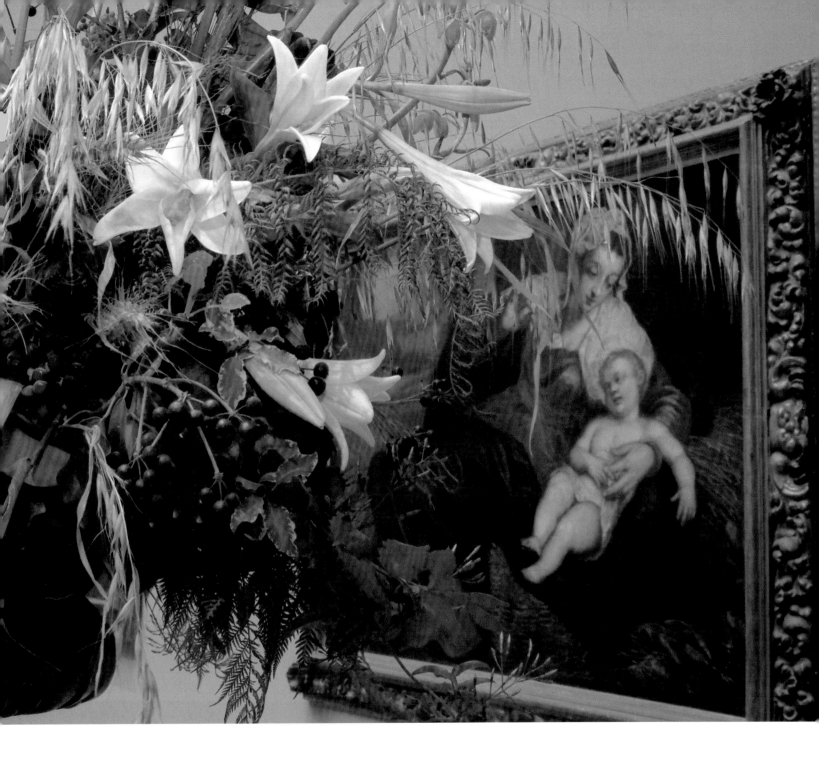

GALLERY 6
THE GEORGE AND MARIE
HECKSHER GALLERY

Jacopo Robusti (Tintoretto)
Italian (1518-1594)
Madonna and Child, ca. 1570-1572
Oil on canvas
Gift of Archer M. Huntington

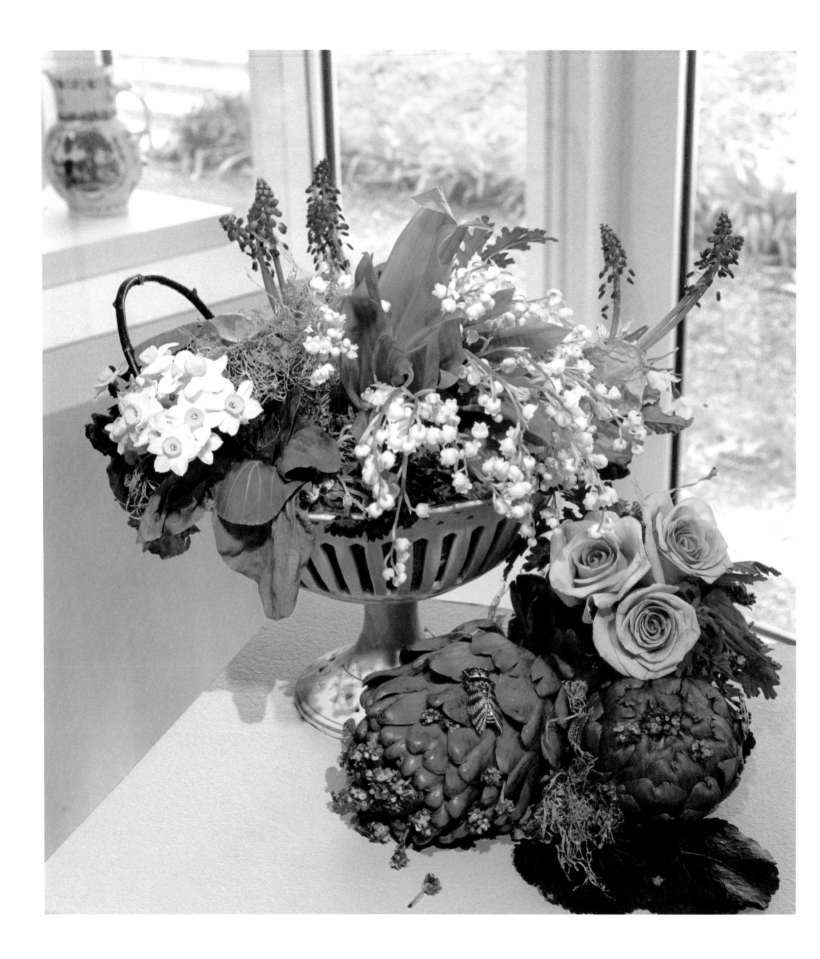

Page 85: *Soft paste porcelain plates,* English, Chelsea, 1745-1760

TORRYNE CHOATE OF INDIGO V, San Francisco, CA drew her inspiration for the 2001 *Bouquets to Art* poster arrangement from the many natural themes depicted in the porcelain plates and in their delicate overall color palette, as seen on page 85. Complementing the gallery's collection, a pedestal porcelain basket container overflows with lily of the valley, grape hyacinths, narcissus, primroses, and cabbage leaves. At the base are three artichokes filled with blush roses and dainty forget-me-nots, accentuated with two metal bug pins that complete the springtime garden theme.

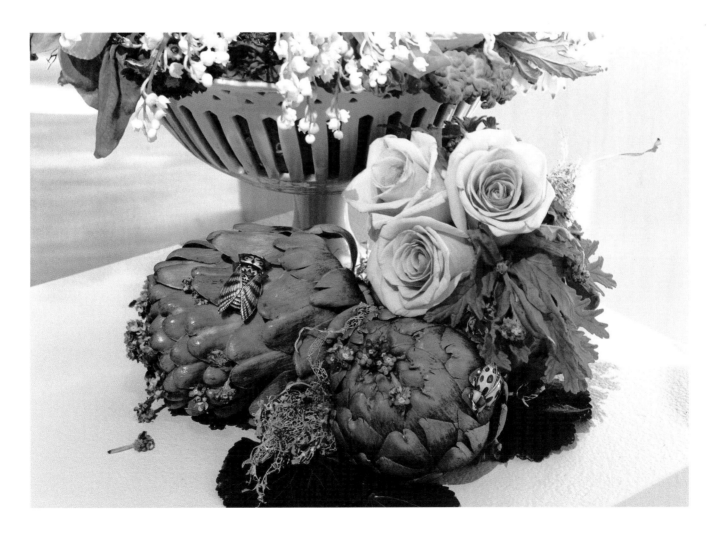

2001

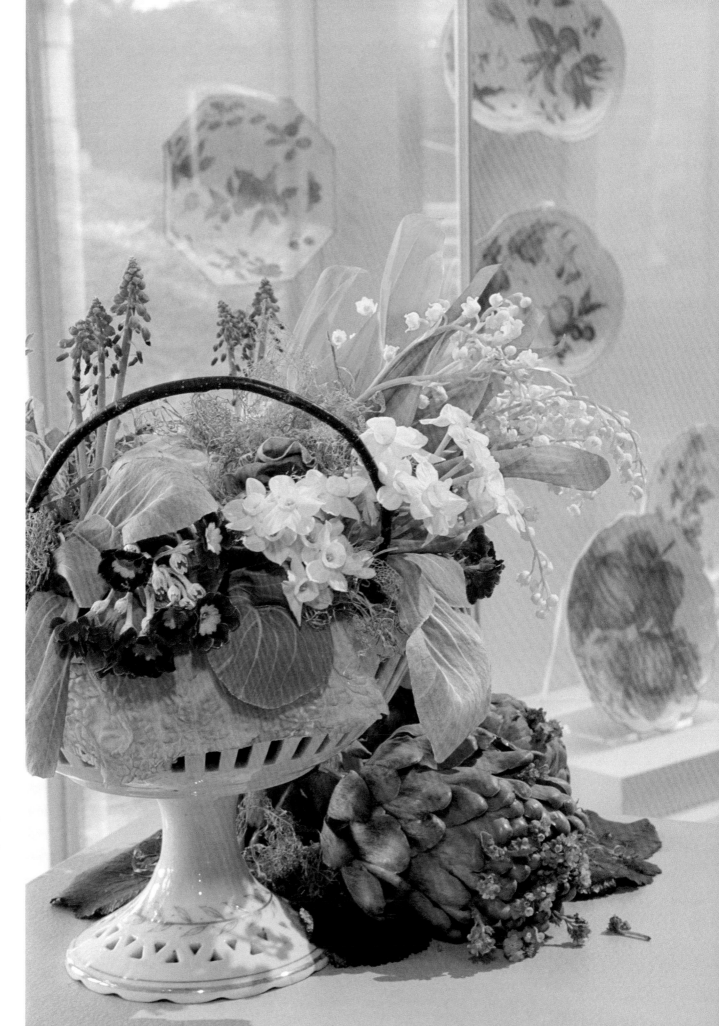

Oh flower of song
bloom on
and make the world
more fair and sweet.

William Wordsworth

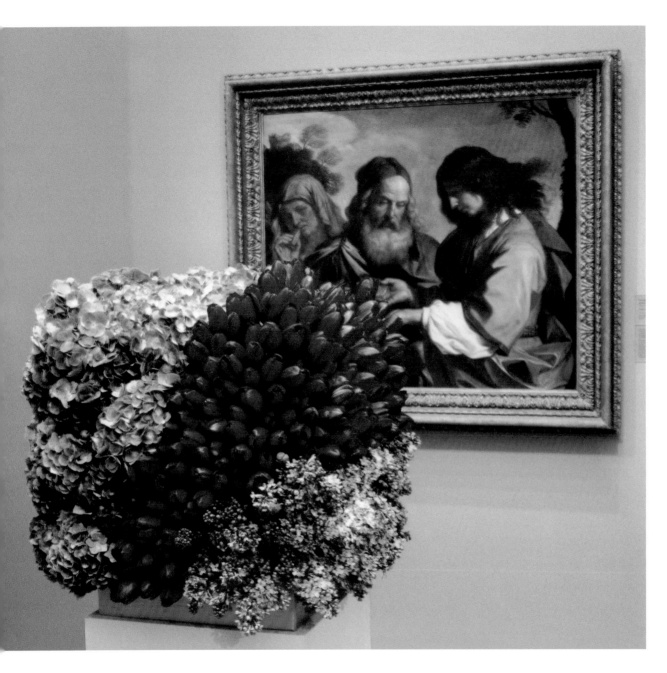

GALLERY 6
THE GEORGE AND MARIE
HECKSHER GALLERY

Left

Giovanni Francesco Barbieri
(called Il Guercino)
Italian (1591-1666)
Samson and the Honeycomb
ca. 1657
Oil on canvas
Roscoe and Margaret Oakes
Collection

Right

Eustache Le Sueur
French (1617-1655)
Sleeping Venus, ca. 1638-1639
Oil on canvas
Mildred Anna Williams
Collection

CATE KELLISON AND ASSISTANT SUSANN KELLISON OF ROSE AND RADISH, San Francisco, CA create an impressive sculptural pair of two very different, yet complementary floral designs. The two paintings they interpret, though different in subject matter, were seen as a set of frames likened to a pair of rich gold boxes. Hundreds of pale pink parrot tulips tightly packed together portray a sense of indulgence and voluptuous feminine beauty in front of the reclining nude. The sculptural form and graceful line of the design represented the woman to the floral designers, while many viewers saw the design as the soft couch on which she was lying, showing

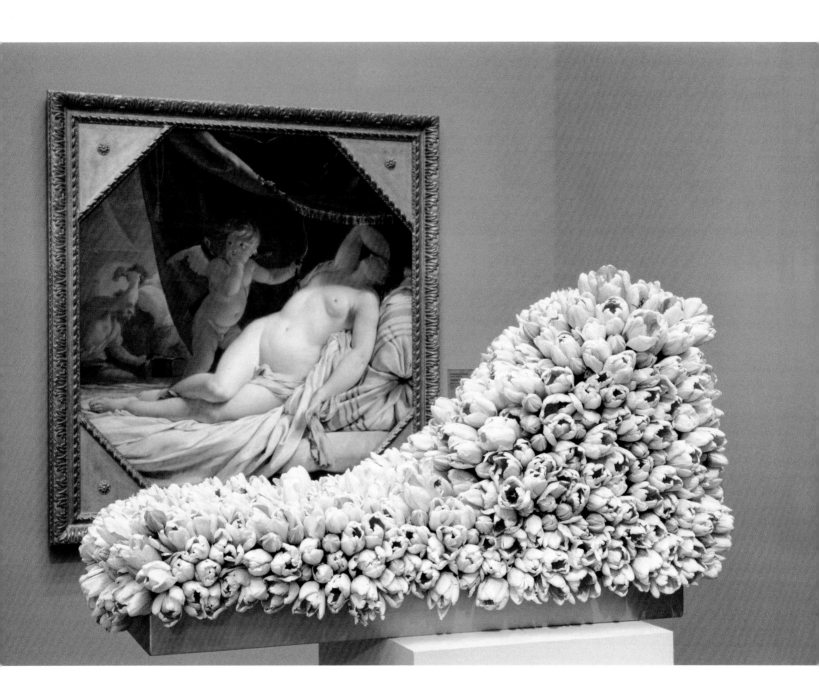

how a highly creative design can evoke a variety of valid interpretations. The square form of the Le Sueur painting and its frame inspired the cube shape of the other floral design, while the colors and draping of the men's clothing inspired the color and line of the flowers. Brilliant blue hydrangea, deep red tulips, and luxuriant spring lilacs are tightly wrapped around the cube-like yards of floral fabric, emulating the fabrics the people are wearing in the painting. Using only plant material that is sold at the San Francisco Flower Mart and one kind of flower in tightly packed masses, Cate creates a beautiful and visually strong pair of floral art works that allows her background in fine art to shine through.

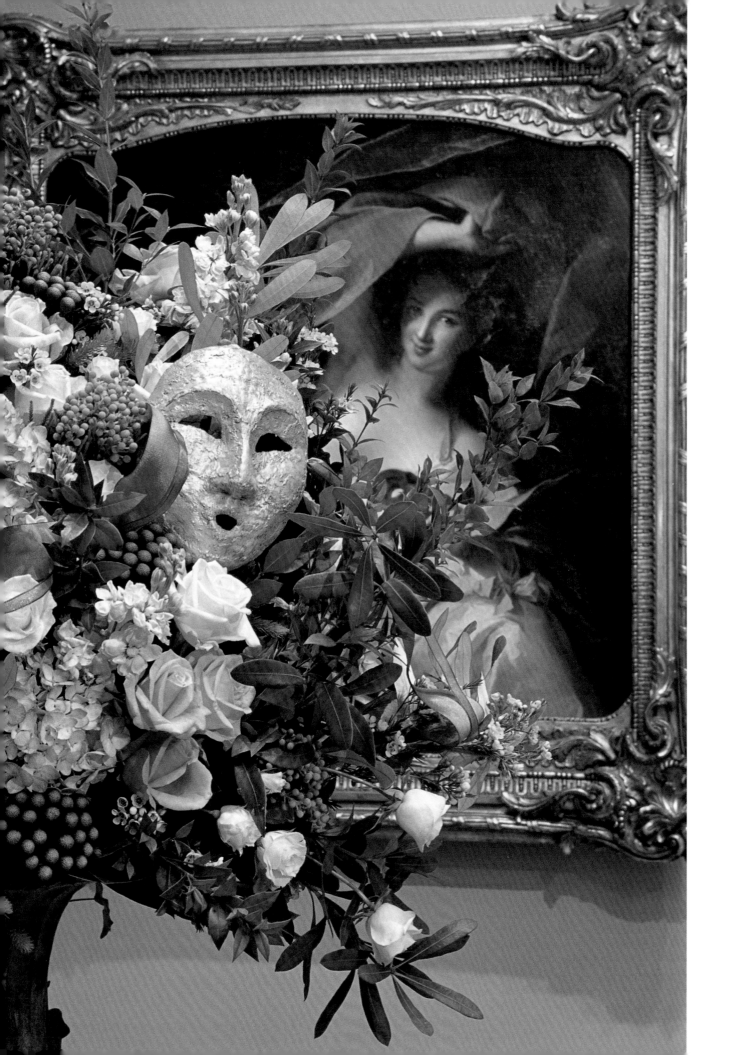

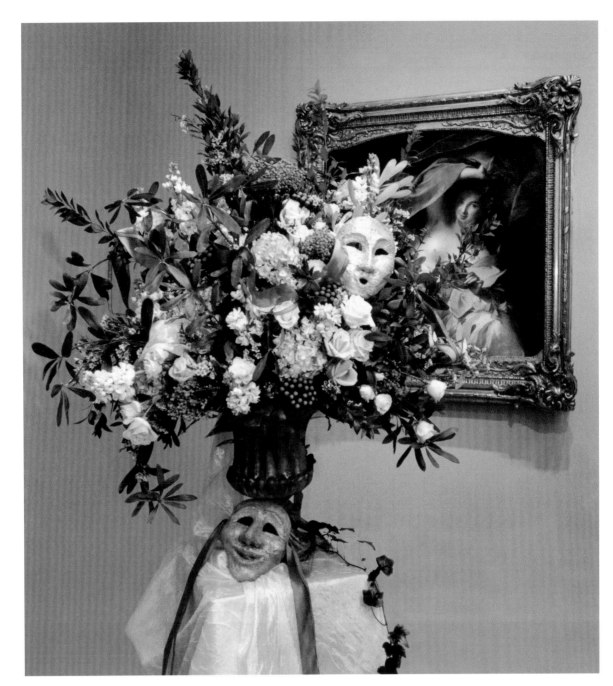

CONSTANCE DAY AND JENNIFER CAPRA OF SUNSHINE FLOWERS, Martinez, CA participate in their first *Bouquets to Art* event with this winning arrangement that captures the wonderful Baroque frivolity of *Thalia, Muse of Comedy*. Focusing on the overall lushness of the painting and the saucy quality of Thalia's smile and the impish twinkle in her eye, the designers succeed through color, texture, and composition in capturing an almost wanton playfulness, while still maintaining a feeling for the formality of the era as well. Soft pink and cream-colored roses and blue hydrangea contrast with the green berries and branches. Cascading ribbons and crushed satin mimic the flow of Thalia's robes and blue drapery. The sculpted masks tucked into the bouquet and at the base add the flourish of comedic drama that is the subject of the allegoric painting.

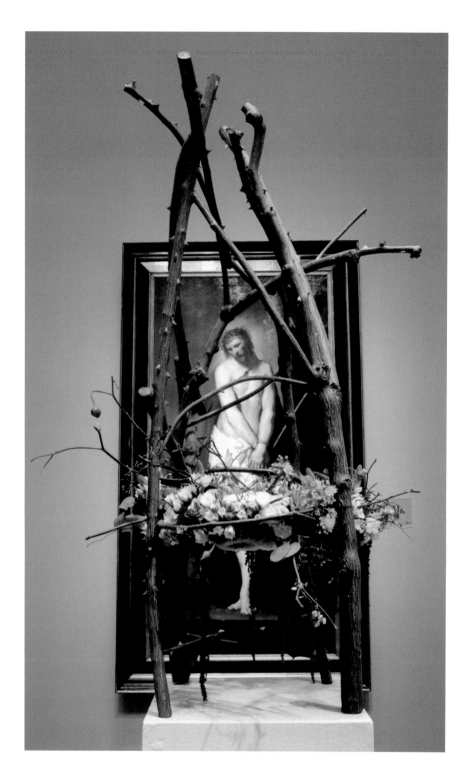

GALLERY 14
MICHAEL A.
AND HANNA NAIFY
GALLERY

Pieter Franz de Grebber
Dutch (ca. 1600-1652)
Christ at the Column, 1632
Oil on panel
Museum purchase
Mildred Anna Williams Collection,
Bequest Funds of Henry S. Williams
in memory of H.K.S. Williams

DONNEL VICENTE OF DONNEL VICENTE DESIGN, Oakland, CA always selects an art work to interpret that relates to his own life experience at the time. The image of *Christ at the Column* with a halo around his head was seen as a sign of hope for the beginning of a new life following the pain of life's trials. A temple-like enclosure made of old rose vines is representative of Christ's own space and creates an environment that is protective and safe. White roses and green salvia leaves form a stark, but gentle contrast in color and texture to the rough, thorny vines, and the hanging red amaranthus represents the blood of Christ.

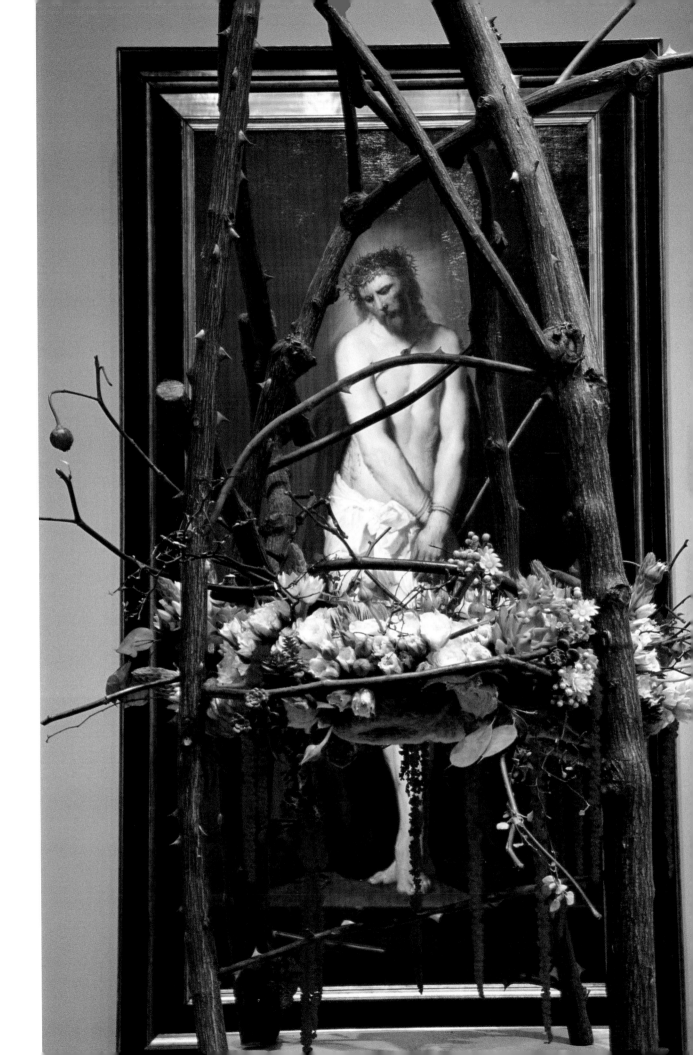

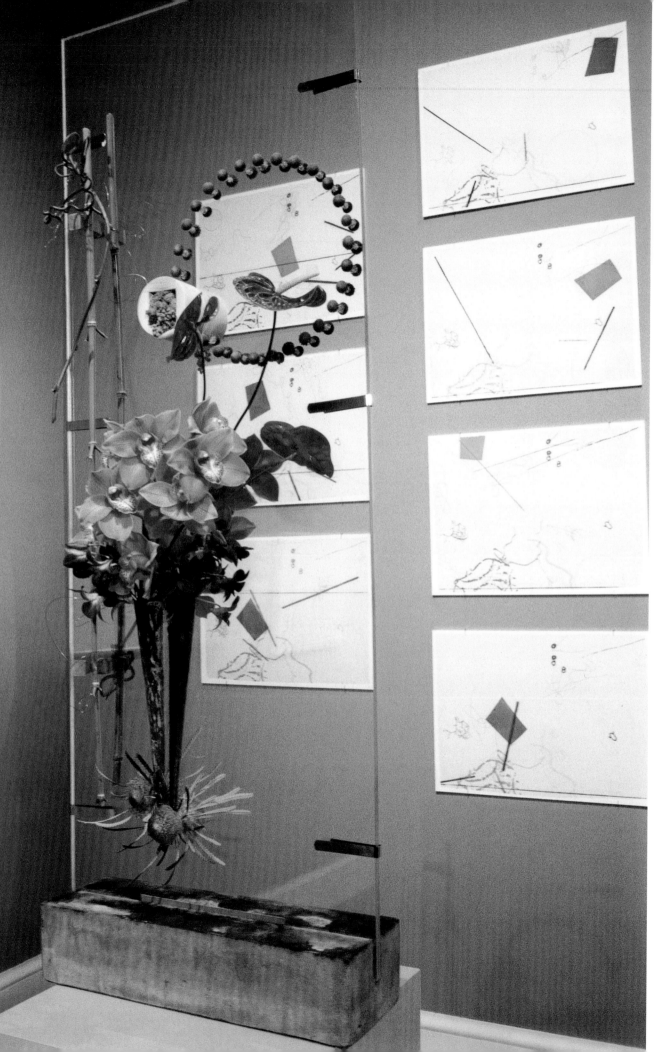

GALLERY 1

Changing Exhibit

John Cage
American (1912-1992)
Dereau, 1982
Color photoetching,
engraving, drypoint
and aquatint

Crown Point Press
Archive

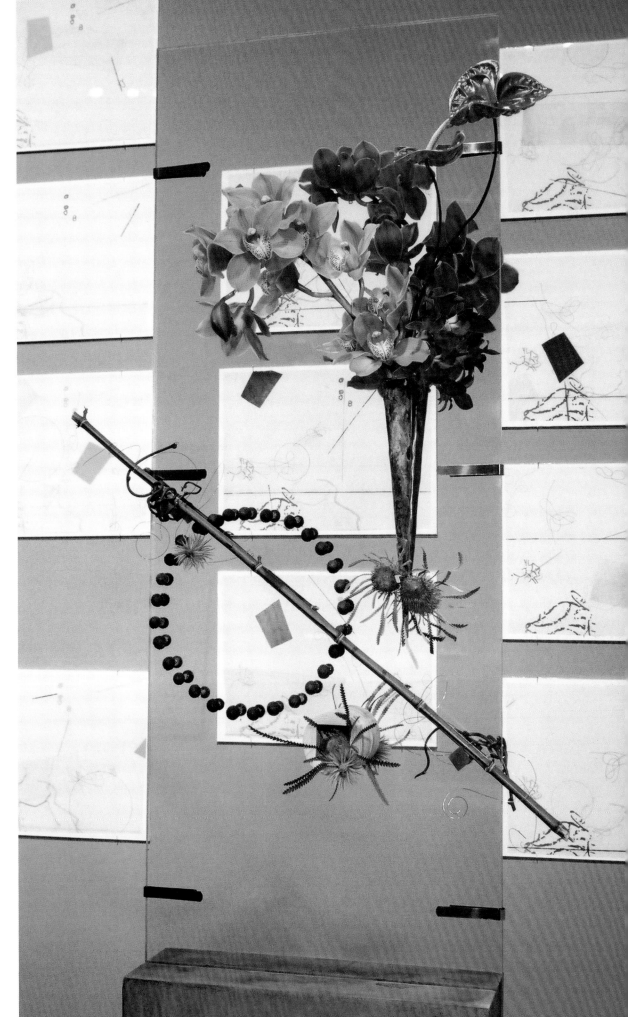

IN MEMORIAM
MICHAEL WEIDNER
FLOWER ARTIST
Monterey, CA

MICHAEL WEIDNER'S exhibits at
Bouquets to Art over the years were al-
ways welcomed with great enthusiasm
and admiration for his enormous cre-
ative gifts and talent. This pair of works
complementing Cage's *Dereau* series
were among his favorites and most cre-
atively challenging pieces. Twin sheets
of plexiglass wedged in blocks of blue-
gray granite are the contemporary can-
vases on which he creates his floral in-
terpretations. Tall tubular copper vases
attached to the plexiglass are filled with
varying shades of rust-red cymbidium
orchids and anthuriums, and purple
dendrobium orchids. His sculptural
pair brilliantly captures the delicate nu-
ances of color, form, and movement of
the Cage *Dereau* series. We miss you,
Michael.

SANDY WONG OF WEST PORTAL FLORAL COMPANY, San Francisco, CA focused on the simplicity of design and the feeling of movement in the John Cage etchings in the creation of this handsome contemporary floral design. Using a large cluster of airy yellow oncidium orchids sweeping to one side and a heavy clump of bear grass cascading to the other side, she recreates both the horizontal and downward movement in the etching. Centered in the middle are purple scillia that provide a burst of complementary color to the yellow orchids. Rising high in the center are

GALLERY 1

Left: John Cage, American, 1912-1992
Seven Day Diary/Not Knowing, 1978
Seven etchings
Crown Point Press Archive

Below: John Cage, American 1912-1992
17 Drawings by Thoreau, 1978
Color photoetching
Crown Point Press Archive

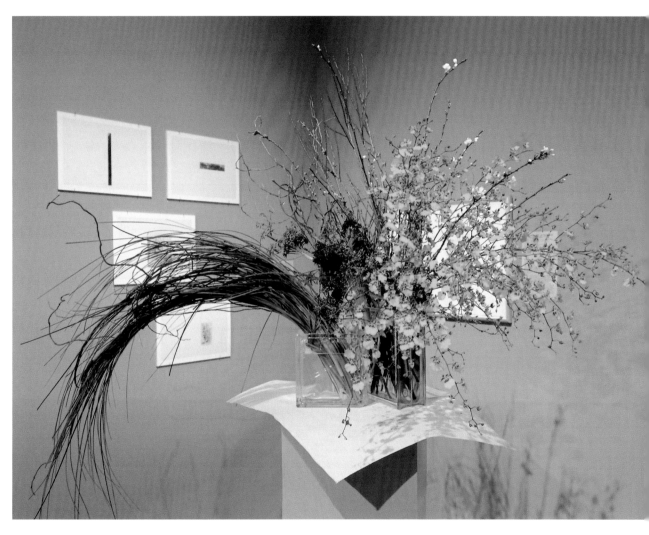

spring branches that provide vertical movment and unify the horizontal elements. The flowers and greens rest in two clear vases, again reflecting the simple and contemporary nature of the artwork. Placed on a diagonal for visual contrast to the rectangular framed etchings, the entire floral work rests on a piece of heavy rag etching paper that provides the final element that unites the fine art and floral art.

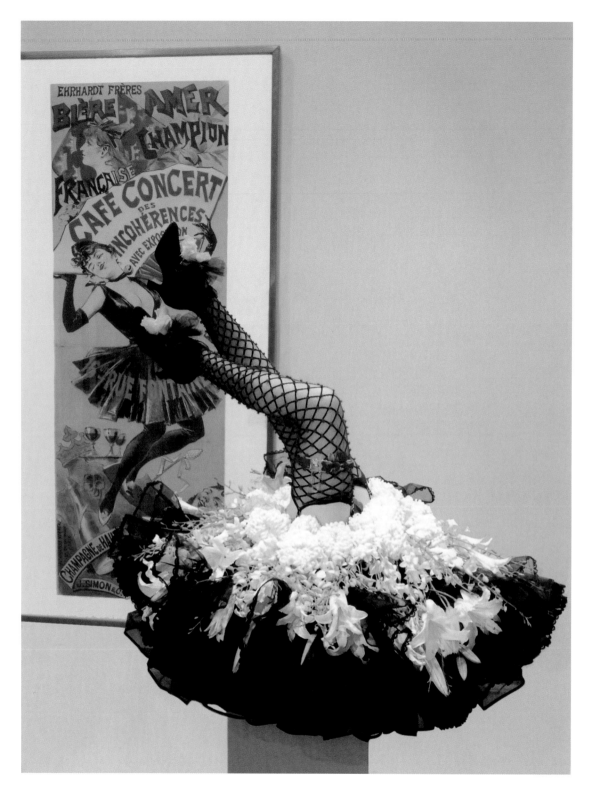

ROSEKRANS COURT

GALLERIES C AND D
Special Exhibition

*Toulouse-Lautrec and the
Spirit of Montmartre:
Cabarets, Humor, and the
Avant-Garde 1876-1905*

Jose Roy,
Café des Incohérences, 1888

Courtesy of the Jane Voorhees
Zimmerli Art Museum,
Rutgers, The State University
of New Jersey

WILSON MURRAY OF MOLECULES, San Francisco, CA delights us with his alluring interpretation of a Parisian can-can girl. Using only the bottom half of an inverted mannequin, Wilson brilliantly captures the high-kicking animation of the dancer. Shapely legs, provocatively dressed up in red and black fishnet stockings secured with garters, emerge from a skirt of large, fluffy white mums, dendrobium orchids, and Casablanca lilies lavishly cascading over a black crinoline. Saucy black boots (a Haight Street find) dressed up in yellow roses and black tulle complete the ensemble.

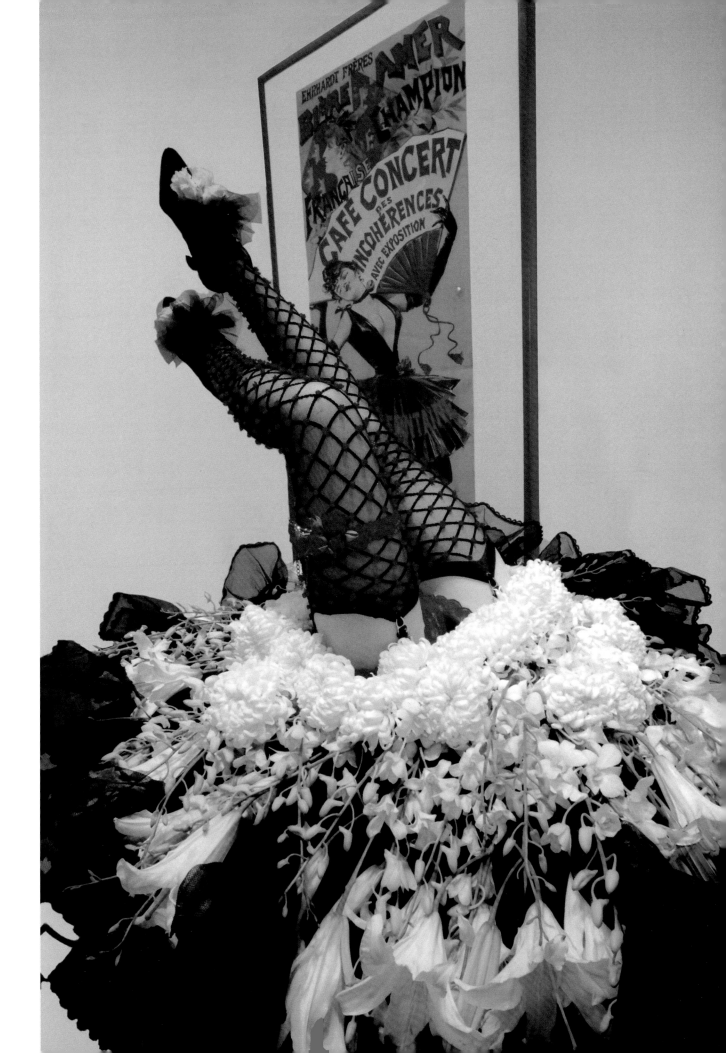

Below and page 105: *Right foreground:*

Auguste Rodin, French (1730-1809) Auguste Rodin, French (1730-1809)
Bust of Victor Hugo, ca. 1917, marble *The Prodigal Son* (L'Enfant Prodigue), 1887, bronze
Anonymous Gift Gift of Alma de Bretteville Spreckels

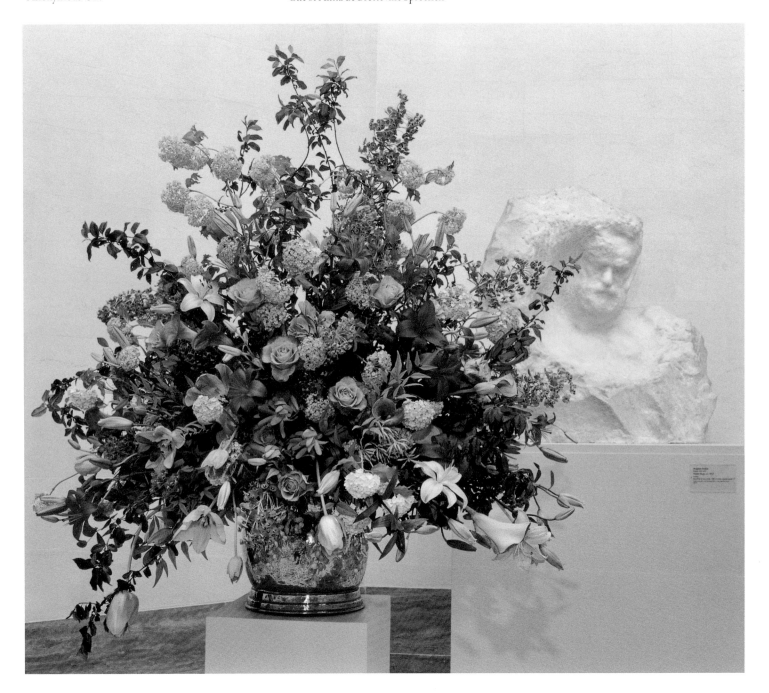

VALERIE ARELT, Sonoma, CA created the inspiration for the 2002 *Bouquets to Art* poster with a lavish tapestry of color, boldly complementing two Rodin sculptures very different in both color and texture. The roughly chiseled white marble bust of Victor Hugo in the background and the polished ebony bronze of *The Prodigal Son* in the foreground are each equally enhanced by the elegant bouquet of bright rust-orange gypsy curiosa roses and soft cream-colored stargazer lilies, creamy orange French tulips, and calla lilies, all dramatically and skillfully accentuated with varying shades of prunus foliage and viburnum.

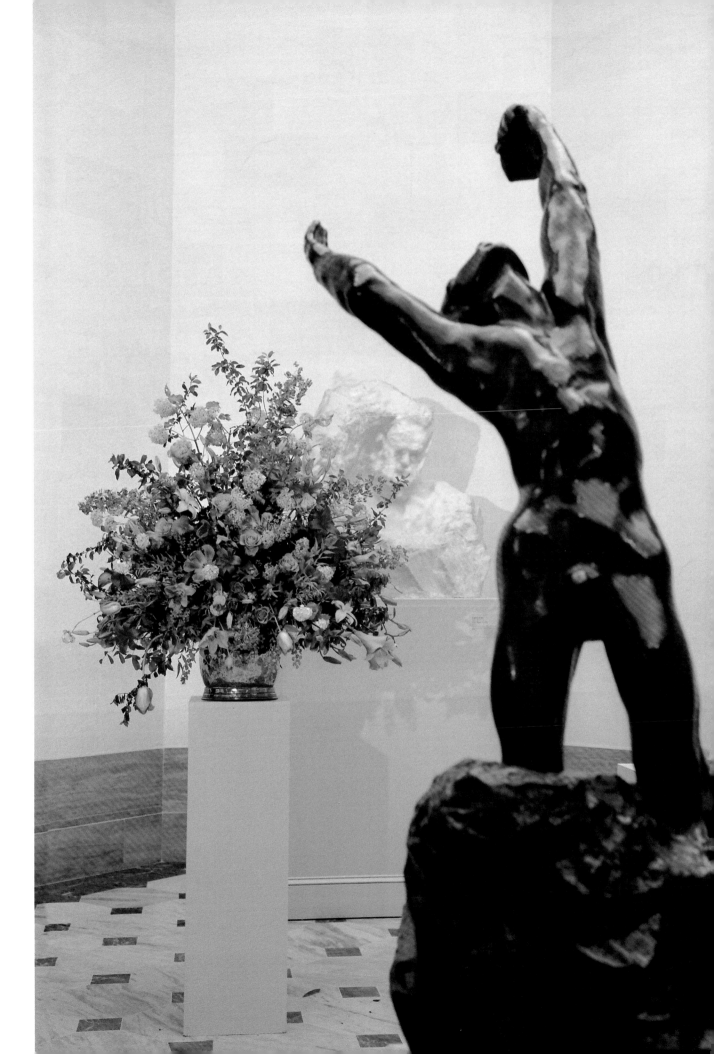

2002

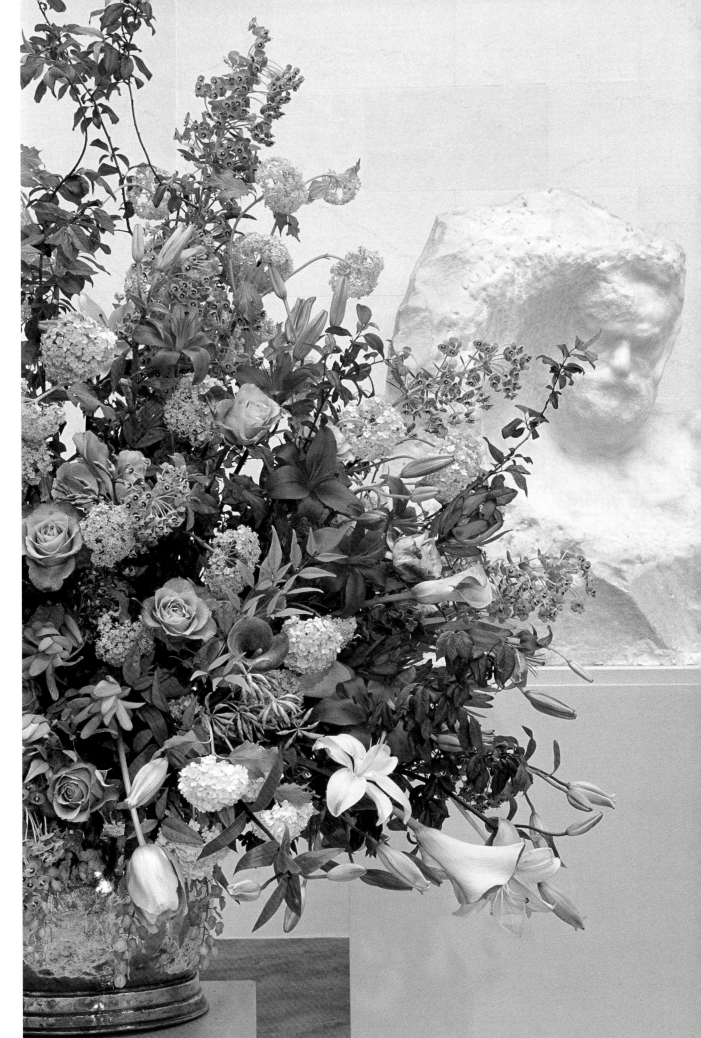

Winter is in my head
but eternal spring
is in my heart.

Victor Hugo

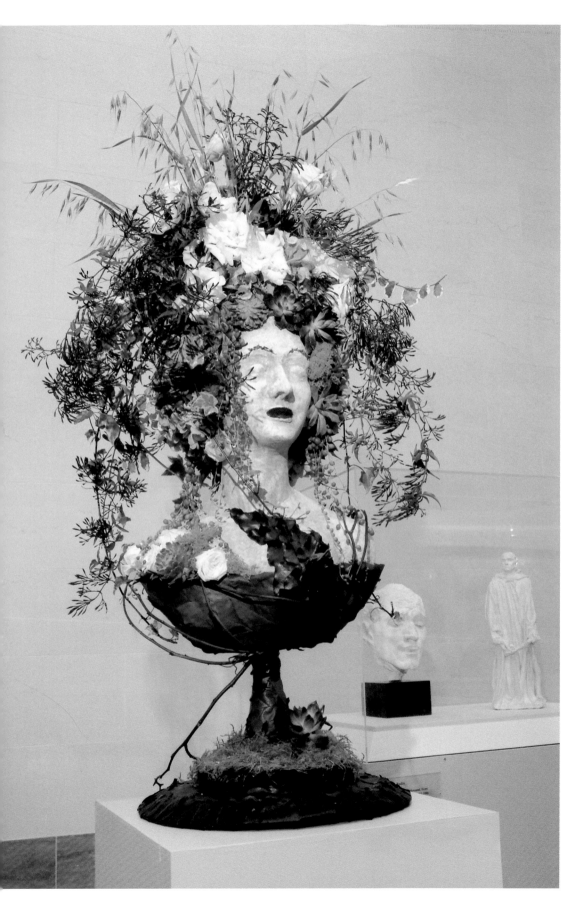

GALLERY 8
THE DIANE AND ALFRED
WILSEY COURT

Auguste Rodin, French (1840-1917)

*Left: Head of Pierre de Weissant,
from The Burghers of Calais,*
19th-20th century, plaster
Gift of Adolph B. Spreckels, Jr.

Right: Burgher of Calais with Key,
1906, plaster
Gift of Adolph B. Spreckels, Jr.

DOMINIQUE PFAHL OF FLO-
RÉAL, San Francisco, CA creates
her own unique floral sculpture to
complement the surrounding white
marble and plaster of Paris Rodin
sculptures. Her bust, with hand-
painted facial features, red rose petal
lips, and dried grass eyebrows, is
made of papier mâché and finished
to look like stone. Her magnificent
floral headdress is a profusion of
fragrant jasmine, foxtails, ivy, moss,
mother-of-pearl succulents, and
a cluster of white lisianthus. Her
bodice is covered with white rose
petals and preserved salad leaves, ac-
cented with more moss, succulents,
and lisianthus. The bust rests on a
wooden pedestal covered with the
brown underside of magnolia leaves
and preserved salad leaves gracefully
emerging from a moss and leaf-cov-
ered base. Expressing her signature
style of creating unique floral art
works, Dominique succeeds in im-
buing fragrant new life within the
marble walls of the sculpture court.

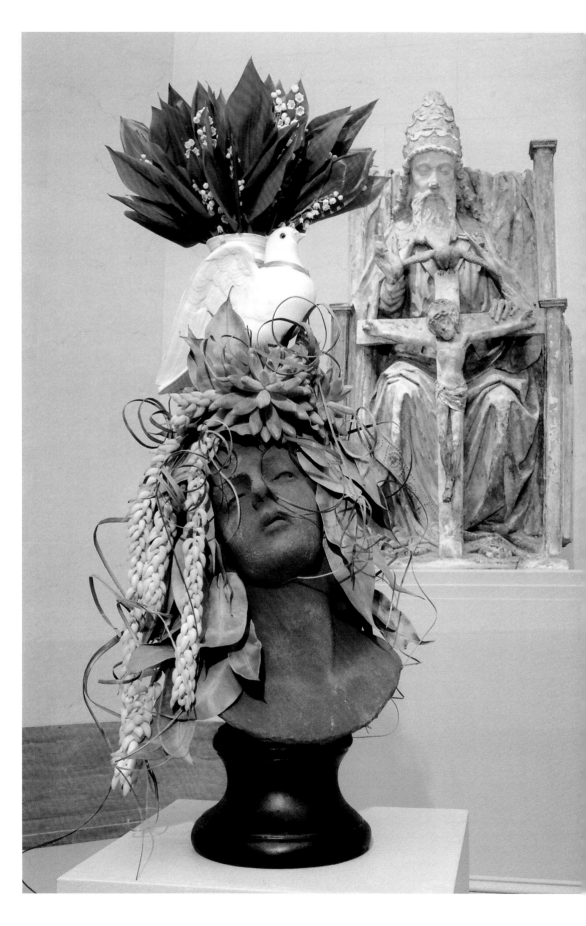

Anonymous, French
Trinity, 15th century,
Limestone
Gift of the
de Young Museum
Society

RON MORGAN, Oakland, CA, captures the essence of the Trinity and its message of peace by focusing our attention on the head of Christ and the doves perched above the cross. The terracotta head, tilting to the side like the Christ figure on the cross, wears a crown of cascading succulents, magnolia leaves, and spiraling bear grass. The beautiful Victorian bisque dove perched above holds a profusion of lily of the valley, the flower of peace. Texture and contrasting elements always play a key role in Ron's unique designs. We see that expressed here in the soft feminine qualities of the lily of the valley and succulents, contrasting with the crown of sharp thorns and the rough-hewn cross. The smoothness of the pure white bisque dove in contrast to the overall roughness of the wooden sculpture completes a very creative and pleasing juxtaposition of textures and elements.

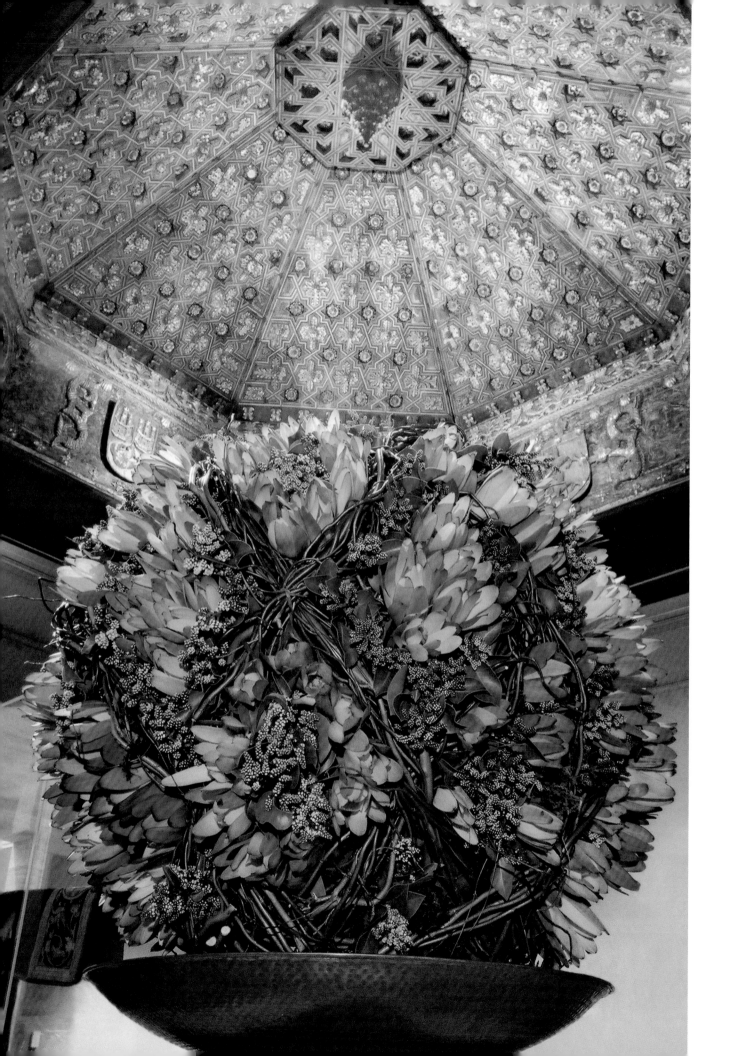

Ceiling from the Palacio de Altimira, near Toledo, Spain (1482-1503)
Painted, gilded wood
Gift of Mrs. Richard Ely Danielson and Mrs. Chauncey McCormick

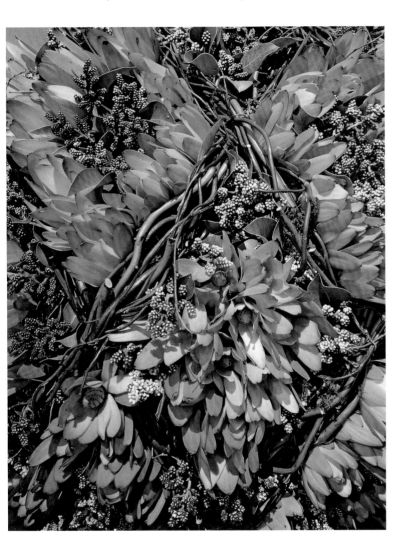

NEIL HUNT FOR MICHAEL DAIGAIN DESIGN, San Francisco, CA sucessfully took on a daunting creative challenge in selecting the Legion's unique and revered 15th century Spanish ceiling for his floral interpretation. The fusion of Moorish architecture with European influences was his inspiration. Creating a globe of foliage and woven willow with a pattern replicating the ceiling, Neil succeeds in remarkably capturing the essence of the ceiling with texture, form, and design. The repetitive pattern is typical Arabic and would be similar to patterns created by craftsmen for Muslim households of the time. The family crest in the center of the ceiling is typically European. Dating to approximately 1482, the ceiling represents the strong Arabic influence in Spain at the time and its harmonious fusion with European culture, which ten years later would be destroyed during the Spanish Inquisition with the driving of the Moors and Jews out of Spain. Neil is presently of HUNT LITTLEFIELD, San Francisco, CA.

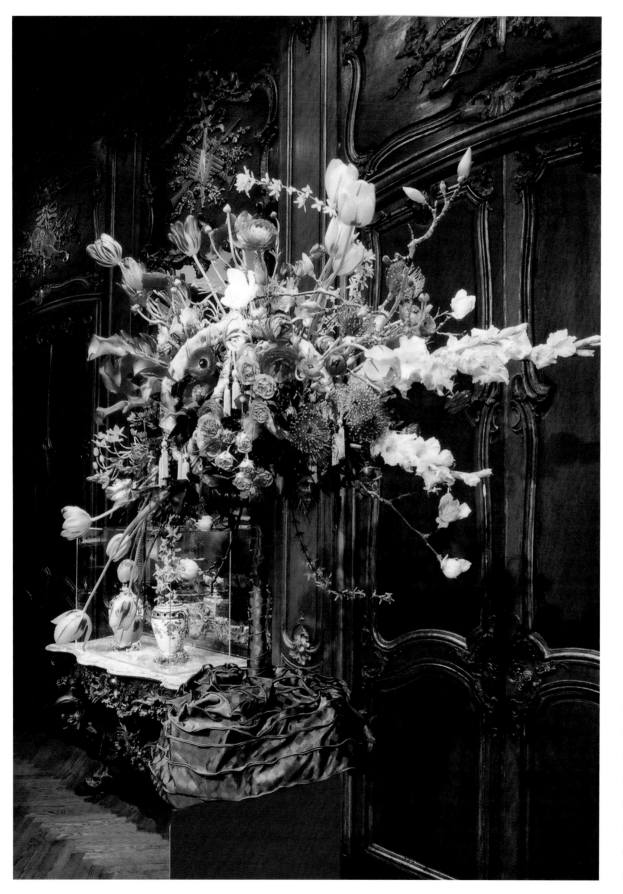

Augustin Pajou
French (1730-1809)
Bust of Madame du Barry, 1773
Marble
Gift of Andre J. Kahn-Wolf

KIWI DEVOY FOR FILOLI, Woodside, CA invokes the grandeur of the 16th century French court for inspiration in this richly woven tapestry of flowers and silk that she entitled "The Sun King," a play-off on Louis XVI. Enhancing and harmonizing with the French paneling from Rouen, the decorative porcelain, and the elegant marble bust of Madame du Barry, Kiwi captures the free-flowing spirit and elegance of the era with an extravaganza of fine silk and blossoms, many from the Filoli gardens: tulips, gladioli, forsythia, magnolia, calla lilies, roses, anemones, proteas, parrot tulips, and ranunculus.

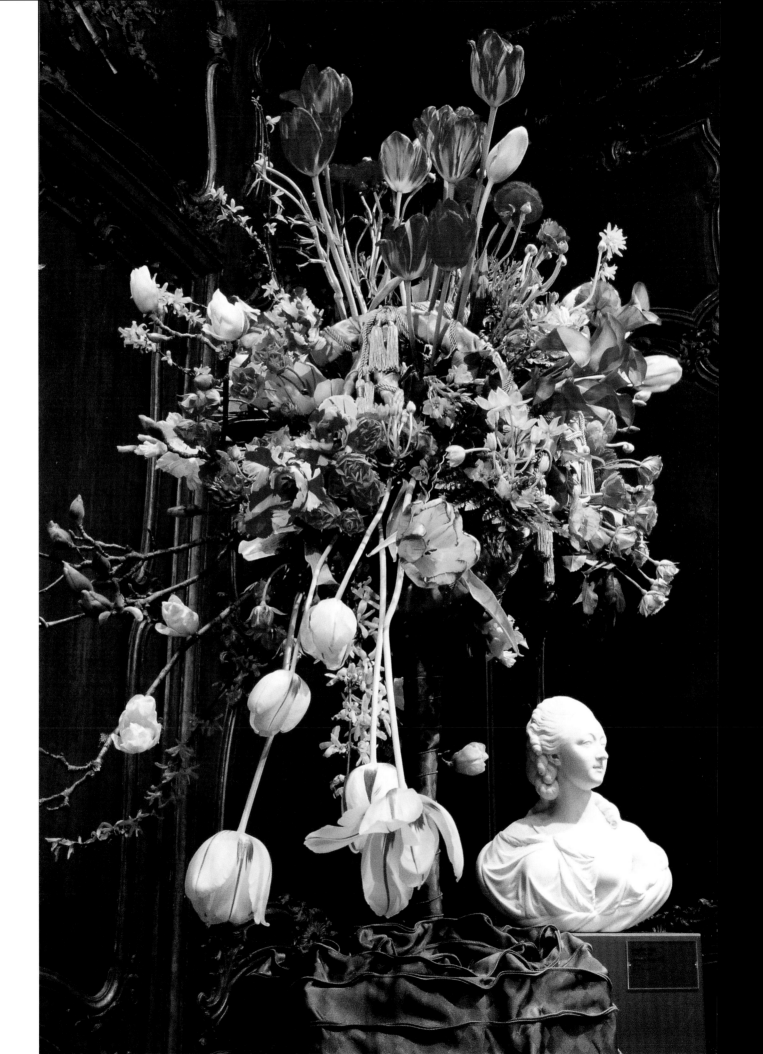

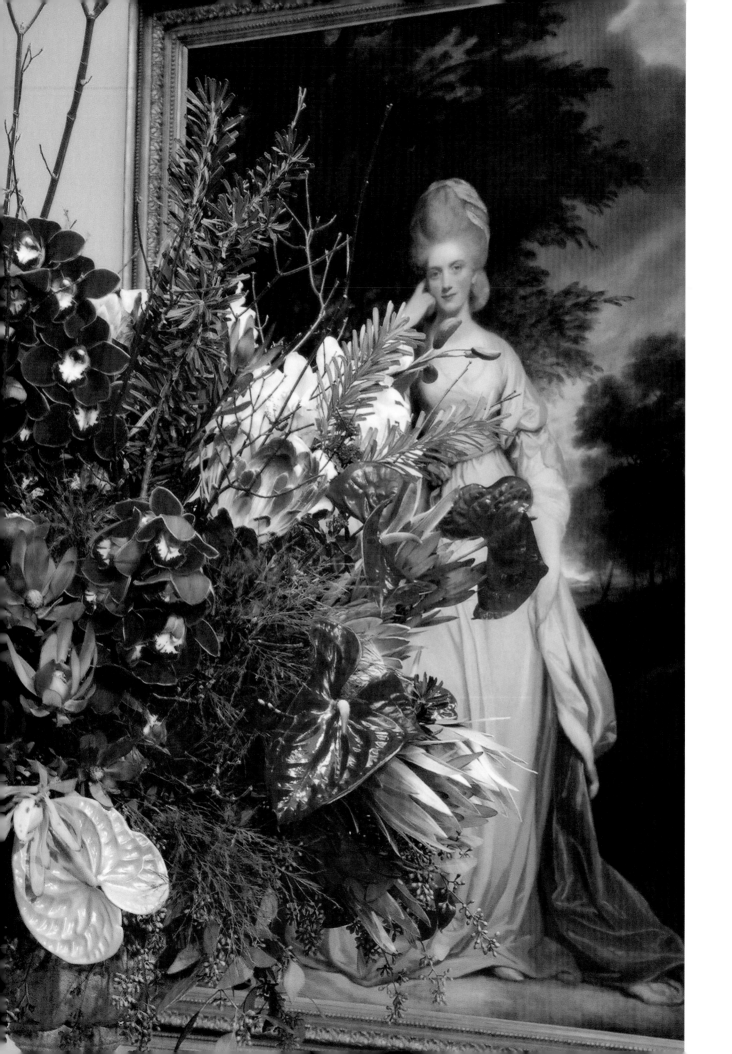

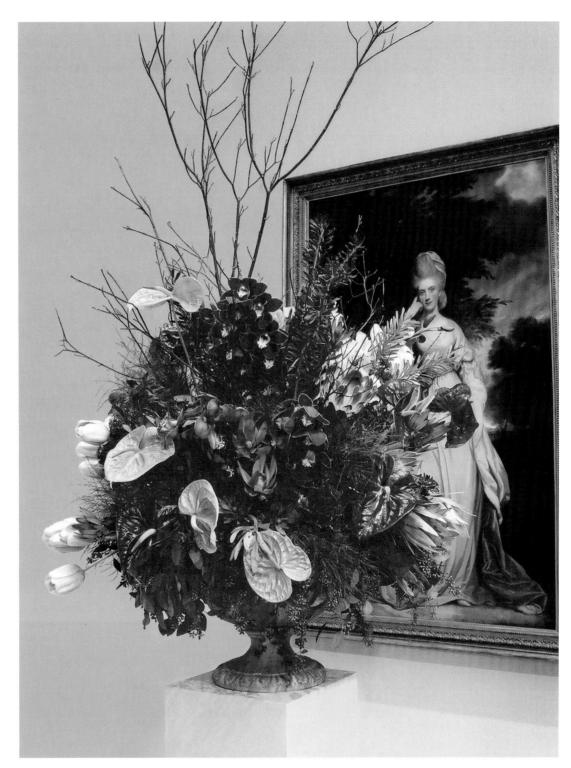

GALLERY 13
THE MARIANNE AND
RICHARD H. PETERSON
GALLERY

Sir Joshua Reynolds
English (1723-1792)
Anne, Viscountess of Townsend,
afterward Marchioness Townsend
1779-1780
Oil on canvas
Roscoe and Margaret Oakes
Collection

MAROLYN STANLEY OF THE PIEDMONT GARDEN CLUB, Piedmont, CA made color the prime point of this rich display of flowers and foliage. The aristocratic elegance of the viscountess is expressed and enchanced by Reynolds' elegant blending of color, which became the inspiration for the floral palette. Deep reddish-brown anthuriums and cymbidium orchids contrast and blend with pale pink anthuriums, cymbidium orchids, tulips, and king protea. Dark green tropical foliage and red-tipped eucalyptus provide depth and contrast and reflect the dark drama of the painting's sky. Red dogwood branches harmonize with the flowers and give the arrangement an upward sweep of height as in the viscountess' elegant hair style.

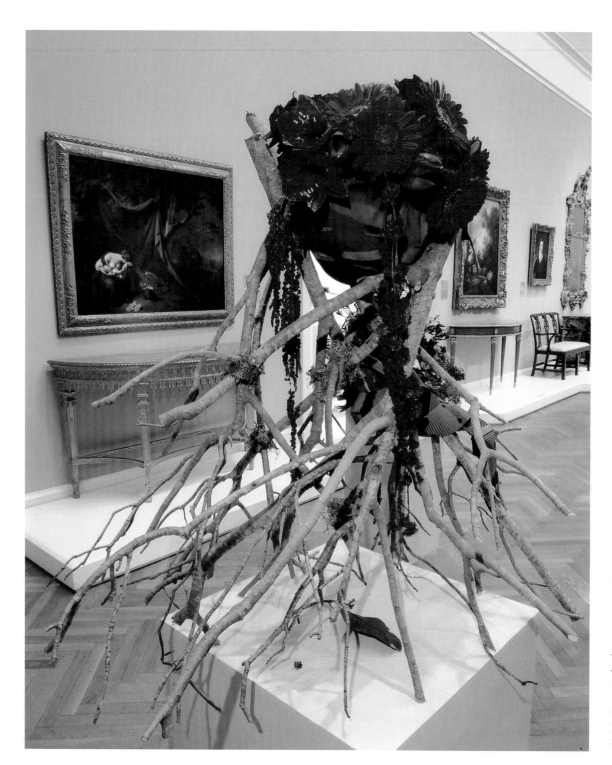

GALLERY 13
THE MARIANNE AND
RICHARD H.
PETERSON GALLERY

Joseph Wright, called
Joseph Wright of Derby
English (1734-1797)
The Dead Soldier, 1789
Oil on canvas
Museum purchase,
various sources

PICO SORIANO OF PICO SORIANO DESIGNS, Redwood Shores, CA poignantly captures the pathos and sorrow of human loss that war brings. Each component of Pico's design is a powerful element relating to both the three figures in the painting and the tragedy of war itself. The military cap and helmet used for the container represent the soldier. Red is the color of life and of sacrifice. The bright red gerbera daisies, roses, tulips, and falling amaranthus respresent the blood of every fallen soldier. With one hand on the soldier and the other on the child, the grief-stricken woman represents the country and the child the future of the country, which for both the soldier has died. Bearing the weight of humanity lost to war is a haunting tangle of branches standing for confusion, conflict, and disrepect for the dignity of life. Centuries pass and still there is conflict, war, and the painful loss of human life. Nothing has changed.

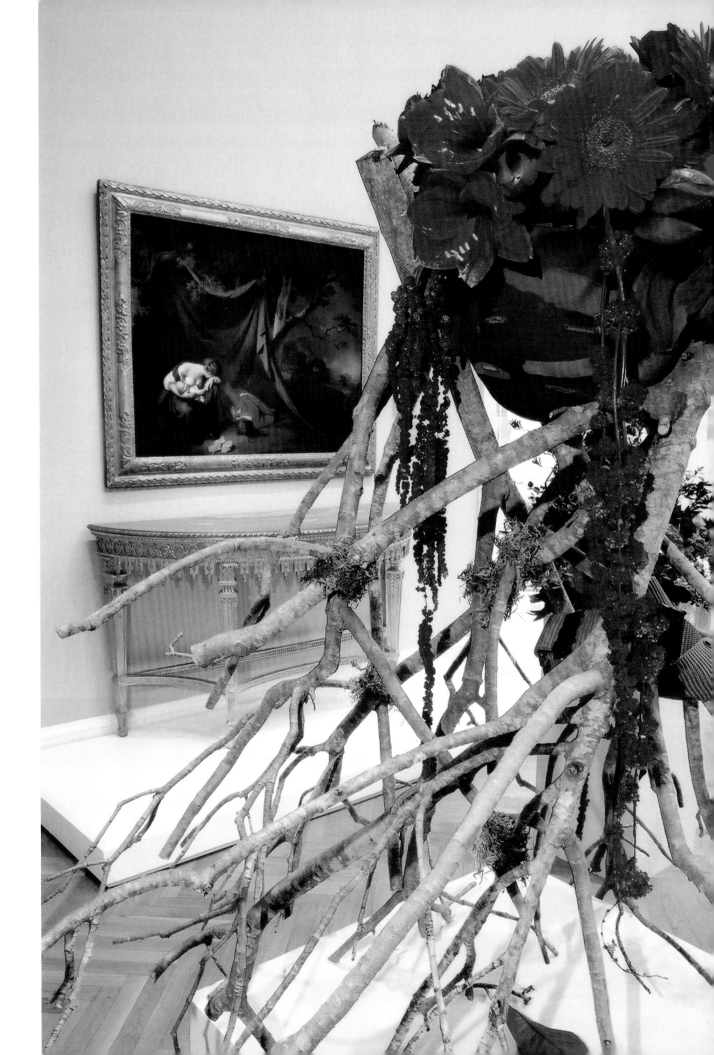

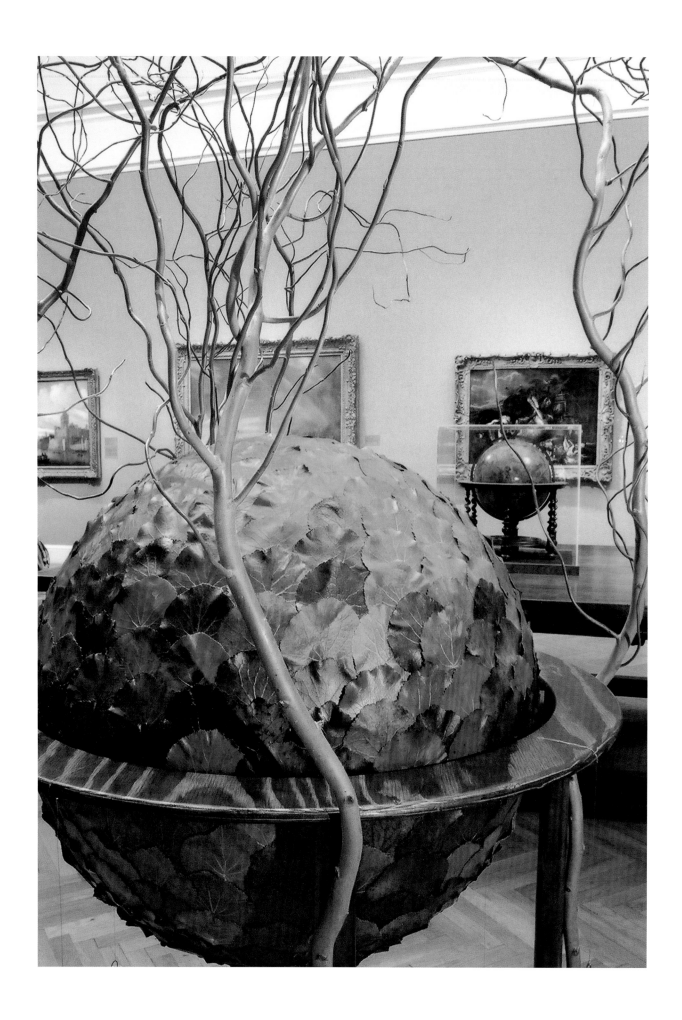

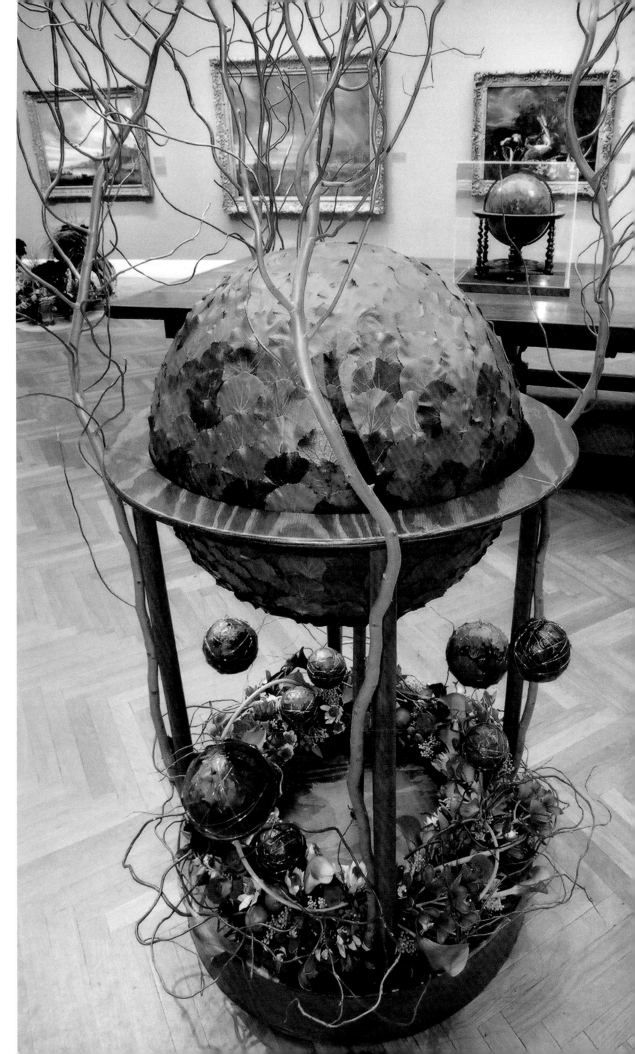

GALLERY 14
MICHAEL A. AND HANNA
NAIFY GALLERY

Terrestrial Globe
ca. 1600
Joducus Hondius
Dutch (1567-1611)
Gift of Mrs. James L. Flood

JENNY TABARRACCI, AIFD, DESIGNER AND INSTRUCTOR AT CITY COLLEGE OF SAN FRANCISCO, CA, RETAIL FLORISTRY DEPARTMENT, together with STUDENTS OF CITY COLLEGE, display the wonderful diversity of design found at *Bouquets to Art* with this impressive floral rendition of the 16th century celestial and terrestrial globes in the gallery. Resting in a hand-crafted stand made by Jenny's father, PETER D. LIND, the globe represents seeing the world from a distance. It is covered with galyx leaves, whose natural and varied tones interpret the earth's continental shapes. Calla lilies, leonidas roses, gentiana, limes, brunia, leucadendron, cymbidium orchids, and curly willow are woven into a floral ring at the base, representing the beauty and diversity of the terrestrial world. The celestial world is represented by the large curly willow branches flowing upward and branching out towards the heavens, and the small hanging globes are the planets in our galaxy.

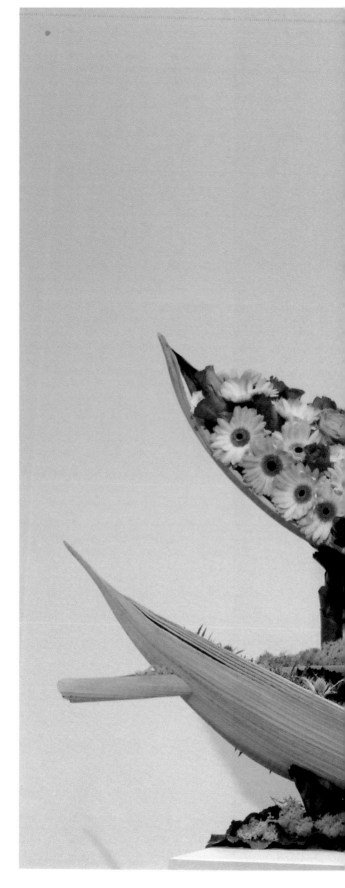

ANDERSON GALLERY OF CONTEMPORARY ART

Richard Diebenkorn (American, 1922-1993)
Ochre, 1983
Color Woodcut
Crown Point Press Archive

MICHAEL DAIGIAN OF MICHAEL DAIGIAN DESIGN, San Francisco, CA captures our imagination and attention with a contemporary design of exotic plant material and graceful movement . The large palm fronds, native to Africa, are placed in alternate positions to replicate the curvature and motion within the Diebenkorn print and depict the back and forth action of a wave at high tide. As a wave comes in towards shore and hits the rocks, it rebounds and then goes out again, going in both directions at the same time. The sturdy, wood-like fronds are filled with flowers in an order that reflect the colors of the art work from top to bottom. A profusion of color fills the top tier to brighten up the arrangement and pull together the flowers and wood: variegated gerbera daisies in colors from yellow to bursts of orange, dark red leonidas roses, and light red gypsy roses. To accentuate the peaked wave in the print, the middle frond is left almost bare, save for a small patch of club moss dyed chartreuse, while the bottom tier is filled with ocean blue erynagium thistle. The originality of the floral interpretation gives the viewer a new way of understanding and relating to both the art work and the ebb and flow of the ocean tides in the natural world.

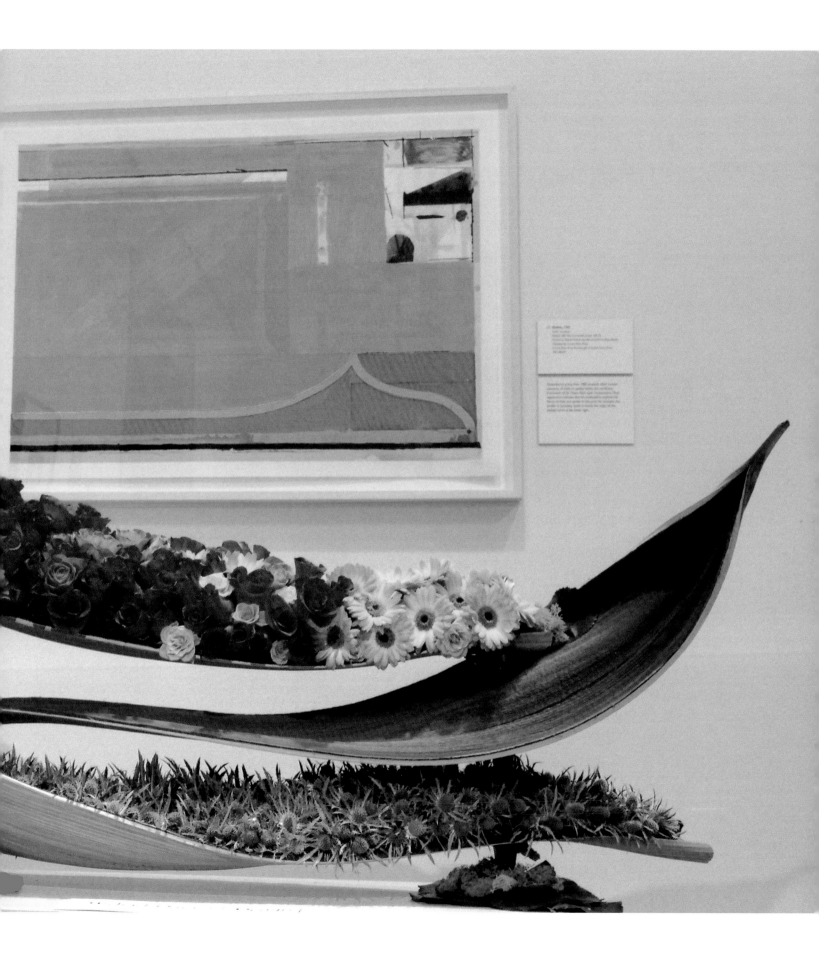

Left: *Figure of Pu-Tai (Chinese Bodhisattva)*, ca. 1765
German, Meissen Factory
Hard paste porcelain
Roscoe and Margaret Oakes Collection

Below: *Pair of Tulip Vases*, ca. 1690
Adriaenus Koeks (fl. 1687-1701)
Delft, "Greek A" Factory, tin-glazed earthenware
Bequest of Frances Adler Elkins

BESS AUSPRUNG of BESS AUSPRUNG DESIGNS, Myrtle Beach, SC gives us a delightful complement to the porcelain laughing bodhisattva in the Legion's much-loved Porcelain Gallery. A round celadon container, repeating the rotund shape of the figure, is filled with an exuberant springtime extravaganza of color and fragrance: white, peach, yellow, and lavender roses; purple iris; pink, orange, and white tulips; pink anemones; and orange and pink ranunculus. The roundness of the tightly packed bouquet and the joyful feeling such a profusion of flowers elicits is the perfect companion to the happiness expressed in the jovial and rotund *Pu-Tai*.

2003

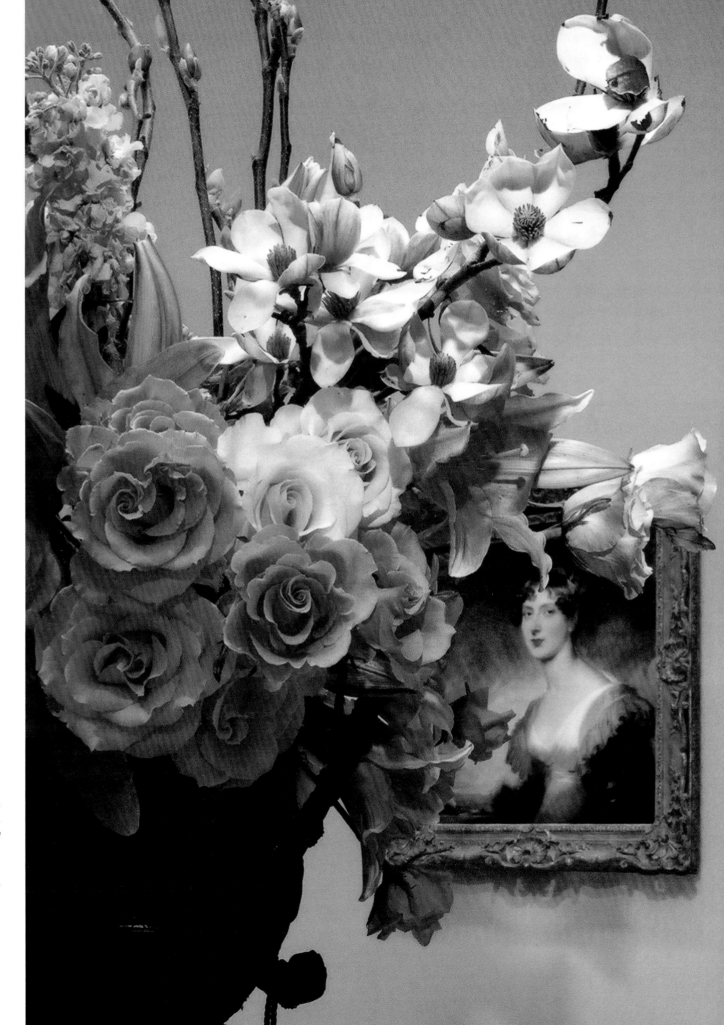

And I will make thee
a bed of roses
and a thousand
fragrant posies.

Christopher Marlowe

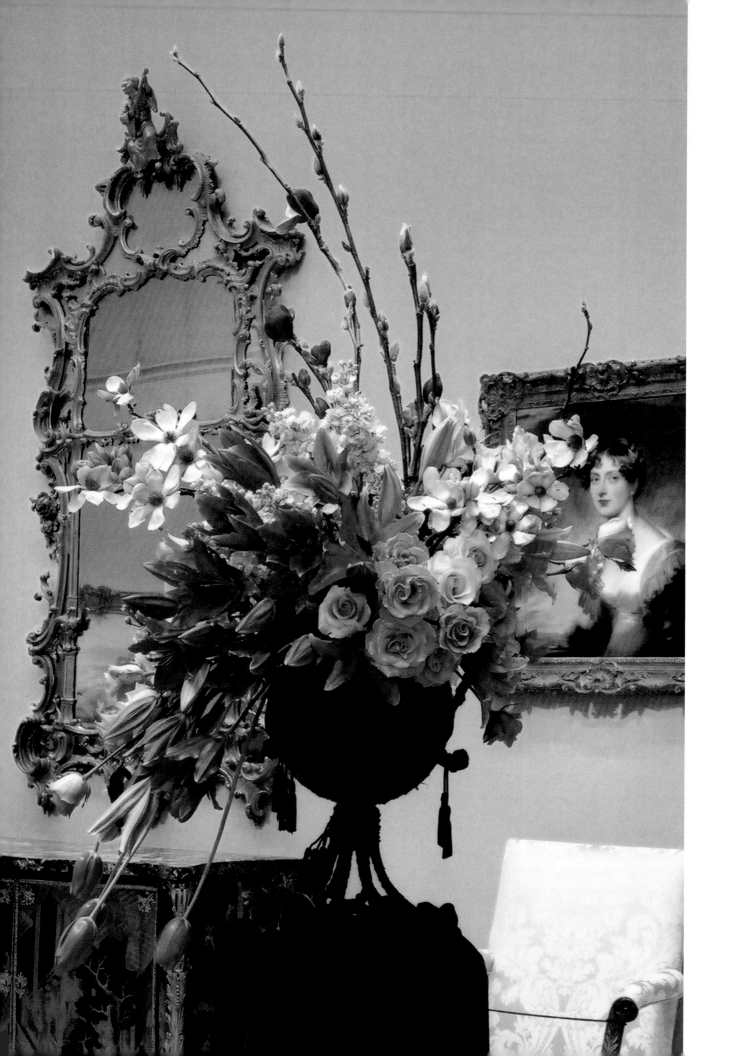

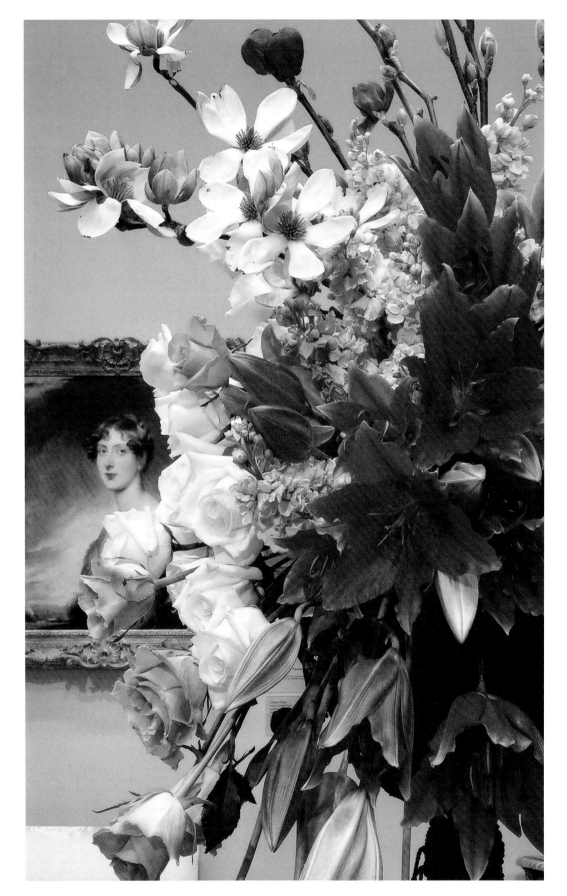

GALLERY 13
THE MARIANNE
AND RICHARD H.
PETERSON GALLERY

Sir Thomas Lawrence
English (1769-1830)
Mary, Countess of Plymouth
ca. 1817
Oil on canvas
Bequest of
Donald McLeod Lewis
in memory of
Mabelle McLeod Lewis

Pier Glass, ca. 1760
Saint Giles House, English
Gilded wood and glass
Gift of Mr. and Mrs.
Robert A. Magowan

KIWI DEVOY OF DEVOY DESIGNS, Atherton, CA captures with color and graceful exuberance the soft feminine beauty and aristocratic nature of the countess. Using roses, magnolia, tulips, Asiatic lilies, and stock in shades of creamy pink to rich burgundy, Kiwi succeeds in the challenge of presenting feminine colors and qualities with visual strength, weight, and movement. The soft sweetness and creamy complexion of her face, the rich coral of her lips, and the delicate nature of her shawl are all reflected in the palette of colors; however, the strong lines and fluidity of movement give the arrangement a strength and presence that is securely grounded through both the design and the silk-wrapped iron pedestal container. One might say that Kiwi has succeeded in creating "an iron hand in a silk glove" arrangement.

ALEXANDER AND JEAN DE BRETTEVILLE COURT OF HONOR

Opening Night Gala , March 13,, 2002
Under the Tent

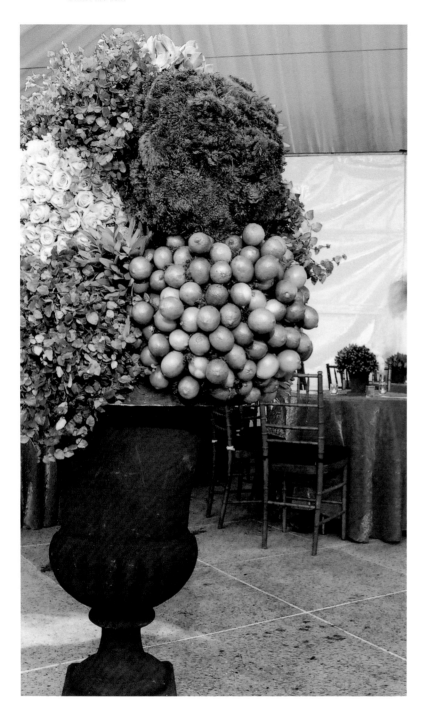
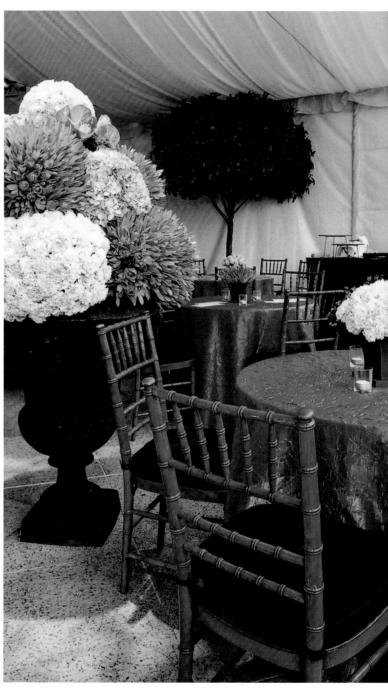

KATHLEEN DEERY OF KATHLEEN DEERY DESIGN, San Francisco, CA transforms the Court of Honor, tented for the 2003 *Bouquets to Art* Gala Opening Night Preview Party, into an elegant topiary garden. Returning from a recent trip to Europe, Kathleen was influenced by the grand gardens of England and France with their edgy and soft elements of design. Rusty metal urns hold massive and compact globe-like clusters of leucodendron, limes, green

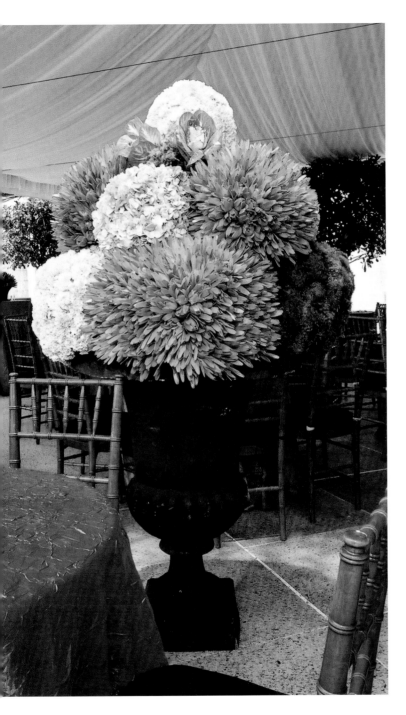

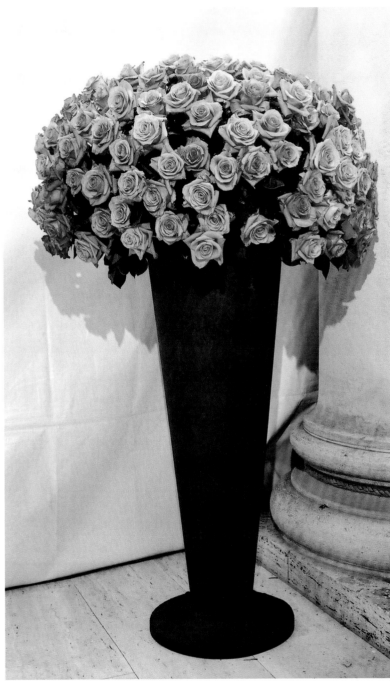

hydrangea, green roses, jade and emerald roses, mini kale, and varieties of sphagnum and mood mosses. Repeating the rich burnt-orange color of the table-cloths, a huge bouquet of melva roses sits atop a large rusty metal cone at the entrance to the Court. By using a monochromatic color palette, the topiaries provide a relaxing and natural atmosphere and yet are also strong and impressive in color, texture, and form.

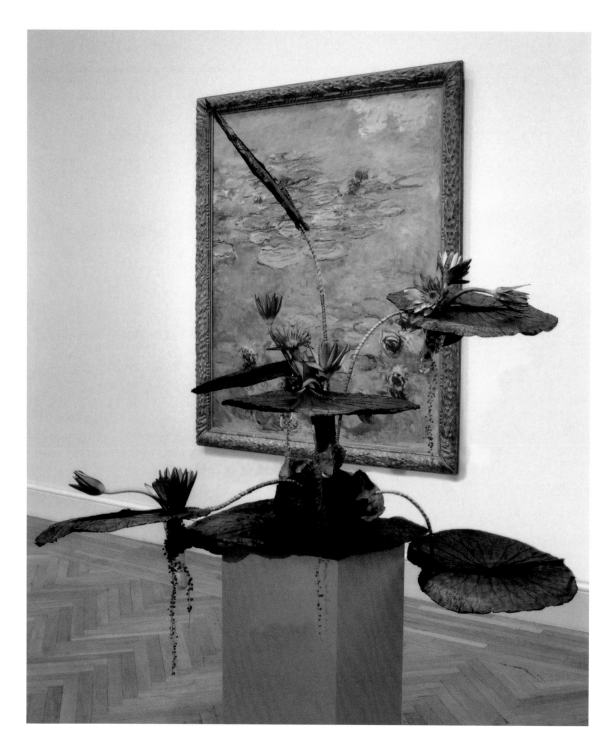

KELLY CARR OF TRILLIUM DESIGNS, San Francisco, CA creates a three-dimensional illusion of water lilies gently floating in space as if on water. A three-tiered pedestal of giant lily pads with pliable rod stems, twisted for shape, gracefully sweep outward and upward. Pink and lavender-blue New Zealand water lilies rest on the leaves with string-of-pearls roots dangling down. Capturing the color, movement, and watery feeling of the painting in her design, Kelly's work becomes at one with the ethereal beauty of Monet's *Water Lilies*.

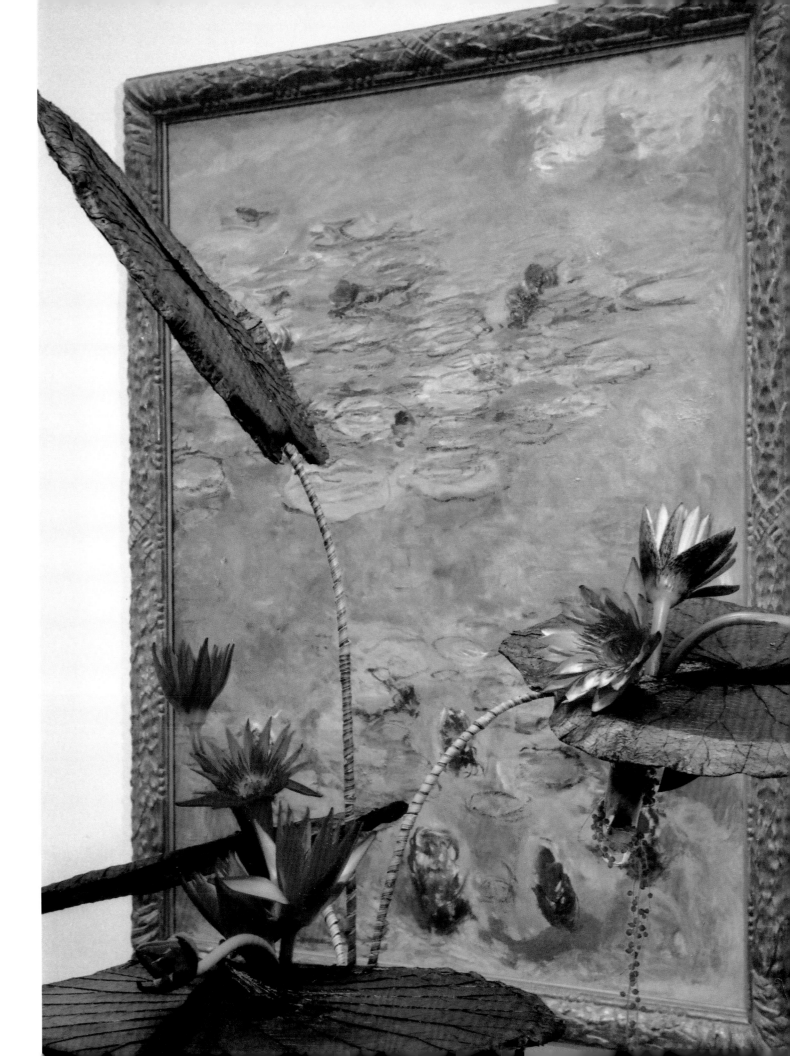

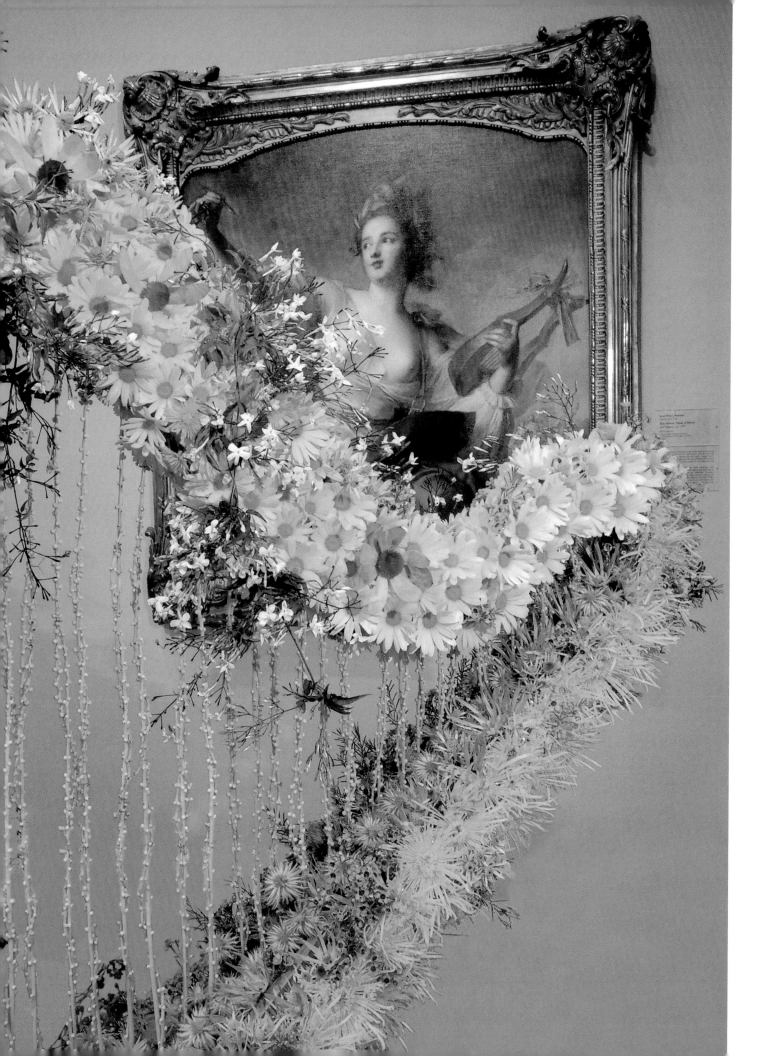

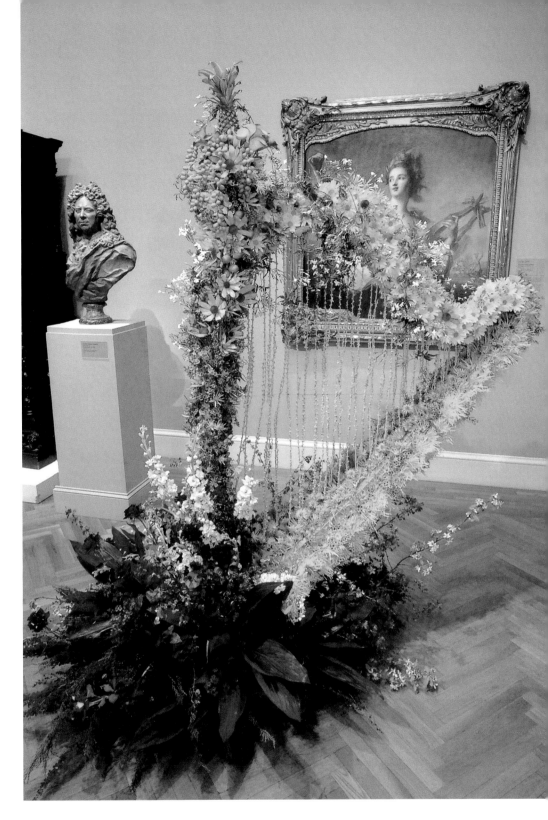

GALLERY 7
THE ROBERT DOLLAR GALLERY

Jean-Marc Nattier, French (1685-1766)
Terpsichore, Muse of Music and Dance, ca. 1739
Oil on canvas
Mildred Anna Williams Collection

SHANNON PATILLO AND TRISHA OLSON OF GOLDEN GATE INTERIORS, Sausalito, CA create a full-size floral harp to complement the beautiful *Terpsichore*. The angle of her pose lent to the shape of the harp, an instrument whose form and size make for a bold and elegant statement. Replicating a golden harp in the painting's distant landscape, the frame is composed of an array of yellow flowers interspersed with soft pink wax flowers, jasmine, marguerite daisies, spider chrysanthemums, date palm clusters, and calla lilies, and topped with a pineapple finial. Golden strings of female date palm complete the floral ensemble. Opposite in color to the yellow-gold of the harp, the base is done in a profusion of dark red plant material accentuated with white dendrobium orchids and delphinium. Ruby ti leaves, black magic roses, and heather reflect the red drapery of the muse's skirt and form a solid and beautiful base for this magical harp that awaits the muse's hands.

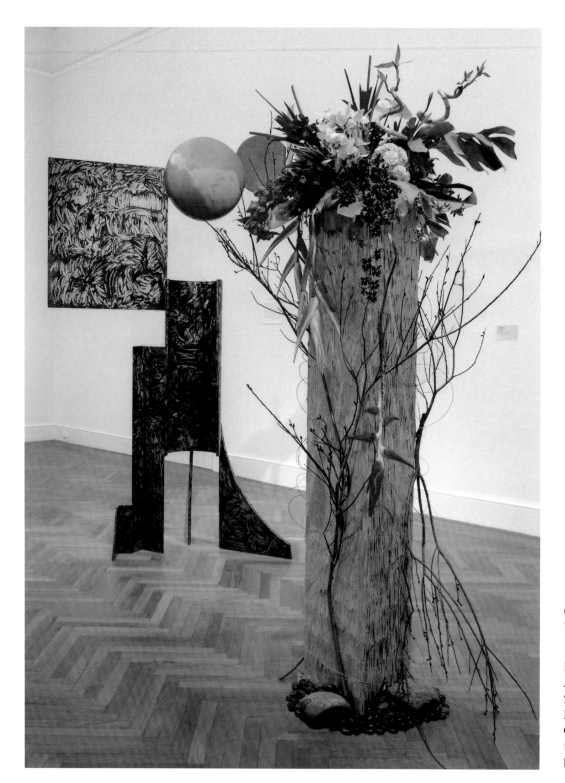

GALLERY 19
THE EDWARD E. HILLS GALLERY

David Smith, American (1906-1965)
Zig V, 1961
Steel and automotive paint
Museum purchase
Gift of Mrs. Paul L. Wattis
©Estate of David Smith
Licensed by VAGA, New York, NY

KYOKO MANABE, AIFD, assisted by YUMI TAKENAKA, AIFD, and CHIZURU INOUE, AIFD, of INOUI FLORAL, Burlingame, CA were inspired by the texture and geometric forms of David Smith's sculpture. Relating to the strong, grounded feeling of the art work, the designers first put emphasis on the stand, which is covered in silver protea, creating shine and texture. With that forming the foundation of the design, the arrangement fell into place. A mass of cymbidium orchids, banana flower, lucky bamboo, obake anthuriums, kale, and monstera leaves flows downward from the top, complementing the volume of the sculpture. Giant heliconia falling downward and branches of red willow sweeping both upward and downward are a very creative reference to the visual contradictions of balance in the art work.

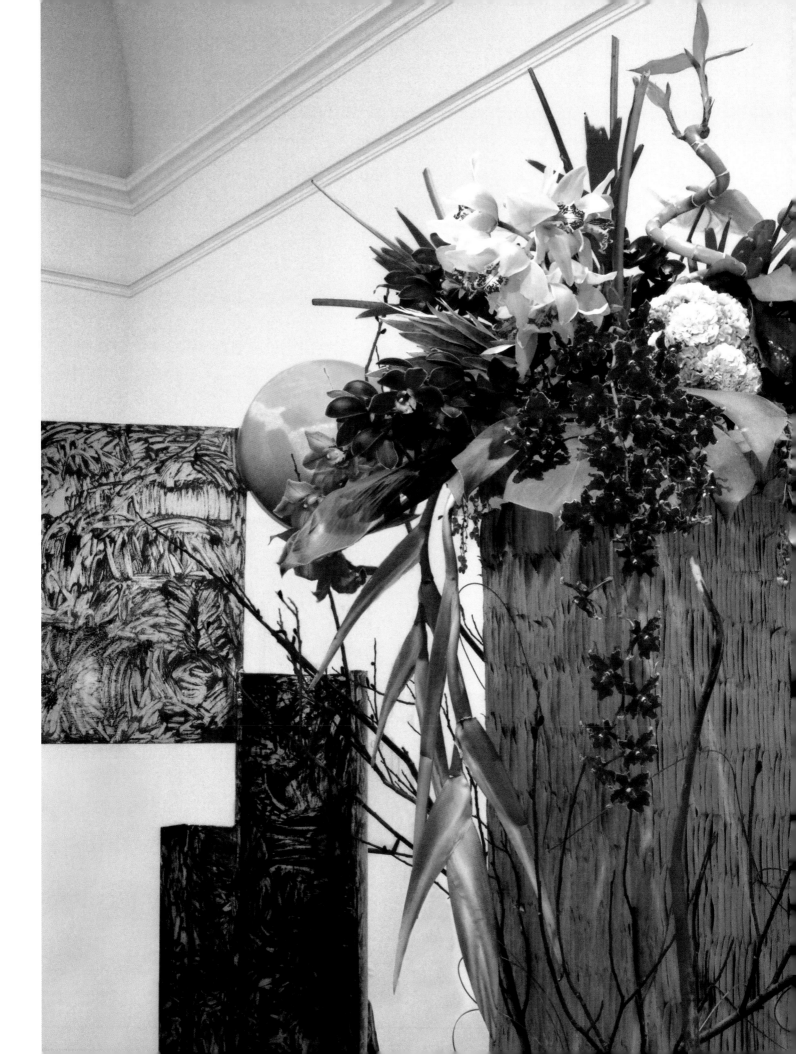

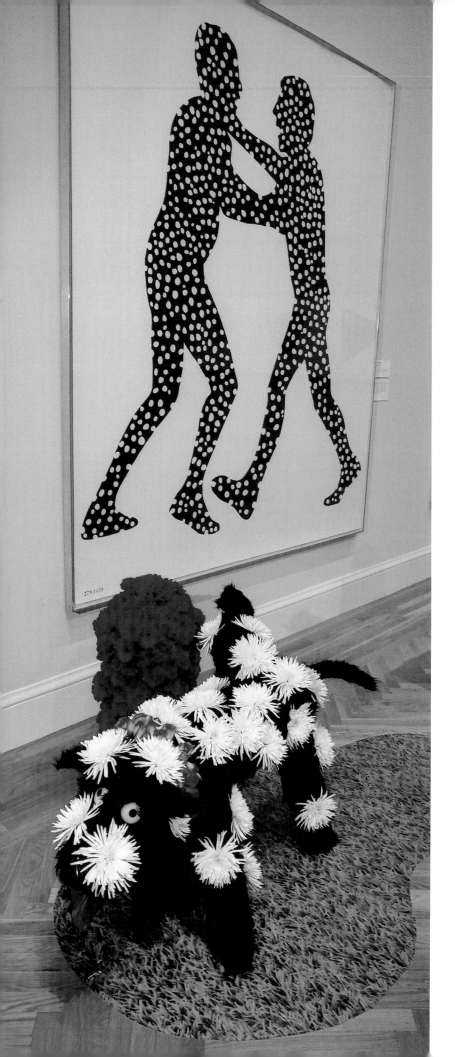

GALLERY 1
ANDERSON GALLERY
OF CONTEMPORAY GRAPHIC ART

Jonathan Borofsky, American, b. 1942
Molecule Men, 1982, screen print
Anderson Graphic Arts Collection

WILSON MURRAY OF MOLECULES, San Francisco, CA, was unquestionably drawn to this work that carries his name. Intially viewing the two men in conflict, Wilson thought of a park as the place of resolution of their differences, hence the addition of a common park visitor, the friendly dog. Once the park theme had been created, the two men were also viewed in a different light, as two friends meeting in the park for a friendly visit. The little dog with spider chrysanthemum spots and red rose collar is obviously unperturbed, casually relieving himself, as dogs will do, on a red gerbera daisy fire hydrant! As viewers passed, his mechanical tail would give a happy wag. The Italian glass "molecule" bowl was a marvelous contrast to the whimsical dog. Inside was a delicate and intricately arranged tiny garden of flowers, making a strong theme statement with a miniature presentation. The two exhibits were a delight and a wonderful example of the diversity of creative talent and imagination that make *Bouquets to Art* so unique.

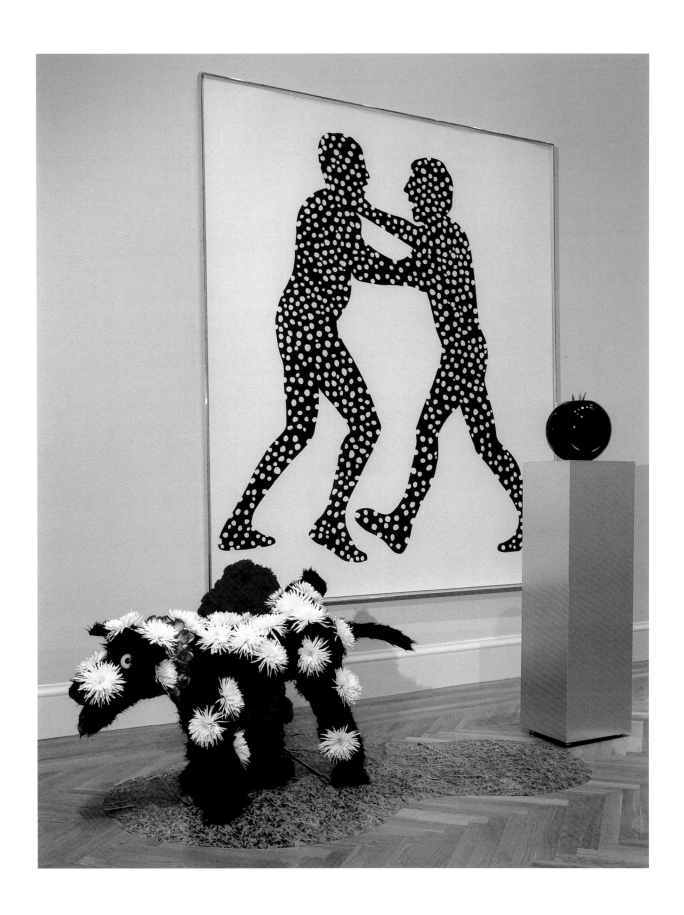

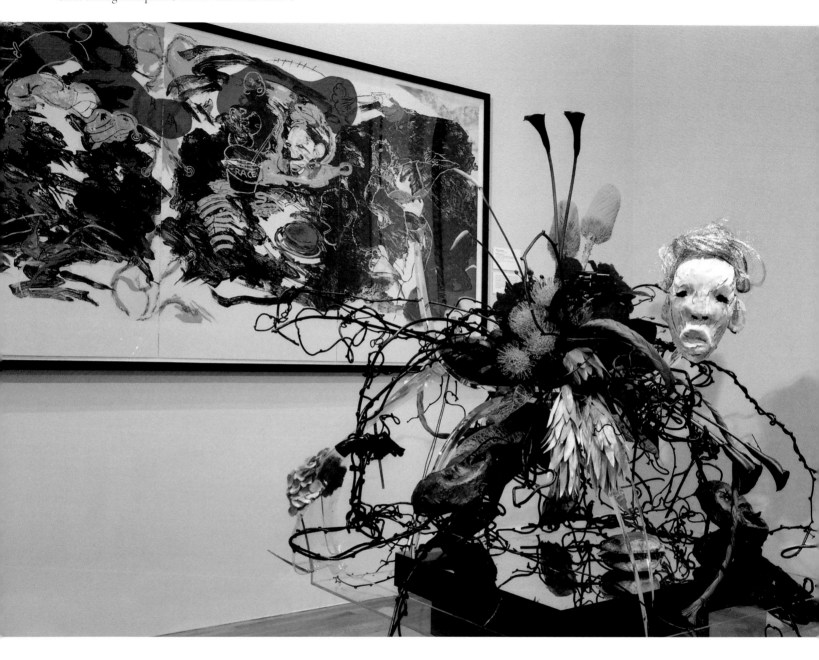

Constance Oakson of Flora, Floral Artisans Studio, Menlo Park, CA creates a powerful social dialogue relating to the factors of contemporary life with this provocative floral interpretation of contemporary artist Robert Colescott's *Ponchartrain*. Her objective was to capture the essence of anger and upheaval expressed in the art work. Guns, sex, fast food living, a paint can spilling blood - all reveal the energy and strife of modern life. The artist, originally from Oakland, CA, moved to the French Quarter in New Orleans, its cultural aspects addressed through the voodoo masks recreated in the floral design under a cover of silver brush and galyx leaves. Reflecting the strong black strokes of the art work, black-painted kiwi branches intertwine and connect all the floral elements: silver brush, a variety of protea, dark burgundy calla lilies, tea leaves, amaryllis, and hypericum berries; orange and red banskia; silvertree leucodendron and braided African steel grass; portobello mushrooms for hamburgers; orange parrot tulips; and star 2000 roses. Resting on a base of alternating tiers of black and clear acrylic, the multitude of diverse elements all work together to express the rawness of the print.

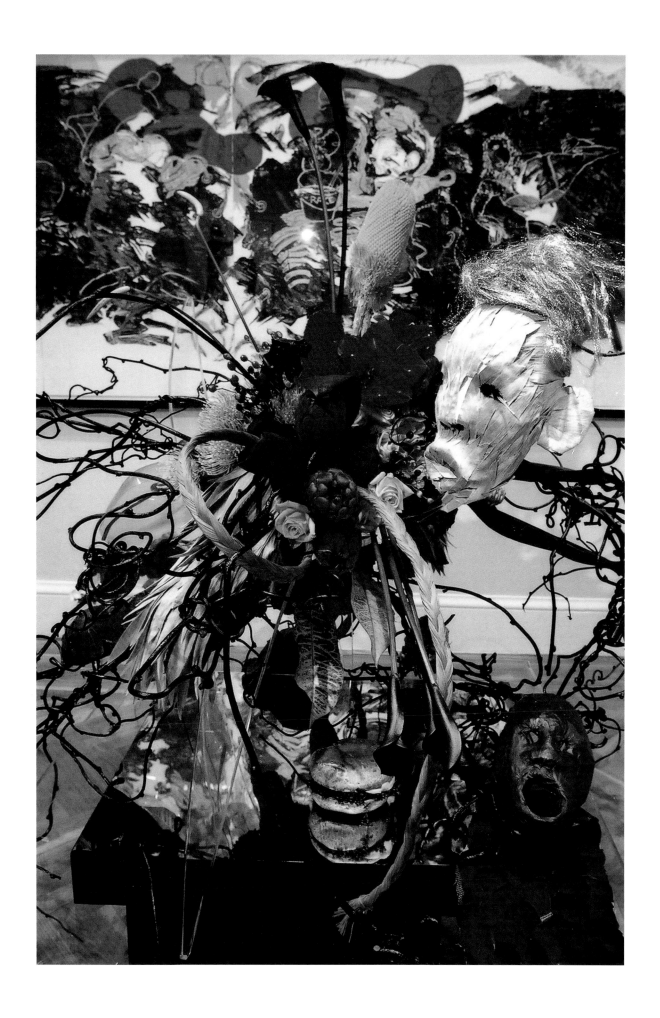

GALLERY 12
WALTER AND PHYLLIS SHORENSTEIN COURT

Mexico or Guatemala, southern lowlands, Late Classic Maya
Stela with Queen Ix Mutal Ahaw, 761
Museum purchase, gift of Mrs. Paul L. Wattis

GALLERY 1
PHYLLIS C. WATTIS WING
Stela with Queen Ix Mutal Ahaw, now at the de Young

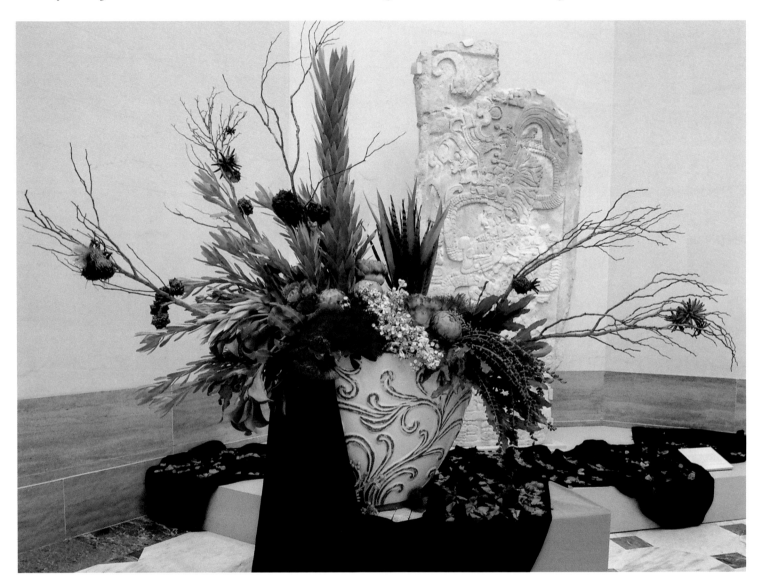

LEIGHSA SMYSER OF BRANCH OUT, San Francisco, CA emphasizes the solid, grounded strength of the huge Mayan sculpture with a large array of plant material and flowers, many native to the Yucatan Peninsula. A large glazed ceramic urn, with scrollwork that echoes the movement in the sculpture, is filled with strong vertical stalks of silver leaf, leucodendron, flax, eucalyptus pods, and a mass of colorful pheasant feathers. Clustered densely, and forming the foundation of the arrangement, are pincushion protea, imported calla lilies, gerbera daisies, artichokes, and star eucalyptus. Large philodendron leaves cascade downward, cradling a mass of date branches. Dark fabric flowing out of the container and scattered with rose petals meanders across the floor like a river or pathway, working its way through the land to the queen's throne and emphasizing the earthiness of the art work and floral design.

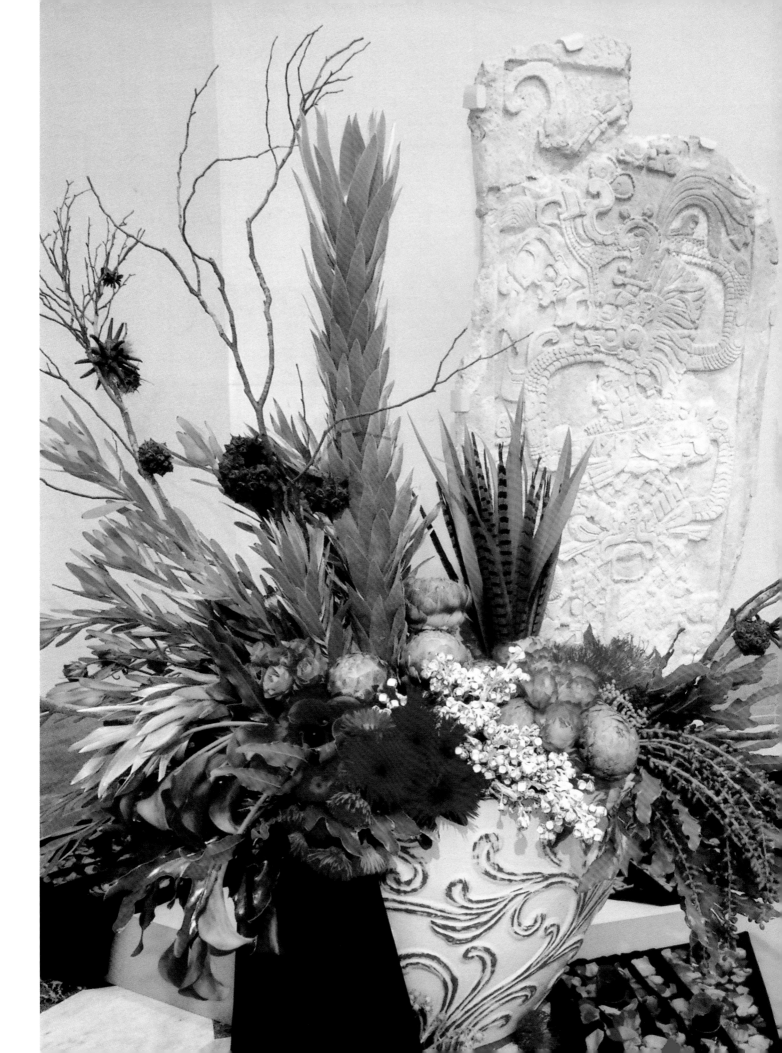

2004

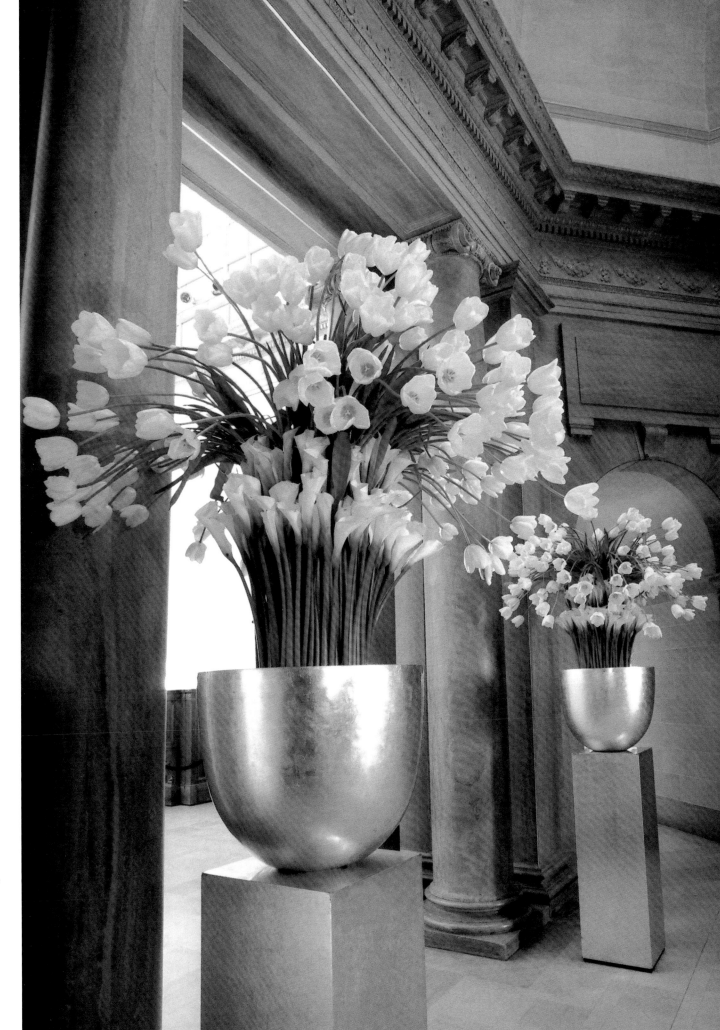

*See how the flowers
as at parade
under their colors
stand displayed.*

Andrew Marvel

Victoria and Albert Museum, London
Oliver P. Bernard, British (1881-1939)
Partial reconstruction of the foyer of the Strand Palace Hotel, London, 1930-1931
Glass, marble, metallic mounts and fixtures
V&A: Circ. 758-1969

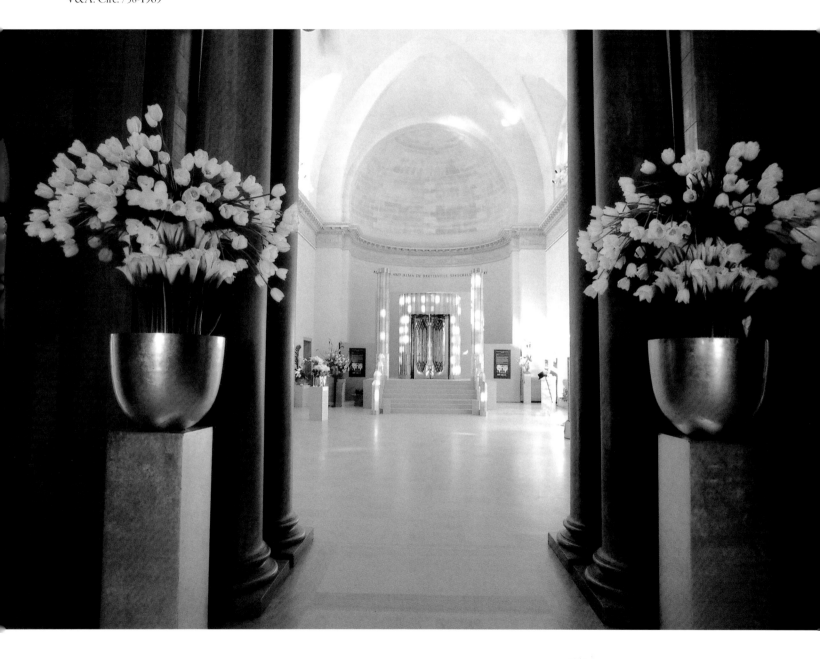

ARLENE BOYLE OF VIOLETTA, San Francisco, CA and ISABELLA BOYER-SIKAFFY OF FLORABELLA, San Mateo, CA grace the rotunda with a stunning matching pair of silver metallic Art Deco containers bursting with a profusion of white French tulips surrounded by a collar of white calla lilies. Working off the clear white glass of the Art Deco entrance to the Strand Palace Hotel, the designers chose to use no greenery. The white flowers, with their strong bold lines, stand on their own and form an elegant contrast to the silver containers. As people entered the rotunda, the pair presented the perfect complement to the masterpiece of Art Deco at the end of the gallery.

MANISSE NEWELL OF MANISSE DESIGNS, Hillsborough, CA creates a sparkling "evening out at the Strand," a marvelous tribute to the Legion's Art Deco exhibit on display during *Bouquets to Art* 2004. Capturing the elegance of the glittering glass *Foyer of the Strand Palace Hotel*, a large silver pedestal urn holds a lavish display of all-white flowers: tall gladioli and calla lilies are surrounded by tiers of Casablanca lilies, creamy white polo roses, and dendrobium orchids. A black top hat, cane, white gloves, and sparkly purse rest on Art Deco glass cubes set atop a multicolored Art Deco pedestal. Early morning light captures the drama and beauty of the memorable night before.

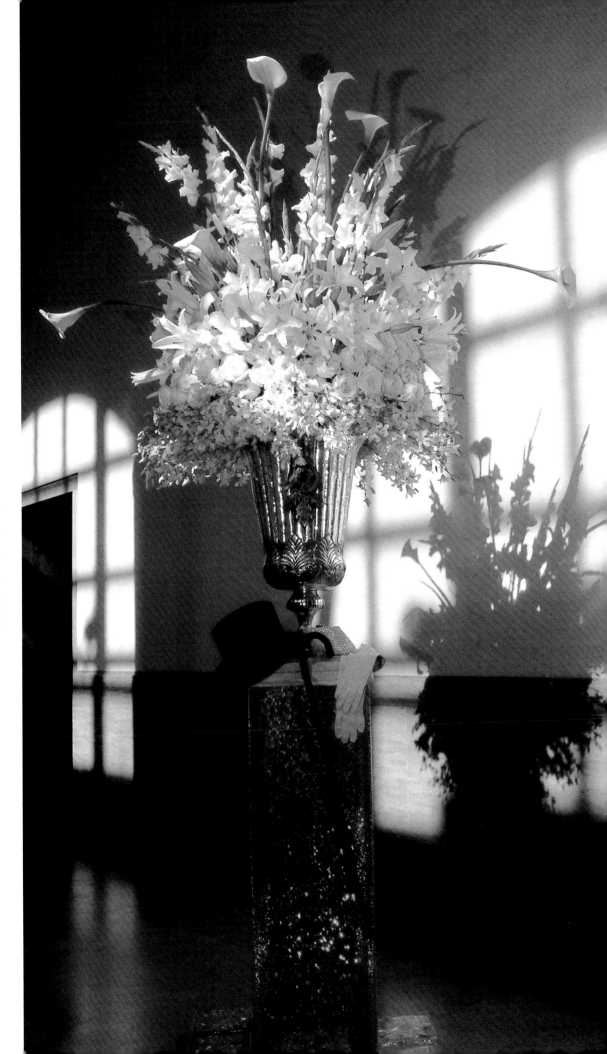

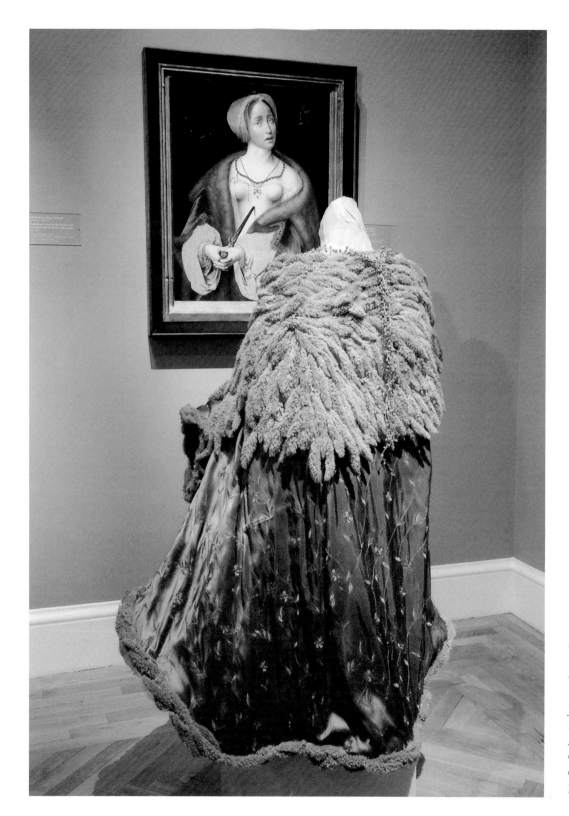

GALLERY 3
HELENE IRWIN FAGAN
GALLERY

Joos van Cleve
Flemish (1485-1540)
Lucretia, ca. 1525
Oil on panel
Gift of the M.H. de Young
Endowment Fund

KELLY CARR OF TRILLIUM DESIGNS, San Francisco, CA, inspired by Lucretia's cloak, creates her own replica as if it were an actual museum piece on display. Draping the cloak over a bodice of bleached eucalyptus leaves with a necklace of string-of-pearls, Kelly emulates the draping of the painting's cloak and captures the feeling of Lucretia actually wearing it. Iridescent printed silk in rich orange-gold, with a wide fur collar

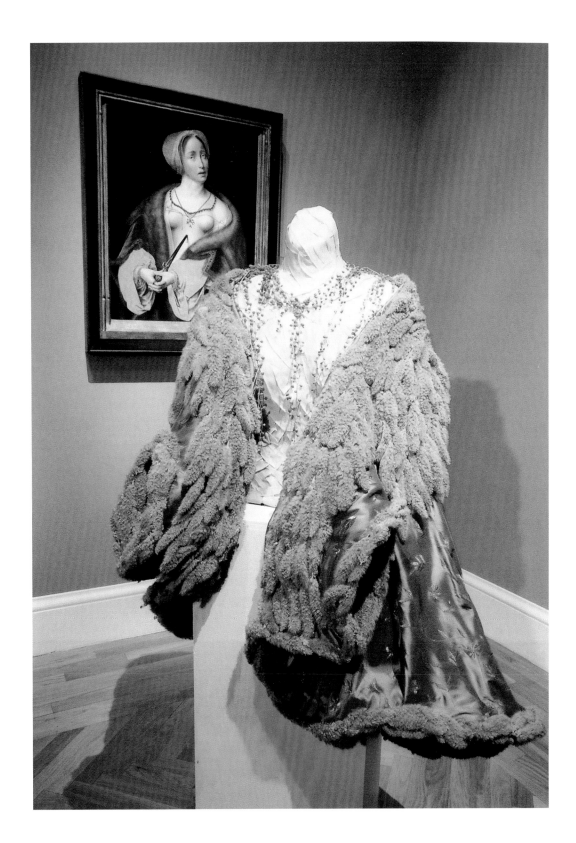

and trim of setaria grass, reflects the color and texture of the painting's cloak. The front and back views reveal the wonderful sense of movement achieved, and we are able to delight in the illusion of Lucretia walking by in her finery.

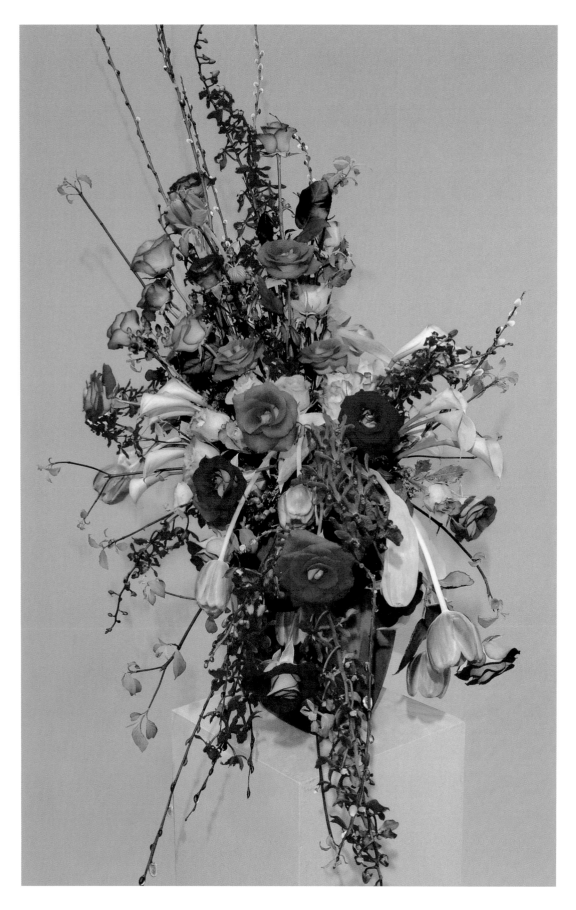

Thomas Gainsborough
British (1727-1788)
Samuel Kilderbee of Ipswich,
ca. 1755
M.H. de Young Endowment Fund

WENDY MORCK OF WENDY MORCK
DESIGN, Redwood Shores, CA was mainly
inspired by Gainsborough's use of color in
the painting. The man's rich velvet orange
collar and the colors of the dog and sky set
the theme for the orange/peach/cream col-
or palette. Vibrant leonidas roses; variegat-
ed gypsy curiosa roses; apricot roses, tulips,
and calla lilies; spider orchid (arachnis);
hypericum berries; and tall pussy willow
branches are arranged in a sweeping flow,
opening upward into a crescent form, giv-
ing full expression to the "Hogarth Curve,"
or the "line of beauty" as it has come to be
known. The great 18th century artist, Wil-
liam Hogarth (1697-1764) considered the
S-curve or sweep to be the most beautiful
and used it throughout his work. Over the
years, it became the classical foundation
for fine floral design and so was called the
"Hogarth Curve." It is this style that Wendy
uses in her work. Using the S-curve to full
advantage, she is careful not to obstruct
the dog's head, but instead uses the line to
frame it. Making a strong statement and
balancing the vivid arrangement is a glazed
black pottery vase that complements and
balances the design with the man's black
coat in the painting.

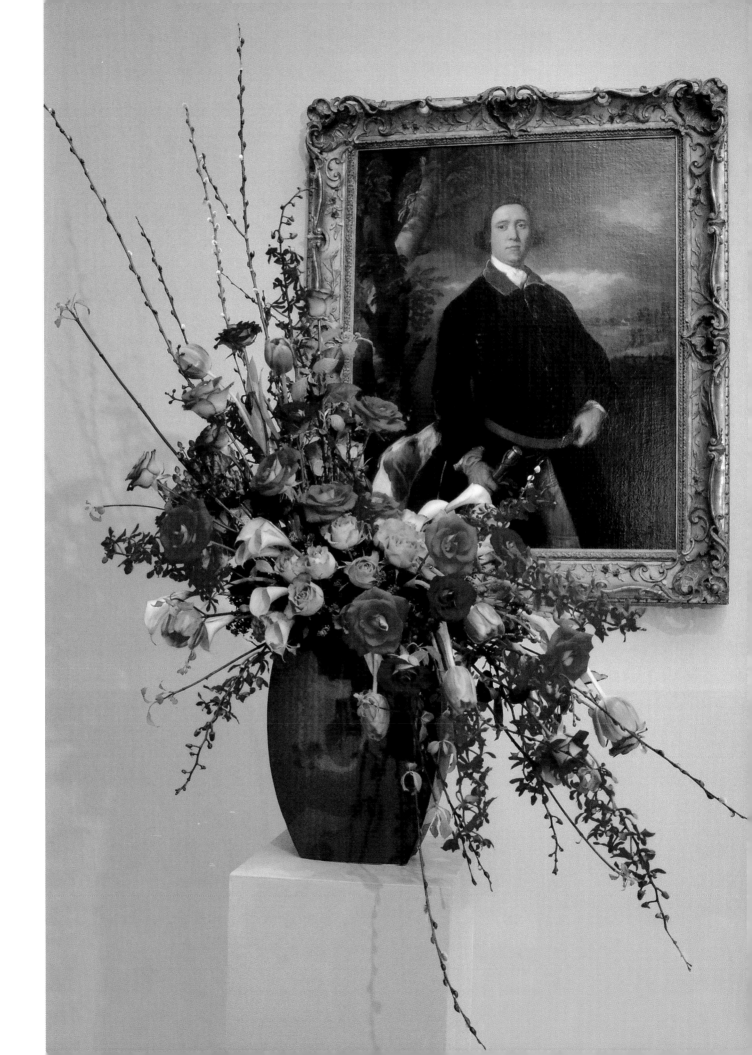

George II Sofa, ca. 1760, William Vile, English (d. 1767)
Carved mahogany and green silk damask upholstery
Museum purchase, M.H. de Young Trust Fund, upholstery donated by Judge Irwin Untermyer

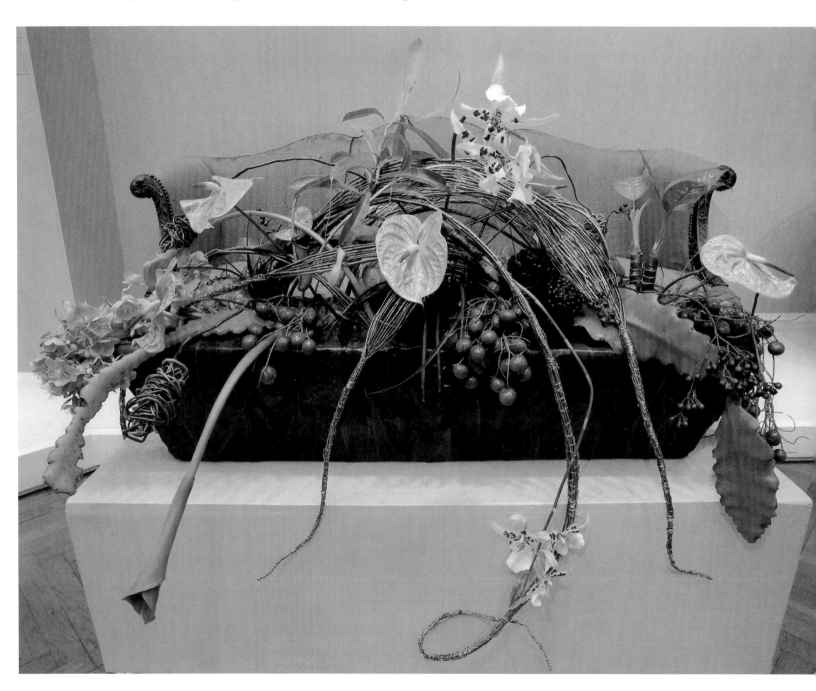

JENNY TABARRACCI, AIFD, DESIGNER AND INSTRUCTOR AT CITY COLLEGE OF SAN FRANCISCO, San Francisco, CA, AND HYUK SANG SEO, AIFD, Korea were drawn to the sofa's rich green fabric and the graceful simplicity of its design for their inspiration. Using willow branches and gold wire, the carved wood and graceful lines of the sofa were artfully replicated by the floral techniques of plaiting and wrapping. The palm trees in the sofa's fabric print inspired

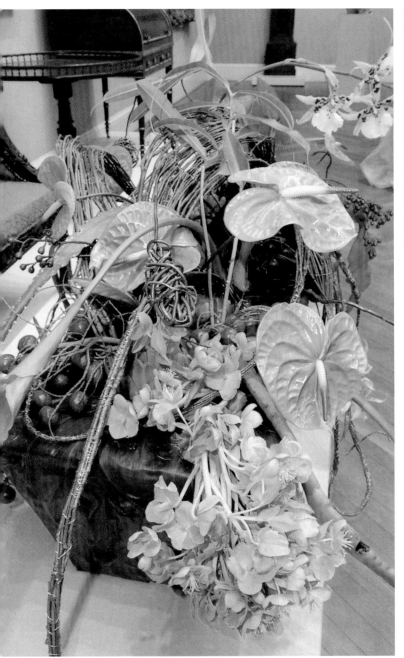
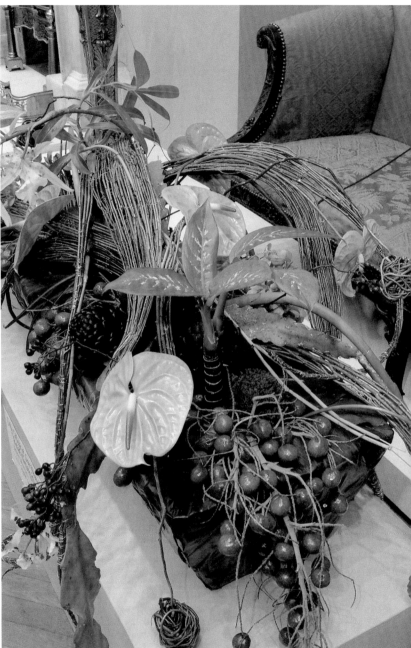

the designers to use exotic plant materials in varying shades of green and earth colors, creating the magical illusion of a tropical rainforest exploding with orchids, anthuriums, helleborus, dates, pods, artichokes, ti leaves, dieffenbachia, nepenthes, selaginellas, bromeliads, and cactuses. The arrangement was designed low and horizontal to complement the length and height of the sofa and to allow the viewer to look down into the exotic imaginary forest.

François Boucher, French (1703-1770)
*Vertumnus and Pomma,*1757, Oil on canvas
Museum purchase, Mildred Anna Williams Collection

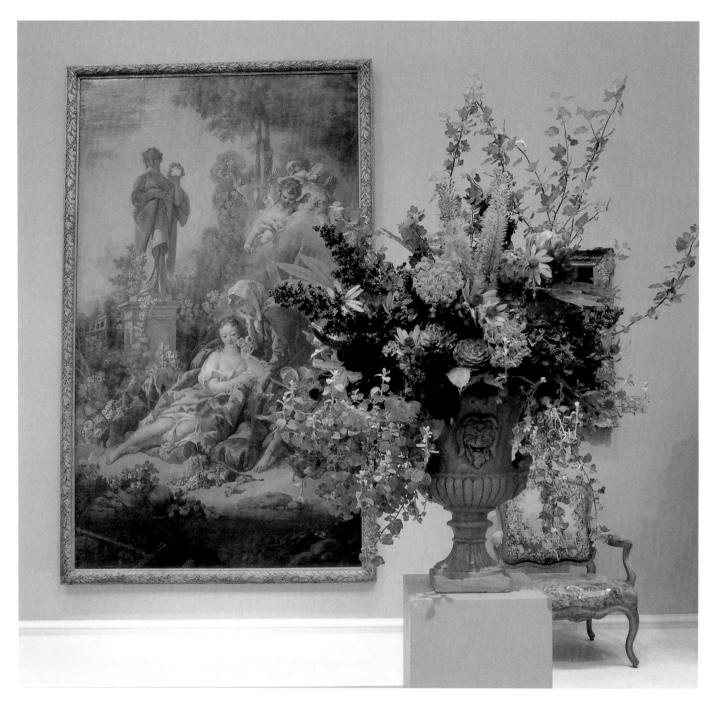

THOMAS TEEL OF CHURCH STREET FLOWERS, San Francisco, CA created this luxuriant floral tapestry with a host of California natives, most of which came from his own and other local gardens. While the painting's garden setting was the main inspiration for the arrangement's lush garden look and the people a more secondary element, Thomas succeeds in creating a symphony of color that echoes the entire painting. Tall gooseberry branches, delicate blue California ceanothus, eremerus, dahlias, euphorbia, licorice plant, clivia, and Tom Pouce Oriental lilies combine to create the richly textural tapestry of flowers. Leucodendron is a whimsical reference to the cherubs, and the succulent strength of echeveria gives structure to the design. A beautiful classic terracotta garden urn holds the lavish bouquet that gracefully sweeps upward at a parallel angle complementary to the painting.

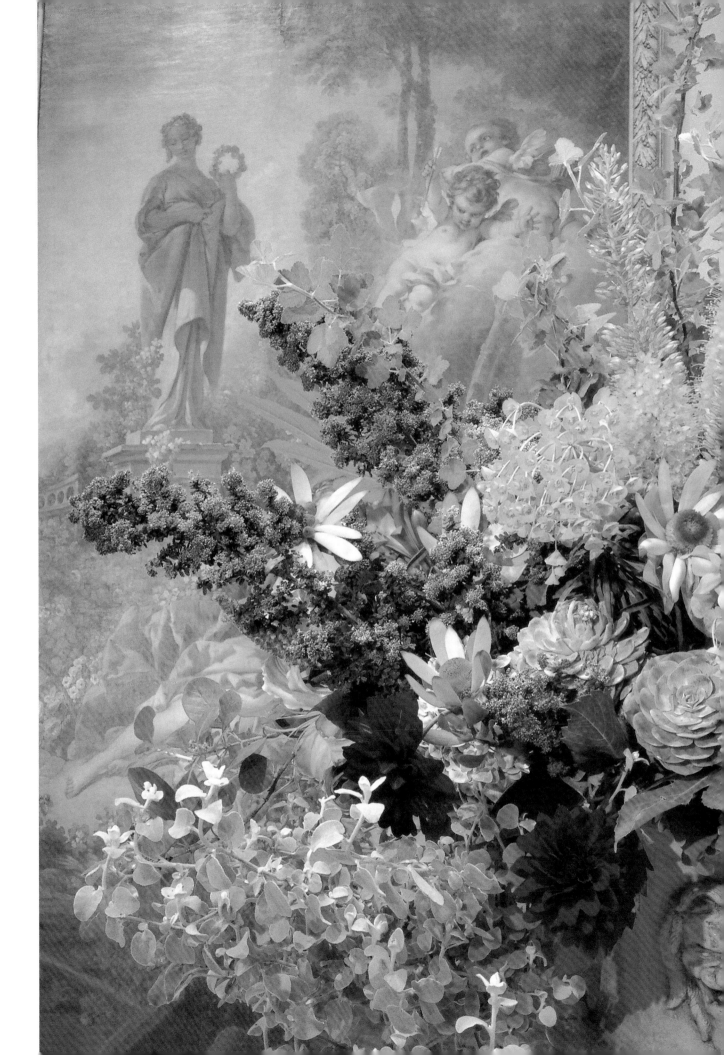

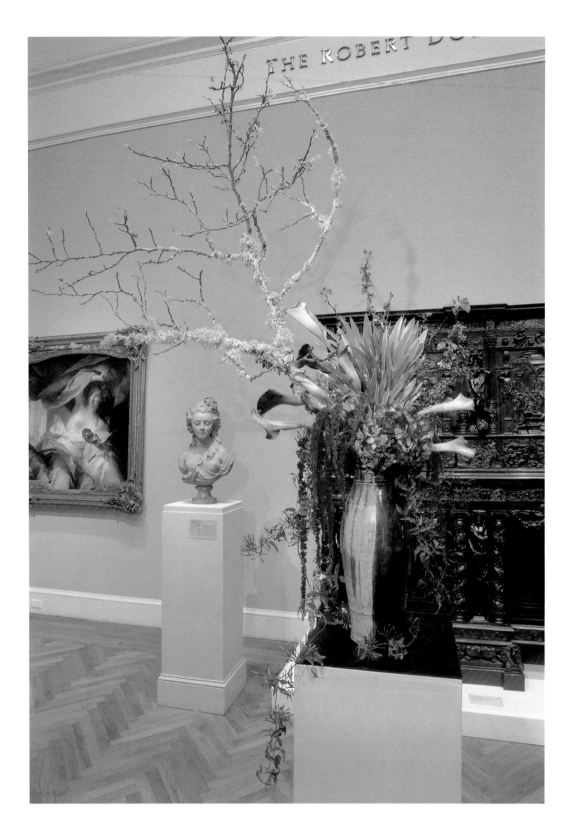

GALLERY 7
THE ROBERT DOLLAR
GALLERY

Jean-Jacques Caffieri,
French (1723-1792)
*Portrait of a Woman
(Marie Anne de Camargo)*, ca. 1770
Terracotta with marble base
Gift of Archer M. Huntington

Cabinet on Stand, ca. 1650
Pierre Gole, French (ca. 1620-1684)
Ebony
Gift of William Randolph Hearst

PHOEBE KAHL AND DIANA KENNEDY OF THE ORINDA GARDEN CLUB, CA, GCA, Orinda, CA mirror the strength and elegance of the black ebony cabinet and also provide a lovely cameo for the terracotta bust with this beautifully designed arrangement. Soft rose-colored hydrangea, calla lilies, and argenteum are clustered around silvertree leucodendron with jasmine and red amaranthus cascading downwards. A tall, strong redbud-cercis branch covered in bluish lichen soars above the flowers and foliage to complement the tall, handsome glazed ceramic container by Lafayette, CA artist EMANUEL ROSENHEIM, which together give the final element of pizzazz to the arrangement.

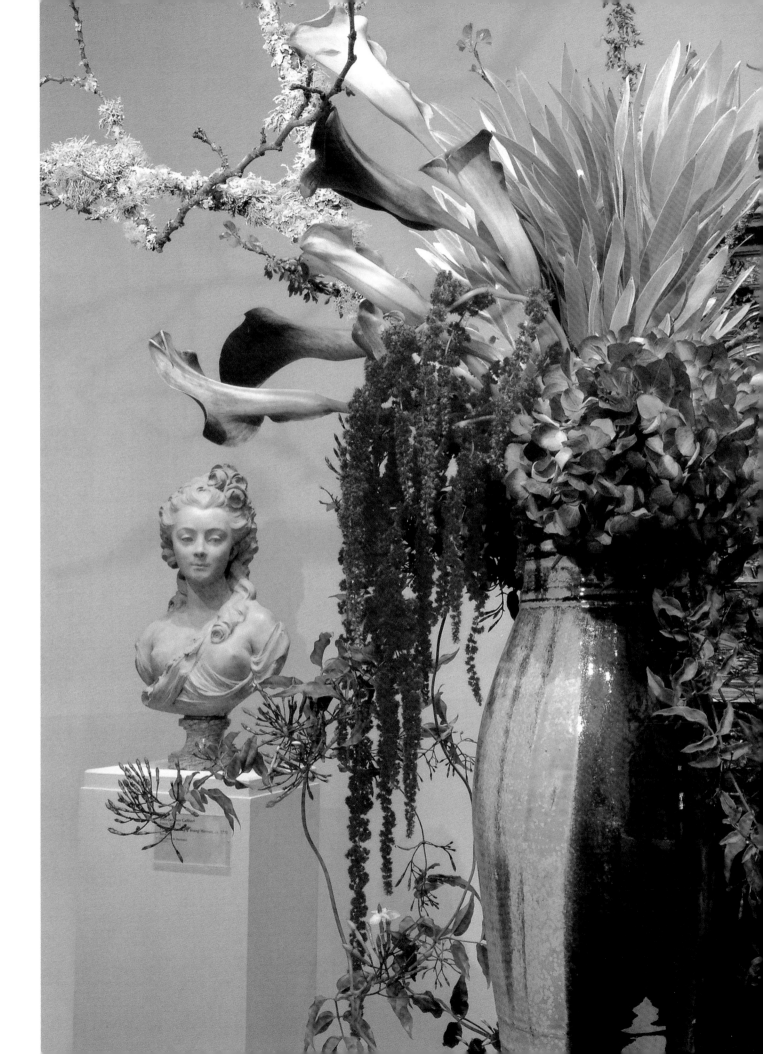

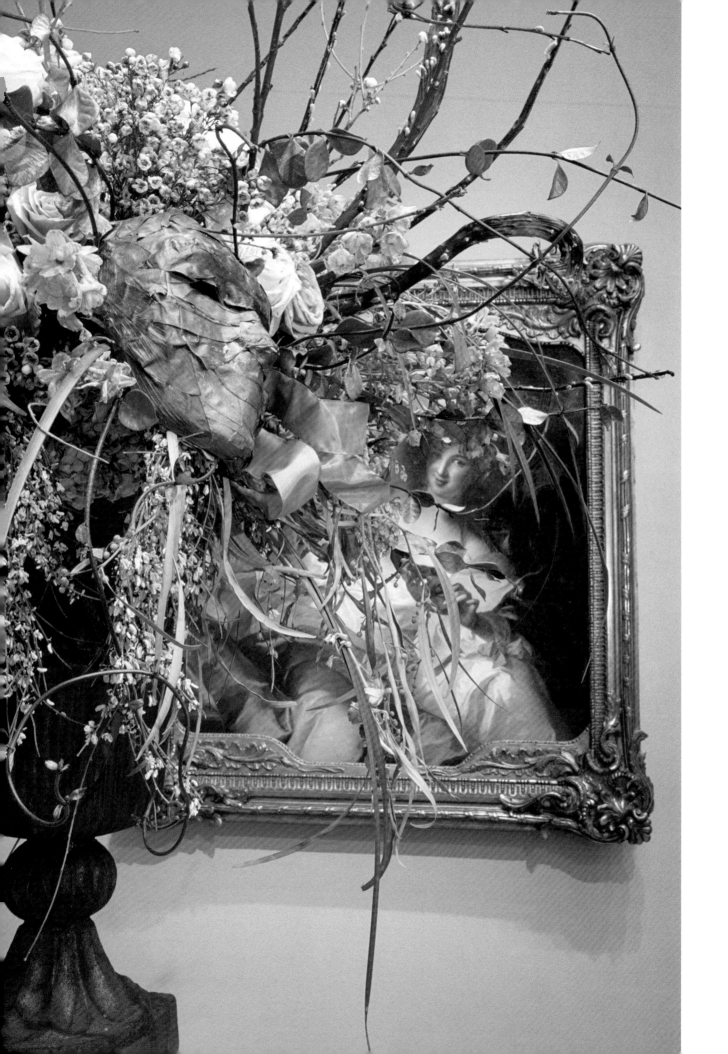

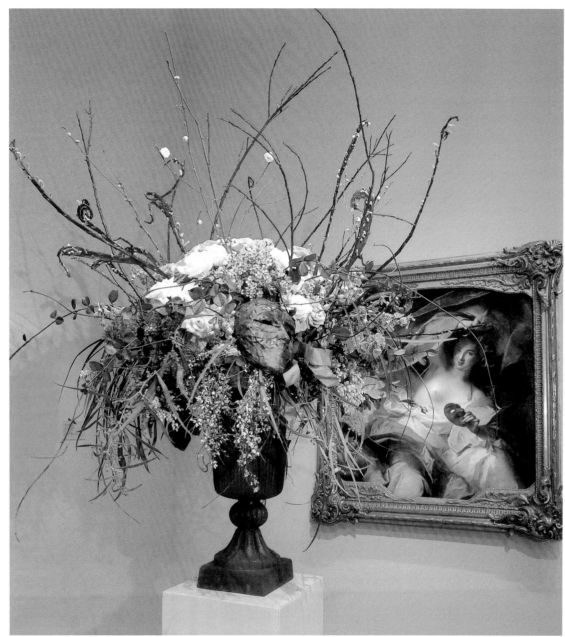

GALLERY 7
THE ROBERT DOLLAR
GALLERY

Jean-Marc Nattier
French (1685-1766)
Thalia, Muse of Comedy, 1739
Oil on canvas
Mildred Anna Williams
Collection

PHYLLIS BRADY OF TWIGS & IVY FLORAL STUDIO, San Rafael, CA captures the mystery and coquettish nature of *Thalia, Muse of Comedy* with this luxuriant bouquet that became the inspiration for the 2005 *Bouquets to Art* poster. A hollow plastic mask covered with layers of various sizes of fresh leaves portrays the secret the muse holds in her eyes, and in the light, takes on an irridescence that complements the French silk ribbon, also seen in the painting. Various vines, pods, glossy jasmine leaves, and lily grass contrast with an array of hydrangea, belladonna, delphinium, snowy mountain wax flower, and roses. Capturing the folds and movement of Thalia's gossamer gown are twigs and palm fronds reaching out from the floral display and balancing the strong earthen pedestal urn. Floral art and fine art come together to express levity and amusement along with a sense of mystery, comedy, and beauty.

2005

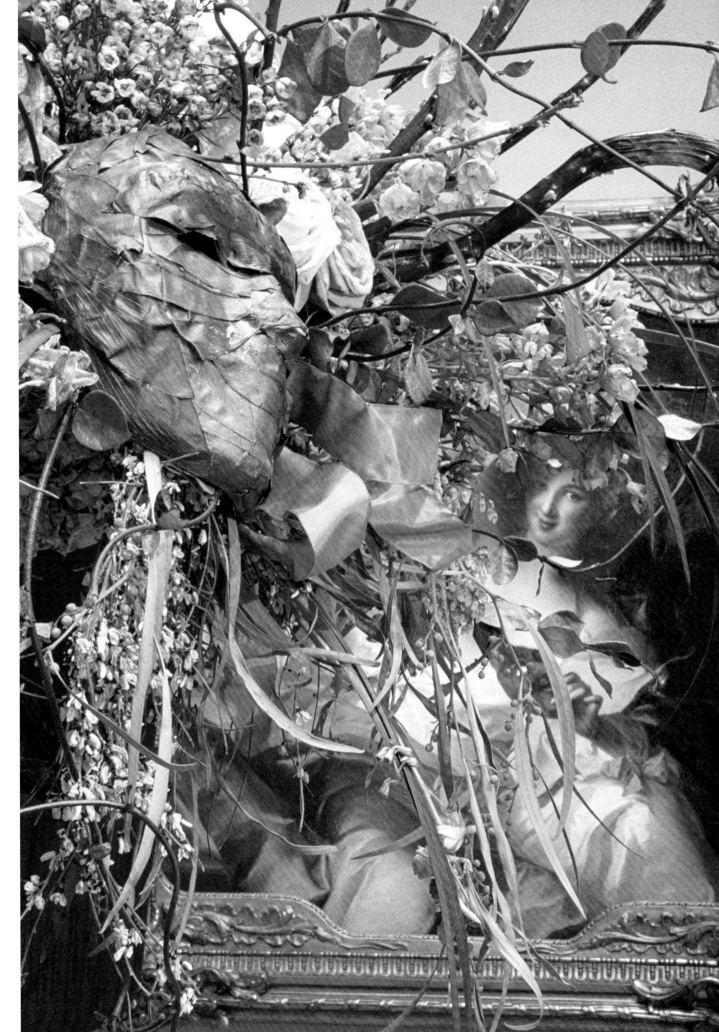

*All I need
to make a comedy
is a park,
a policeman,
and a pretty girl.*

Charlie Chaplin

ALEXANDER AND JEAN DE BRETTEVILLE COURT OF HONOR
Opening Night Gala, March 14, 2005

Auguste Rodin, *The Thinker*, bronze, gift of Alma de Bretteville Spreckels

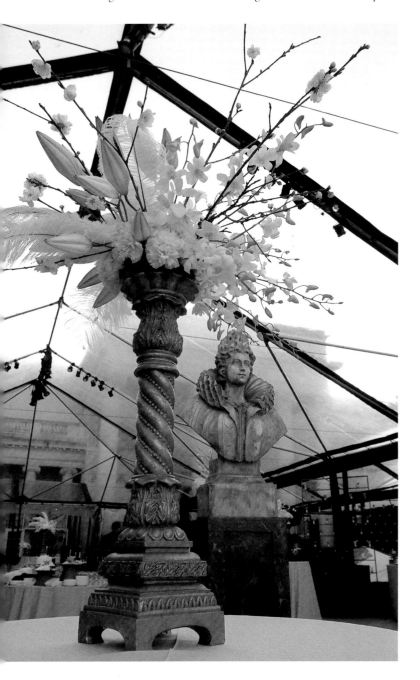

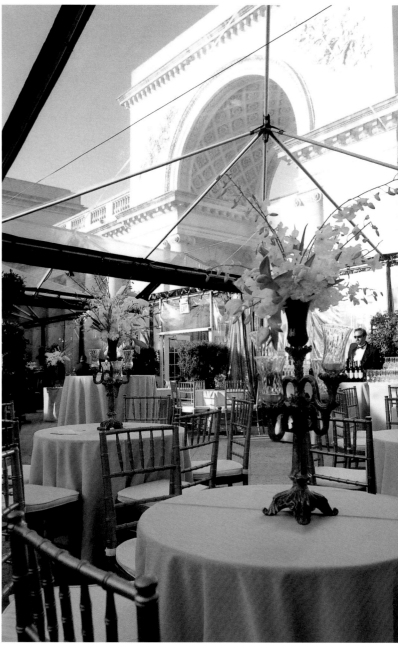

ROBERT FOUNTAIN, San Francisco, CA AND RON MORGAN, Oakland, CA transform the Court of Honor into an inviting venue of French elegance for the 2005 *Bouquets to Art* Gala Opening Night Preview Party. The French theme, inspired by the Corbet exhibit at the time and the 2005 *Bouquets to Art* poster image, was also a fitting tribute to the Legion's own historical beginnings as a replica of the Legion of Honor in France. French blue tablecloths and abundant sprays of white Casablanca lilies, dendrobium orchids, roses, and ostrich feathers gathered atop tall gilded pedestal-style containers complete the blue and white theme. Plaster of Paris busts with a faux bronze finish in the 17th century French

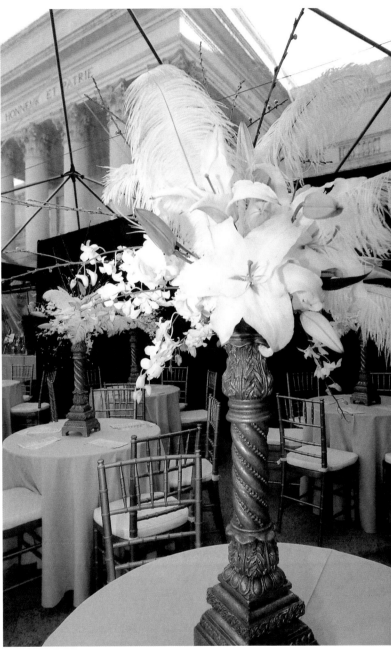

court style add elements of creative decor. Huge glass vases with floating candles are stacked in front of Rodin's *The Thinker* to serve as mood lighting for the gourmet feast to follow. The transparency of the tent allowed for beautiful vistas of the classical archway to the Court of Honor and to the Grecian columns that grace the impressive entrance to the museum. And later in the evening it gave everyone the pleasure of a romantic night under the stars, providing the finishing touch to an evening of French savoir-faire.

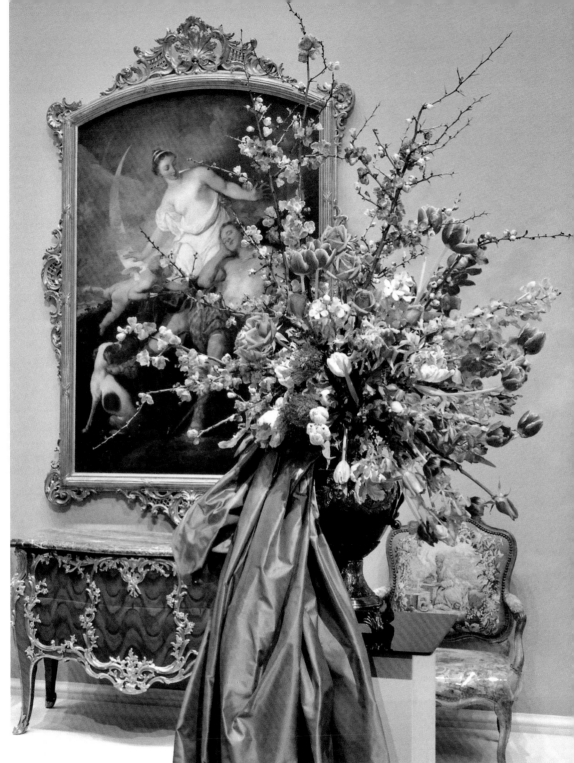

KIWI DEVOY OF DEVOY DESIGNS, Atherton, CA was drawn to the Greek mythology theme of Diana, goddess of the hunt portrayed in the two paintings. She uses color as her prime design element to create a strong visual line to pull the eye in and move it downward. The cascading spiral of flowers and richly woven silk fabric provide a sense of movement that, together with the richly saturated colors, give the arrangement a powerful presence. The flowers were chosen and meticulously prepared to be at their optimum for the show: rare true-coral quince, coral roses, bicolored orange-gold flame roses, protea, finger orchids, parrot tulips, and dendrobium orchids. The lushness of the paintings and voluptuous female figures are enhanced by the flowers that echo the colors of their faces, hair, and skin tones. The color and texture of the draped fabric further integrates the floral design with the paintings, creating a final dramatic sweep.

Auguste Rodin, French (1840-1917) *Reductions of the Burghers of Calais*, 1885-1886

Jean de Fiennes, Eustache de Saint-Pierre, Jean d'Aire, Andrieu d'Andres, Pierre de Weissant

Bronze, gifts of Alma de Bretteville Spreckels

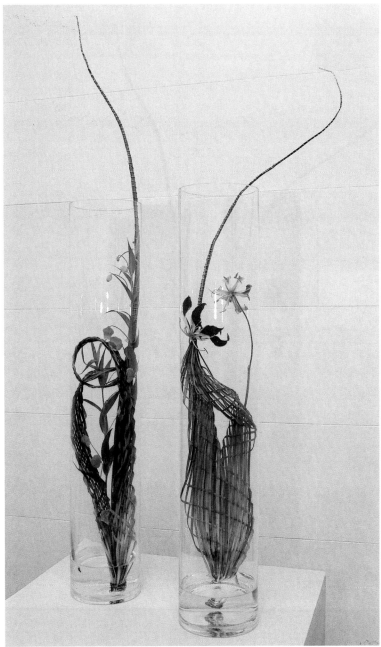

Katsuko Thielke , Teacher in the Sogetsu School of Ikebana, Mountain View, CA charms us with her beautifully creative interpretations of Rodin's *Burghers of Calais*. Exhibiting her signature style of woven plant material with intricately woven bear grass designs, she succeeds in capturing the different movements and stances of the five figures with a delicacy and grace that form an intriguing contrast to the solidity of the bronze sculptures. Fine gold wire is used to shape the design of the woven grass and to secure it at the base. The wire is also wrapped around the top narrow portion of the designs to allow for bending into the desired shape. After the woven design was completed, a single flower of gloriosa lily or sandasonia was poked into the wired base and the entire arrangement placed in a tall, clear column vase. Ethereal angel hair around the bottom of the vases give the floral figures the appearance of rising out of a morning mist.

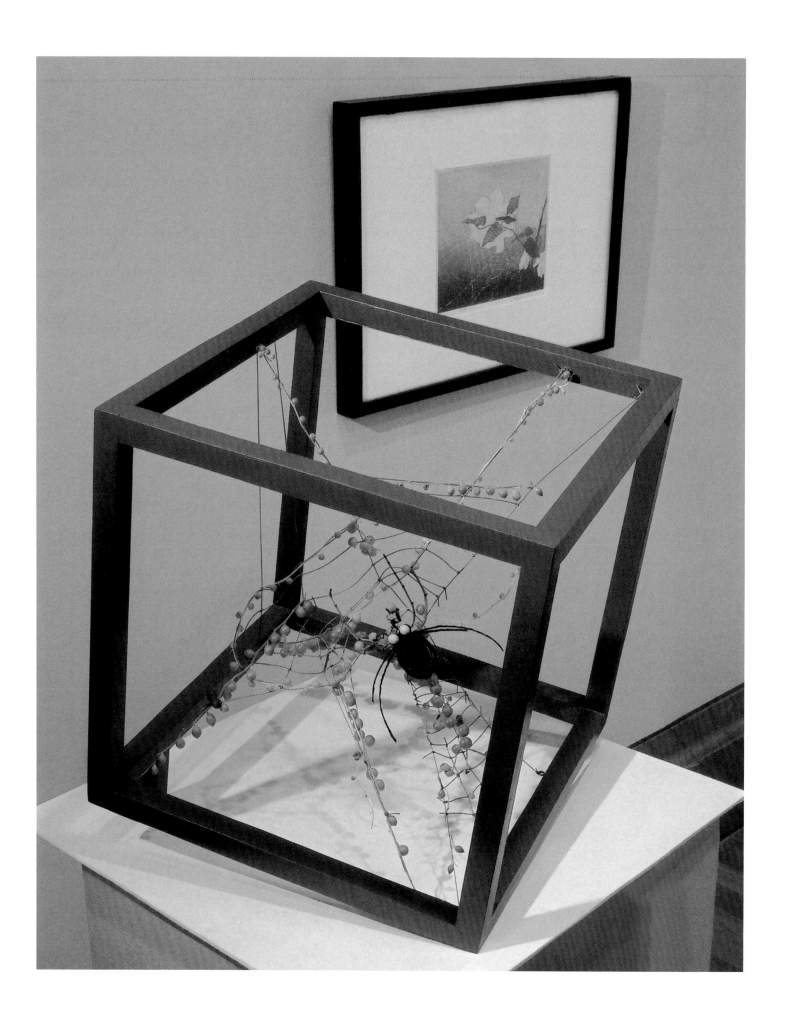

Rosekrans Court, The Wattis Gallery

Special Exhibition: *Windows Facing East*

Arthur Rigden Read, British (1879-?)
Spider's Web, n.d., color woodcut
Achenbach Foundation for Graphic Arts, gift of Edward Tyler Nahem

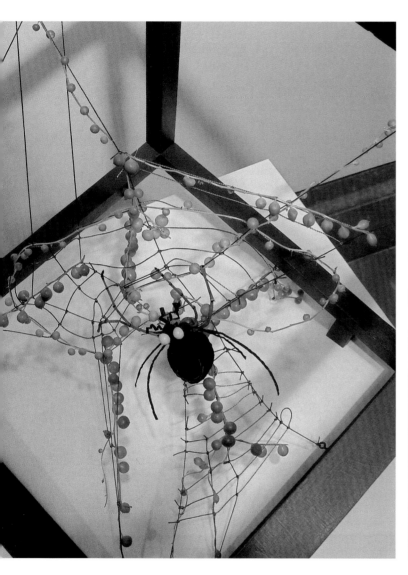
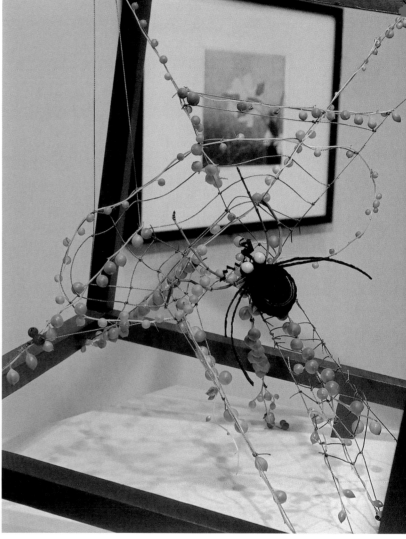

Regula Allenspach Weill, AIFD, of Regula's European Design, San Francisco, CA dazzles us with this unique botanical sculpture of a spider's web that is a work of art itself. Inspired for many years by the architecture of a spider's web and its dewy magic glistening in the sunlight, Regula thought, "Someday, I am going to make a big one of my own!" Seeing this print on display during the floral designers' January selection day for the art work they would complement in *Bouquets to Art* that March was the moment of opportunity for Regula to seize the challenge and fulfill this creative wish. The web is inside a twelve-inch pinewood cube, painted dark brown to go with the picture frames in the gallery. The spider is rolled-up textured black paper. The eyes are split dried soybeans. Its back legs are strips of black paper and the front legs are wired mini horsetail bamboo and bent to hold onto the web, which is string-of-pearls attached to stretched cotton pearl twine. As a spider's artistic web entraps the body of its victim, Regula used string-of-pearls to symbolize the dew on the silky web and to capture the imagination of the viewer.

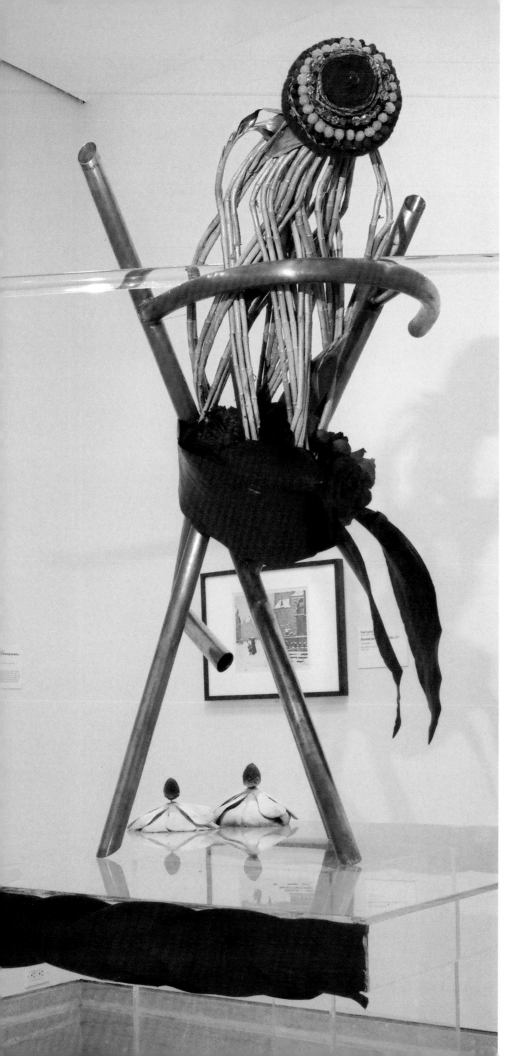

Constance Oakson of Flora, Floral Artisans Studio, Menlo Park, CA found her inspiration in the print of the *Tightrope Dancer*. Her contemporary floral sculpture tells the story of the print. On the acrobat's head is a beanie, intricately detailed in the design with red leucodendron berries, hypericum, and enhanced blue eucalyptus berries. Her red sash is represented by red tea leaves bound together by gathered roses. A mass of dracena stems, or lucky bamboo, form the body, while copper pipes form the legs. The tightrope dancer carries a balance bar represented by the clear acrylic horizontal rod. Watching the spectacle are two young ballerinas recreated on the plexiglass table by upside-down green succulents topped with red leucodendron berries. The blue-gray umbrella a clown is holding rests inside the base of the beautiful plexiglass table. Made from an old umbrella and covered in silver dollar eucalyptus leaves and blue thistle, it is the final detail to complete the circus scene.

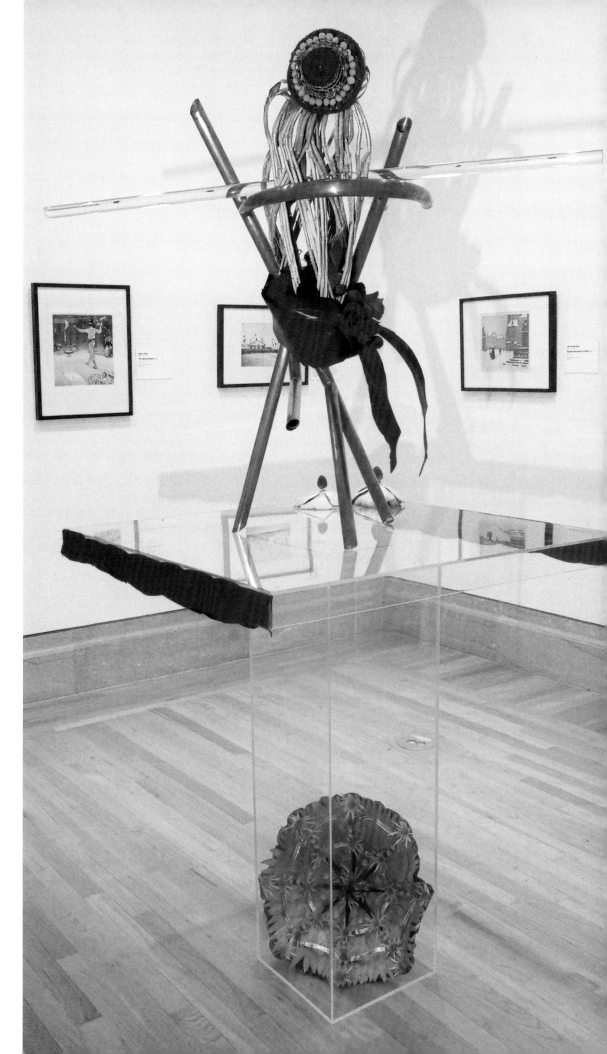

ROSEKRANS COURT
GALLERY D

Special Exhibition
Windows Facing East

Left: Mabel A. Royds, British (1874-1971)
Tightrope Dancer, n.d.
Color woodcut
Achenbach Foundation for Graphic Arts
Gift of Edward Tyler Nahem

Middle: Anonymous
(Japanese, active 19th century)
Japanese Firemen Performing Acrobatics,
ca. 1880
Museum purchase
Achenbach Foundation for Graphic Arts
Endowment Fund

Right: Tavik František Šimon
Czech (1877-1942)
Staroměstské Náměstí in Winter, 1911
Color aquatint
Achenbach Foundation for Graphic Arts
Gift of Edward Tyler Nahem

GALLERY 3

HELENE IRWIN FAGAN
GALLERY

Attributed to Hans Cranach
German (ca. 1503-1537)
*Portrait of a Lady of the Saxon Court as
Judith with the Head of Holofernes*
Oil on beechwood panel
Mildred Anna Williams Collection

LATISHA CHIURCO OF LATISHA'S FLORAL DESIGN, Sonoma, CA uses a stunning cluster of fully-open black baccara amaryllis interspersed with leopard vanda orchids as the focal point in this unique floral interpretation of her favorite painting in the Legion, *Judith with the Head of Holofernes*. Judith, a prominent lady of the Saxon court, who in a 17th century male-dominated society took it upon herself to execute the notorious traitor of the court, Holofernes, represented to LaTisha the power of women in society despite social and political limitations. In the floral arrangement, black magic roses form a resting place for the severed head of daisy chrysanthemums and spray-painted Spanish moss. The rusty-red underside of peacock leaves complement the dark red flowers, and curly willow echoes the twisting, random nature of the orchids. A metal sword and burnished metal container in a guillotine shape complete the executioner theme.

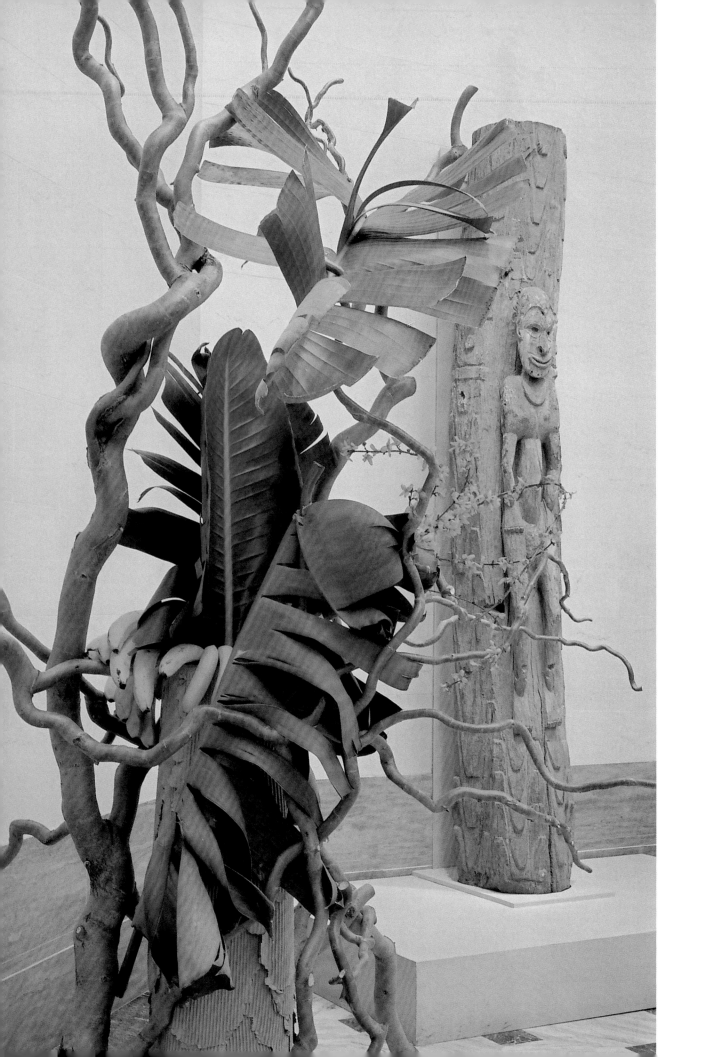

GALLERY 12
WALTER AND PHYLLIS
SHORENSTEIN GALLERY

Middle Karawari River
Yimam people
Papua New Guinea
Hunting spirit, 19th century
Wood
Museum purchase,
Mrs. Paul L. Wattis Fund

THE SOHO STUDY GROUP, Richmond, CA, including SOHO SAKAI, OLIVIA CAMGROS, MARYANN FORREST, NANCY HOUTKOOPER, SCOTT JOB, SALLY KETCHUM, JANETTE MACKINLAY, JUNE MATSUOKA, and ANNETTE MUNGAI SULLIVAN bring a smile to the face of the totem man by surrounding him with plants from his natural habitat. Tropical trees are formed with a structure of thick curly willow branches and oversized bird of paradise leaves. Yellow forsythia and bananas are used to repeat the flecks of yellow paint still remaining on the totem. The containers are wrapped in corrugated paper, which is torn and aged to enhance the old weathered wood of the piece. The large scale of the works and abundant use of indigenous materials transports us out of the museum environment and into the forests of New Guinea, where we unexpectedly happen upon an ancient totem.

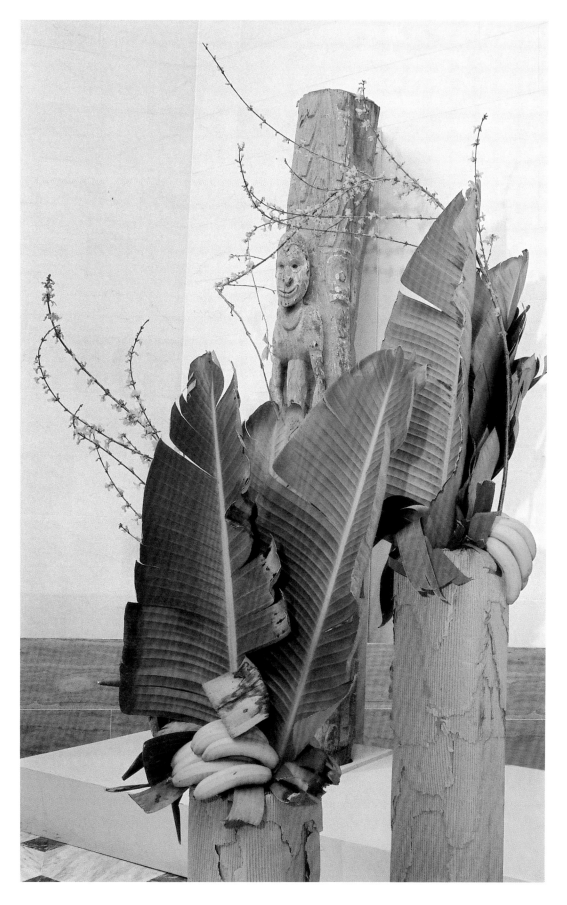

2006

at the de Young

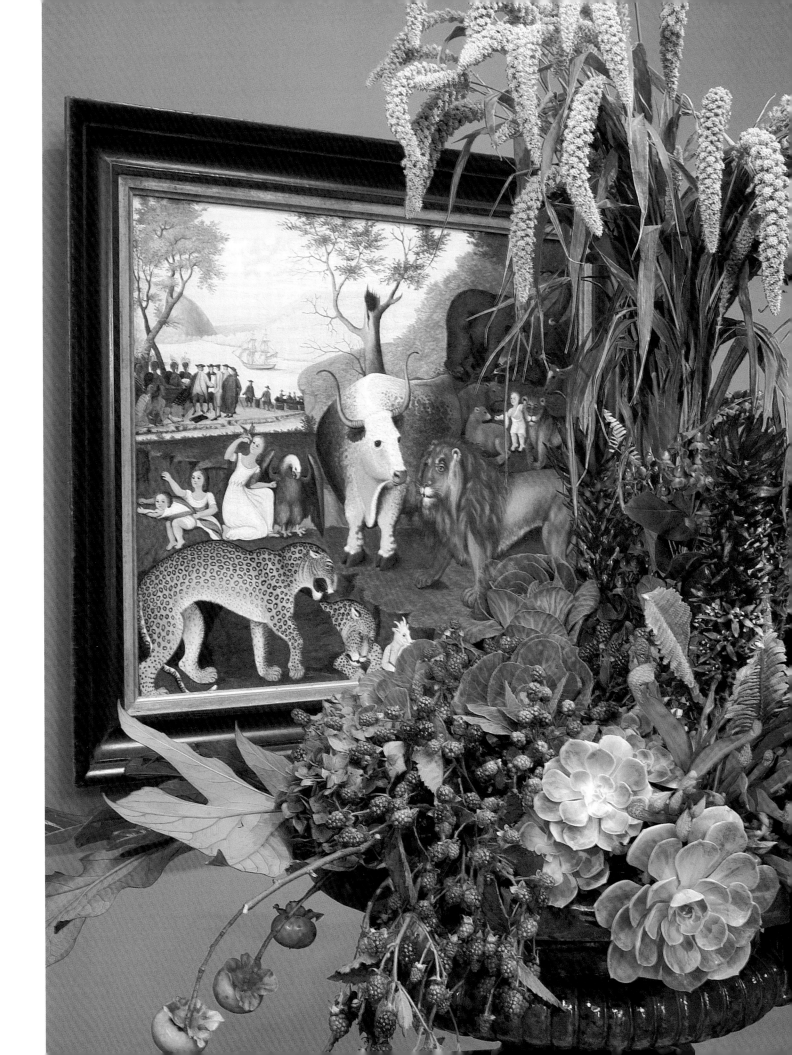

Page 169

GALLERY 23 THE J. BURGESS AND ELIZABETH B. JAMIESON GALLERY
Edward Hicks, American (1780-1849), *The Peaceable Kingdom*, ca. 1846
Oil on canvas, gift of Mr. and Mrs. John D. Rockefeller III

RON MORGAN, Oakland, CA creates a textural and earthy arrangement for the 2006 *Bouquets to Art* poster image. Capturing the pastoral setting of Edward Hicks' *The Peaceable Kingdom*, he uses an array of plants, flowers, greens, and fruit to represent the complete cycle of plant life from seed to flower to fruit. Diverse textural elements contrast and complement one another. The different shades of green found in the succulents, ferns, oak leaf hydrangea, cabbage, and field grasses are accentuated with the soft burgundy of the eucomis, hydrangea, blackberries, and hypericum. Together they create an ideal floral complement to the artist's very literal recreation of *Isaiah 11:6-9* from the Bible.

JUN PIÑON OF PIÑON DESIGN, San Francisco, CA presents a pair of dramatic contemporary designs that are a striking complement to the visually captivating *STRONTIUM*, destined to be the de Young signature art work. Creating texture and pattern with color, Jun forms collars of scabiosa pods, burgundy peonies, kumquats, lady apples, hydrangea, gloriosa lilies, and purple orchids atop two tall, clear column vases lined with maple and flax leaves and bursting with a profusion of white calla lilies. Individually and together, the cluster of flowers echo the circles of the photographs and the soaring calla lilies reflect the grand scale of the art work.

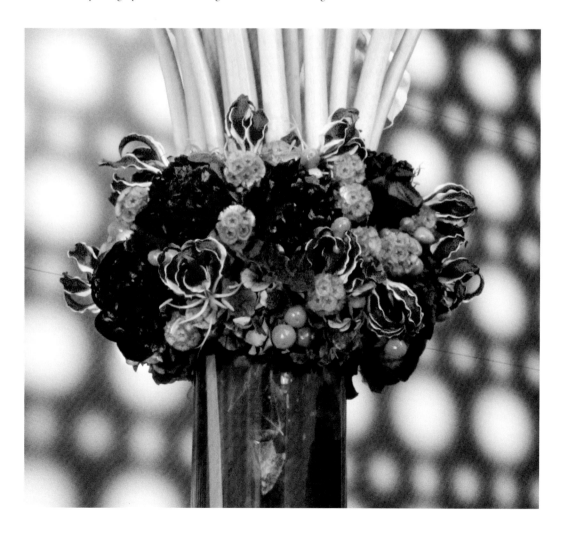

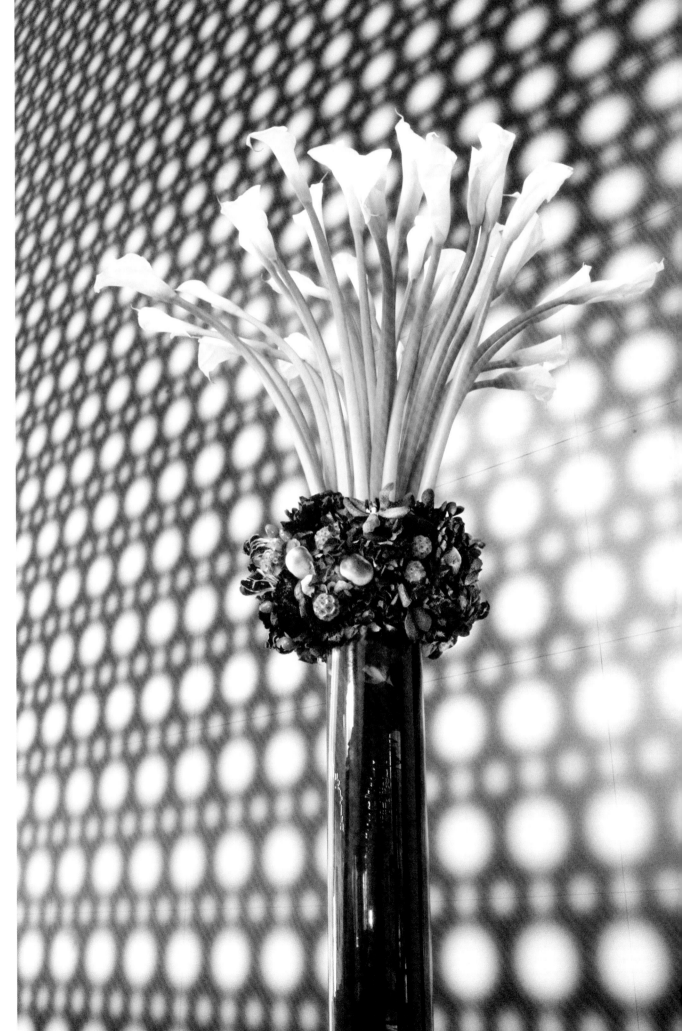

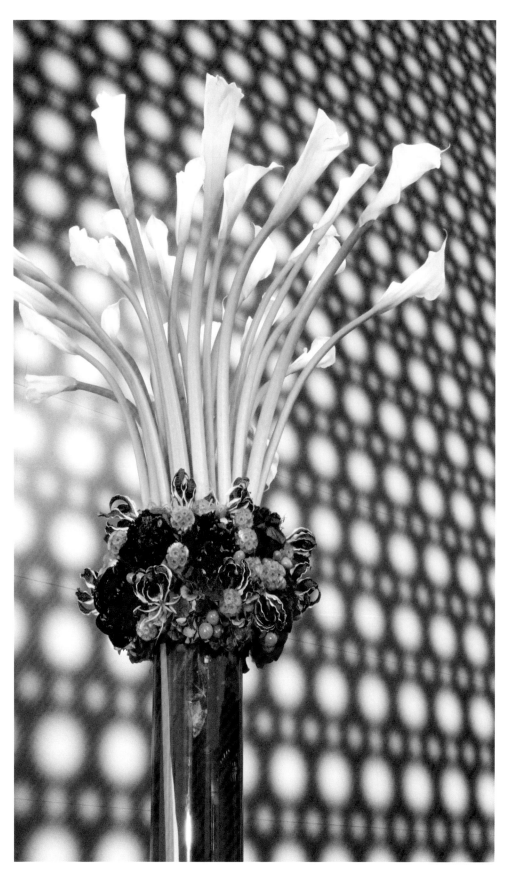

Jun Piñon,
Piñon Design,
San Francisco, CA

Full view of the other
one of his pair of
dramatic arrangements
in front of *STRONTIUM*,
presented on the
previous page.

The Diane B. Wilsey
and Alfred S. Wilsey Court

STRONTIUM, 2004
Gerhard Richter
German, b. 1932
130 C-print photographs
mounted on aluminum

Foundation purchase
Gift of Diane B. Wilsey
President
Board of Trustees
Fine Arts Museums of
San Francisco
On the occasion
of the opening
of the new
de Young museum
on October 15, 2005
in memory of
Alfred S. Wilsey

MUSEUM ENTRANCE, DE YOUNG

Richard Deacon, British, b. 1949
UW84DC#2, 2001, ash and aluminum
Museum purchase, Robert and Daphne Bransten New Art Purchase Fund

THE FINE ARTS MUSEUMS OF SAN FRANCISCO FLOWER COMMITTEE each week creates a beautiful and creative floral display to greet visitors as they enter through the courtyard into the de Young museum. Here we see an autumn color palette of rust amaranthus, green goddess calla lilies, leonidas roses, and Queen Anne's lace. The round textural pattern of the de Young's copper-clad exterior reflected in the glass is echoed by Gerhard Richter's *STRONTIUM* to the left and is a fascinating artistic complement to the Richard Deacon sculpture below.

GALA OPENING

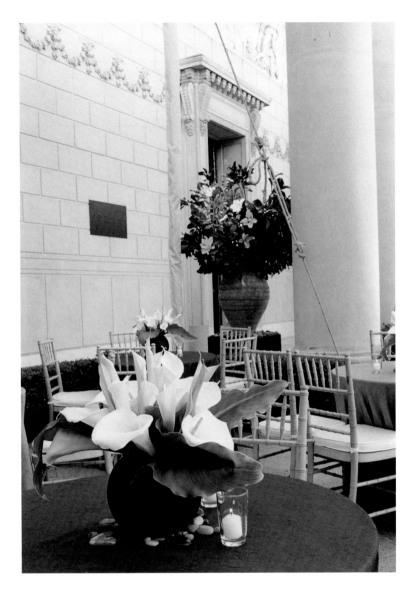 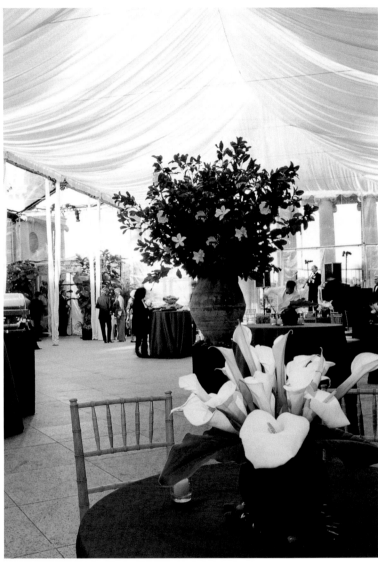

PREVIEW PARTY

Bouquets to Art 2000

The Court of Honor
Legion of Honor

Flowers and Tent Decor
by KATHLEEN DEERY
KATHLEEN DEERY DESIGN,
San Francisco, CA

SILENT AUCTION

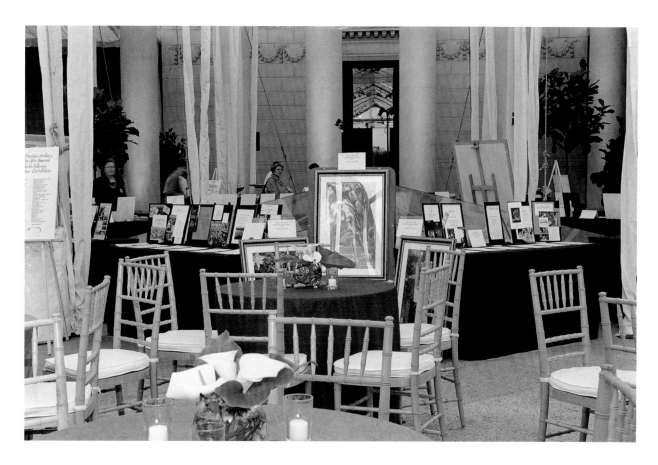

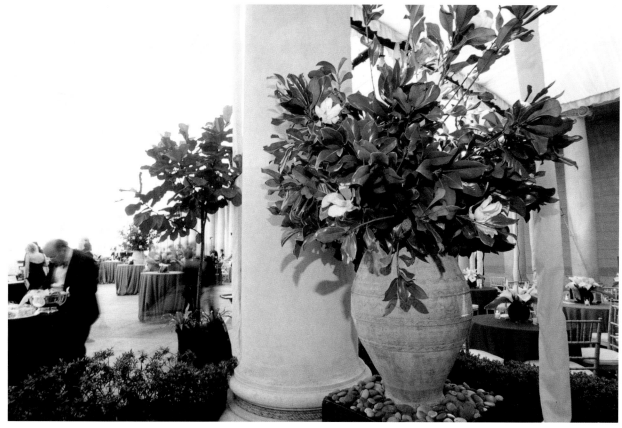

FLORAL
DEMONSTRATIONS

Bouquets to Art 2005

Above:
JUN PIÑON,
PIÑON DESIGN, San Francisco, CA
"Endless Possibilities in Bloom"

Bottom right:
MATT WOOD,
AIFD, Alameda, CA
"A New Day"

Bouquets to Art 2005

PAULA PRYKE
London, England

"Flair with Flowers"

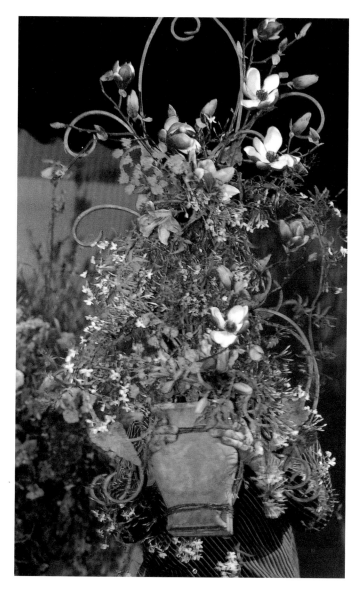

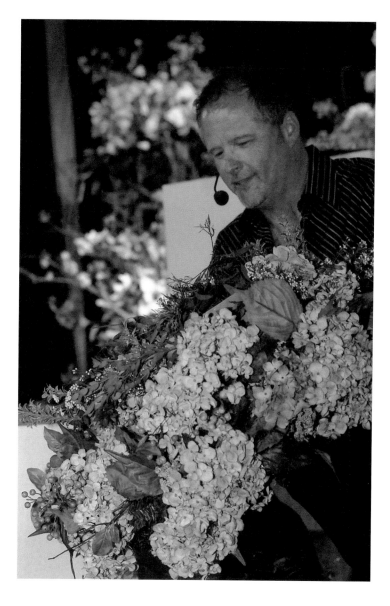

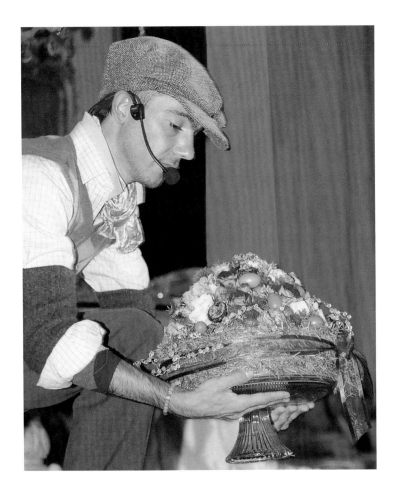

Bouquets to Art 2004

PIETER PORTERS

Pieter Porters Decorations
Antwerp, Belgium

"Tablescapes"
 and
"Interior Still Life"

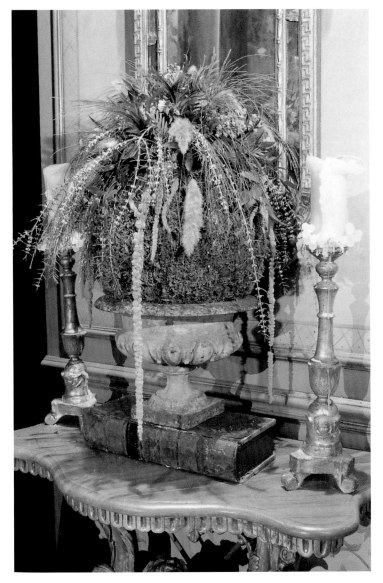

Bouquets to Art 2005

JEFF LEATHAM

Four Seasons Hotel
George V
Paris, France

"Flowers by Design"

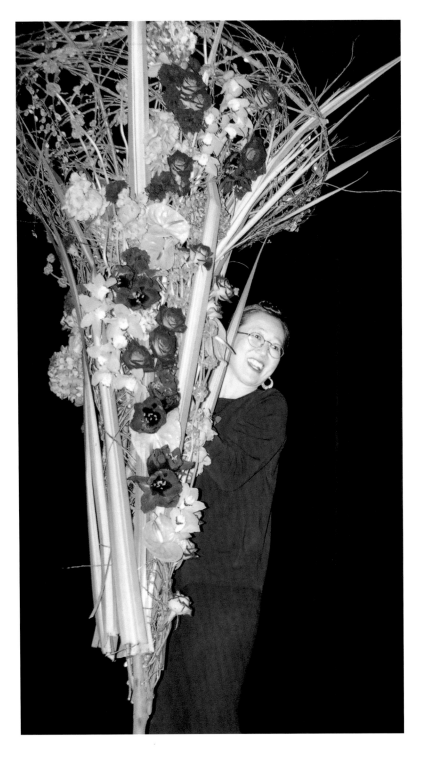

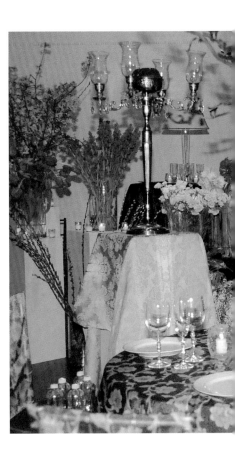

Bouquets to Art 2004

HITOMI GILLIAM
Vancouver, BC, Canada

"East-West Art Deco"

Bouquets to Art 2004

ROBERT FOUNTAIN, San Francisco, CA

"Creating a Mood Through Flowers"

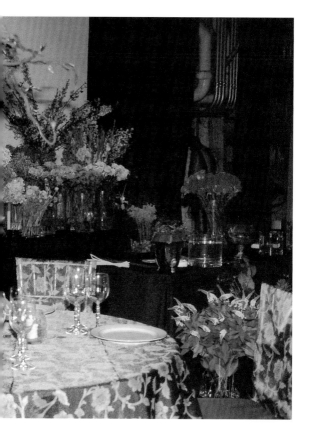

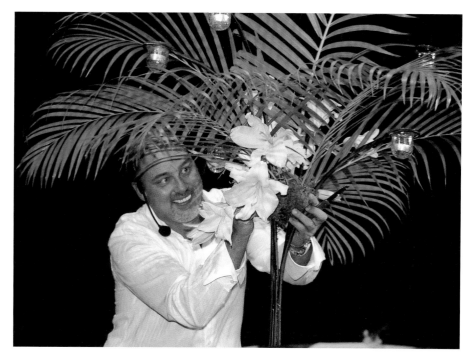

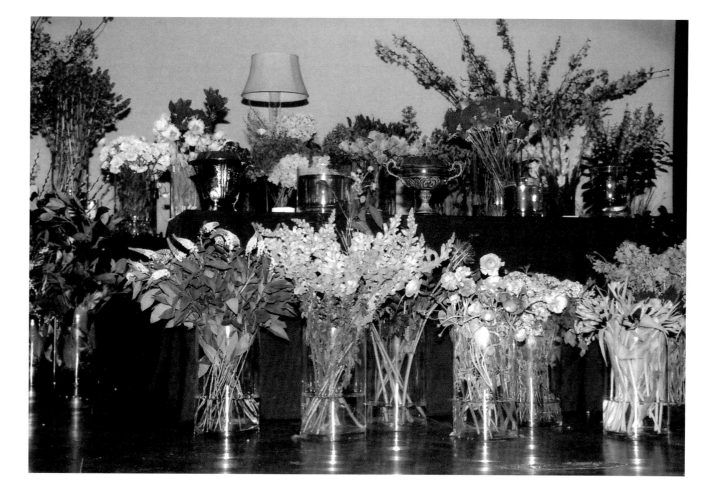

MASTER
DESIGN CLASS

Bouquets to Art 2003

Jeff Leatham

Four Seasons Hotel
George V
Paris, France

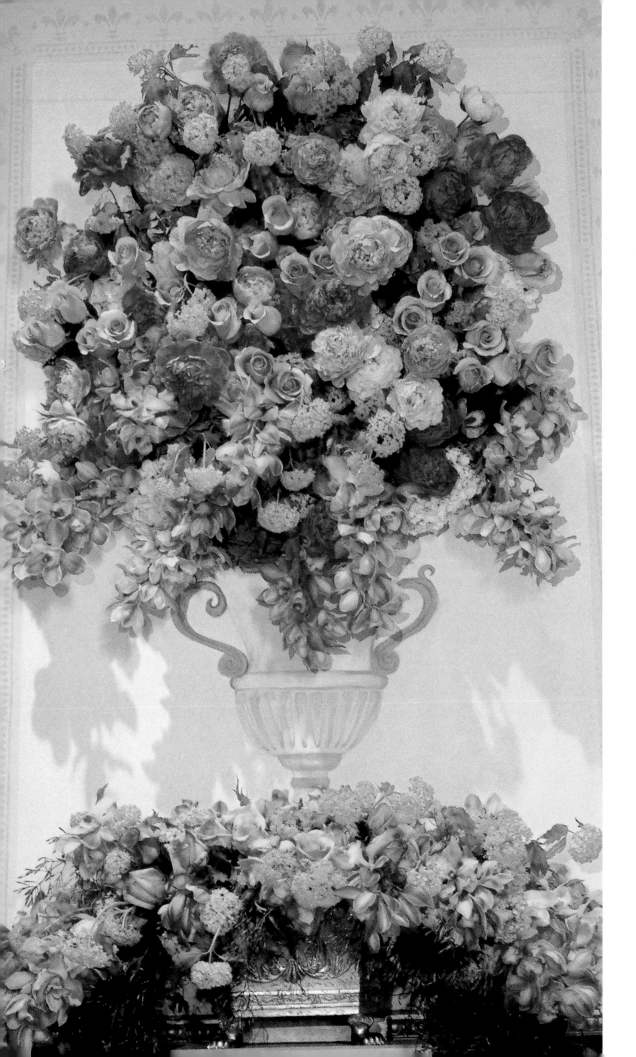

Bouquets to Art 2005
Museum Entrance

ROBERT FOUNTAIN,
San Francisco, CA

Seventeenth century Flemish still life paintings by the old Dutch Masters were the inspiration for this extravagantly beautiful floral painting. Emulating their style, Robert uses a lush array of huge vibrantly colored flowers. Peonies, tulips, roses, jasmine, and cymbidium orchids are woven together in shades of pale to ruby pink; deep blue hydrangea, light green viburnum, and sprigs of ivy give contrast and depth to the arrangement. Mounted on a canvas with a handpainted urn and frame of fleur-de-lis, each flower is individually placed through a hole in the canvas into wet oasis bars strapped to the back. Using fresh flowers in lieu of paint, contemporary floral mechanics, and a highly skilled creative eye, Robert succeeds in painting with flowers his own living, and fragrant, Flemish masterpiece.

THE SAN FRANCISCO AUXILIARY
of the
FINE ARTS MUSEUMS

THE SAN FRANCISCO AUXILIARY OF THE FINE ARTS MUSEUMS had its beginnings long before the idea of *Bouquets to Art* became a reality. In 1941, Mrs. Helen de Young Cameron, along with an interested group of museum supporters, formed the kernel of what was to become the de Young Museum Society, and later the Junior Committee, and finally the Auxiliary.

Late in 1941, Mrs. de Young Cameron officially formed the Society with eleven members. Her goal was to broaden the participation of non-trustees in an effort to increase widespread interest in the museum and fine art. The war years intervened, however, and the society was suspended until 1948 when it was revived with the original directors. Over the years that followed, the society sponsored many events and recruited young women to assist. As these activities increased, a Junior Committee of thirty-five members led by Mrs. William Hewitt was formed with one of their first programs being a "Children's Art Exhibition."

In May of 1952, the Junior Committee held the first of a series of Treasure Hunt sales in Herbst Court. These Treasure Hunt sales and auctions continued through 1976 along with other activities, including Domino Tournaments and sponsorship of various exhibits and lectures. In 1953, the Junior Committee organized the Docent Program and the same year was rewarded for their many efforts with the new name of the Auxiliary of the de Young Museum Society, which later became the San Francisco Auxiliary of the Fine Arts Museums, supporting both the Legion and the de Young.

Today the Auxiliary devotes most of its attention and energy into the planning, orchestration, and promotion of *Bouquets to Art*, which over the years has been developed into the major fundraising event for the Fine Arts Museums of San Francisco. It is a year-round effort, as there is only a brief window of repose after the event in March before preparation and planning begin for the next year. All work is on a volunteer basis, and with the committee chairpersons changing every two years, it takes a strong commitment on the part of everyone involved to fulfill their part in the success of the event. And successful it is, with many people volunteering year after year, knowing that their efforts will benefit the Fine Arts Museums and in turn enrich people's lives with a greater exposure to and understanding of both fine art and floral art.

Numerous floral designers also return year after year and many new ones arrive eager to participate in an event that gives them a unique opportunity to express their creativity within the rich and stimulating environment of the museums' collections. *Bouquets to Art* begins in early January for the designers, when they come to the museum on selection day to submit a choice for the art work they will complement in March, and the Auxiliary does their best to assure that eveyone is satisfied with their final assignment. This working relationship between the Auxiliary and the floral designers is one that has been cultivated over the years and is the foundation of the event's success.

The week of *Bouquets to Art* is an opportunity for the Auxiliary to shine. Beginning with the gala opening and through the week of lectures, teas, luncheons, and an extravaganza of glorious floral art, all the hard work of the past year melts into enjoyment. But it is well-earned, for it is all the behind-the-scenes work that few see that makes *Bouquets to Art* not only a success, but a possibility. And for this dedicated effort, we are all enriched and the Fine Arts Museums of San Francisco are generously supported.

Augustin Pajou, French (1730-1809)
Bust of Madame du Barry, 1773
Marble
Gift of Andre J. Kahn-Wolf

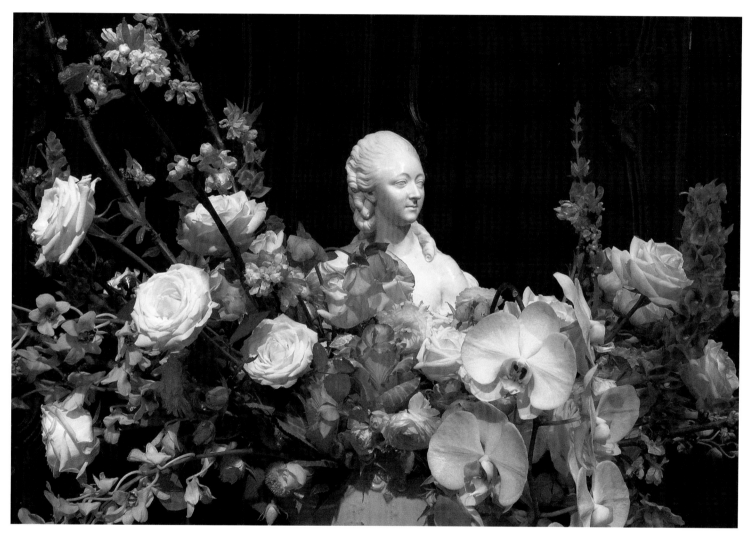

WENDY MORCK OF WENDY MORCK DESIGN, Redwood Shores, CA captures the beauty of Madame du Barry's alabaster skin with a lush arrangement of polo roses, white phalaenopsis orchids, and apple blossoms. The pale green dendrobium orchids, bells of Ireland, and ornamental kale give just the right amount of soft contrast to the white sculpture and flowers. Sweeping upward, embracing the bust, and framing her face, the arrangement complements the aristocratic beauty of Madame du Barry and adds to the sense of peace and serenity the sculpture elicits.

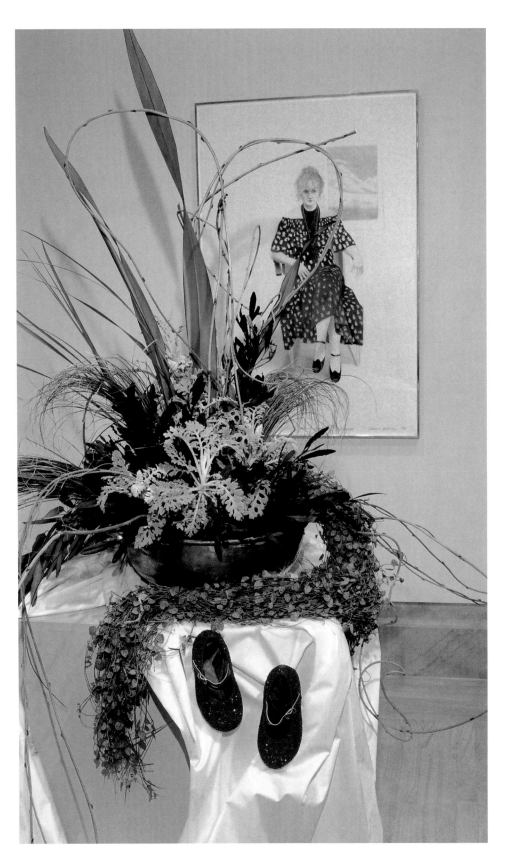

ANDERSON GALLERY OF
CONTEMPORAY GRAPHIC ART

David Hockney, British, b. 1937
Celia, 8365 Melrose Ave.,
Hollywood, 1973
Lithograph
Anderson Graphic Arts Collection

Bouquets to Art 1998

FLORAL DESIGN BY
KIM HAYWORTH
Brisbane, CA

We can go without most things
for long periods of time,
anything almost,
but not our joy,
not those handmade red shoes.

Clarissa Pinkola Estes, Ph.D.
Women Who Run With the Wolves
Ballantine Books

WITH HEARTFELT APPRECIATION

Creating this book has been a labor of love and a wonderful opportunity for me to combine my passions for flowers, art, and photography, and in so doing, share with others the unique legacy of *Bouquets to Art*. It has also been a long journey of hard work and dedication which without the support, encouragement, and involvement of many people would not exist.

The journey began in 1996 when my dear friend Sharon Rose, with her life-long love of flowers, introduced me to *Bouquets to Art*. This set the wheels in motion for Susan at the San Francisco Flower Mart, M.J. of the Auxiliary, and Ron Morgan to connect me with the Auxiliary and begin my photography of the event. A very special thank you to them for opening the door to this exciting and rewarding journey.

Thank you to all the Auxiliary members who welcomed me and my work into the event. Special thanks to Pat, who over the years has been a constant source of support and encouragement; and to Barbara, who each year patiently fulfilled all my requests for much-needed information for that year's program.

A very special thank you to all the floral designers both within the Bay Area and in other parts of the world who have supported and expressed their appreciation for my work over the past nine years. My relationship with all of you has enriched my life and it is an honor to use your fabulous and inspiring creations in this book.

Thank you to all the Fine Arts Museums staff for supporting me in my work. A special thanks to Sherin and Duffy, who each year were always willing to help and arrange for my requests in addition to the monumental organizational tasks that *Bouquets to Art* demands. A special thanks to Susan, Karin, Ann, Debra, Daniell, Lynn, and Mary who patiently and willingly offered their support in providing me with all the necessary permissions needed to produce this book, and to Harry S. Parker III, who gave his permission for this book to go forward.

Thank you to the all the security staff at the Legion and de Young, who each year welcomed me and made working there a delightful experience, and especially to Andrea, who shared with me her love of *Bouquets to Art* and appreciation for my work.

Thank you to the museums who gave permission to use images containing works from their collections that were in special exhibits at the Legion: Victoria and Albert Museum, London; the Royal Museum for Central Africa, Tervuren, Belgium; and the Jane Voorhees Zimmerli Art Museum, Rutgers, The State University of New Jersey.

Thank you to those living artists who gave their permission to use photographs containing their work and to those artists now deceased whose timeless beauty now lives in our museums.

Many thanks to Michael K. and Tyler W., who gave generously of their time and creative talents and offered valuable advice when it was most needed. My sincere gratitude to Jean for her editorial expertise, and to Stan and Doug for their invaluable technical support. And special thanks to Martha at TWP, who opened doors and helped to make it all happen, and to all the staff at Tien Wah Press in Singapore, especially Karen, who worked so hard to make this book a success.

Thank you to the flowers, which I have loved since I was a child.

Finally, I would like to say a very special thank you to my friends and family, my sons Iain and Jason, and my Mother for their love and much-appreciated support of my photography and my life. To Daisaku Ikeda, my mentor in life, I wish to express my deepest appreciation for his life philosophy and example, which has been and continues to be a source of the courage and perseverance necessary to pursue my dreams, of which this book is one.

TIEN WAH PRESS

———●———

FINE PRINTING AND QUALITY SERVICE FOR THE WORLD

Tien Wah Press in Singapore,
established 1935